Marcel Duchamp

Marcel**Duchamp**Respirateur

Staatliches Museum Schwerin

Hatje Cantz

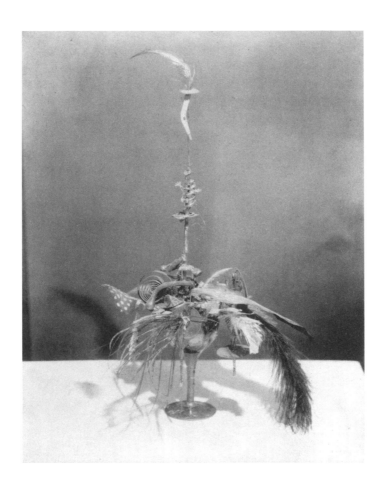

Charles Sheeler
Portrait of Marcel Duchamp by Elsa Baroness Freytag-Loringhoven, 1922
Porträt Marcel Duchamps von Elsa Baroness Freytag-Loringhoven

Inhalt / Contents

Roue de bicyclette, 1913/1964 / *Fahrrad-Rad*

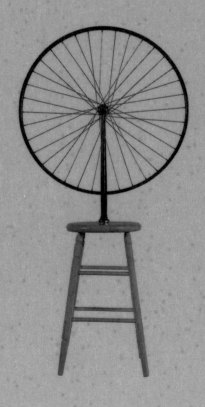

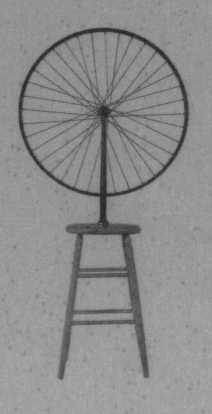

Vorwort

Mit der Ausstellung und der Publikation »Marcel Duchamp – Respirateur« in Schwerin realisierten wir keine Werkübersicht des Künstlers, sondern gehen der Frage nach der dem Werk zugrundeliegenden Struktur, der geistigen Haltung und der von ihm entwickelten Methode nach, den Gebrauchsfluß der Dinge zu unterbrechen. Duchamp hatte sich einer Lebens- und Arbeitsweise der skeptischen Leichtigkeit verschrieben, der die Firmen- und Reklameschilder oder die technischen Gerätschaften das dingliche wie das visuelle Material für seine Werke lieferten. In den Ready-mades sprengte Duchamp das Diktat des Zwecks und aktivierte die notwendige Distanz des Bewußtseins und die Freiheit, um ein anderes Beziehungsgeflecht über die Dinge zu legen. Er thematisierte die kategoriale Zeitabhängigkeit des Kunstwerks, seinen Verfallswert.

Im Rahmen der 1995 gezeigten Ausstellung und der Herausgabe des Buches gelang es dem Staatlichen Museum Schwerin, einen großen Teil der Sammlung von Ronny und Jessy Van de Velde, Antwerpen, zu erwerben. Damit besitzt das Staatliche Museum Schwerin 69 herausragende Werke des Meisters, darunter allein 13 Ready-mades und elf Handzeichnungen.

Die Neuauflage des Buches kennzeichnet die Schweriner Werke und erscheint im Rahmen der Gesamtpräsentation der Schweriner Marcel Duchamp Sammlung, die anläßlich der Ausstellung »Pablo Picasso – Der Reiz der Fläche« konzipiert wurde. Die Präsentation der beiden bedeutendsten Künstlerpersönlichkeiten des 20. Jahrhunderts mit ausschließlich konzeptuellen Arbeiten in Schwerin ist einmalig. Daß dies gelang, stimmt uns dankbar und glücklich.

Der Erwerb der Sammlung wurde durch die Unterstützung und das Engagement vieler Sponsoren und Spender möglich. Besonders danken wir dem Bundesministerium des Innern, Bonn, der Nord LB/Norddeutsche Landesbank für Mecklenburg-Vorpommern, den Freunden des Staatlichen Museums Schwerin e. V., der Ostdeutschen Sparkassenstiftung Mecklenburg-Vorpommern und der Sparkasse Schwerin, dem Landtag Mecklenburg-Vorpommern sowie allen privaten Spendern.

Mein Dank gilt den Autoren Professor Dr. Herbert Molderings, Köln und Bochum, und Dr. Gerhard Graulich, wissenschaftlicher Mitarbeiter der Abteilung Gemälde des Staatlichen Museums Schwerin. Für namhafte Hinweise zum Werk Marcel Duchamps danke ich Jacqueline Matisse Monnier, Villiers-sous-Grez.

Kornelia von Berswordt-Wallrabe

Introduction

The Schwerin exhibition "Marcel Duchamp—Respirateur", which includes a publication with the same title, is not meant to be a comprehensive exposition of the life work of the artist. The main emphasis lies on the basic concept and attitude as well as on the methods of the painter, who had the remarkable ability to remove everyday items from their context. Duchamp aspired an attitude of sceptical easiness, both in life and work. As regards the visual material of his art and its motifs, he drew inspiration from advertisements and billboards as well as from technical installations. His "ready-mades" overcome the dictate of purpose and the artist was able to create the necessary distance of the conscience and of freedom in order to interlace things in a new manner. His main motif is the categorical dependence on time of all works of art, in other words their expiry date.

The 1995 exhibition and accompanying publication presented the Staatliche Museum Schwerin with the opportunity to purchase a large part of the collection of Ronny and Jessy Van de Velde of Antwerp. The museum is now in possession of 69 outstanding works of Duchamp, including thirteen "ready-mades" and eleven drawings.

The new edition of the book includes the works in Schwerin and has been issued in time for the complete presentation of the Schwerin Marcel Duchamp collection. The collection is presented to the public as part of the exhibition "Pablo Picasso— The Appeal of Surface". This joint presentation of exclusively conceptual works of the two main representatives of 20th century art in Schwerin is a unique event. We are extraordinary happy and grateful for this great opportunity.

The acquisition of the collection was only made possible thanks to the generous support of sponsors and volunteers. Our special thanks go to the Federal Ministry of the Interior, Bonn, the Nord LB/Norddeutsche Landesbank Mecklenburg-Vorpommern, the association of the Friends of the Staatliche Museum Schwerin, the Ostdeutsche Sparkassenstiftung Mecklenburg-Vorpommern and the Sparkasse Schwerin, the State parliament of Mecklenburg-Vorpommern as well as all private supporters.

I would like to take this opportunity to express my thanks to the authors Professor Dr. Herbert Molderings from Cologne and Bochum and Dr. Gerhard Graulich, curator of the department for paintings of Staatliches Museum Schwerin. I would also like to thank Jacqueline Matisse Monnier, Villiers-sous-Graz for her support in relation to the work of Marcel Duchamps.

Kornelia von Berswordt-Wallrabe

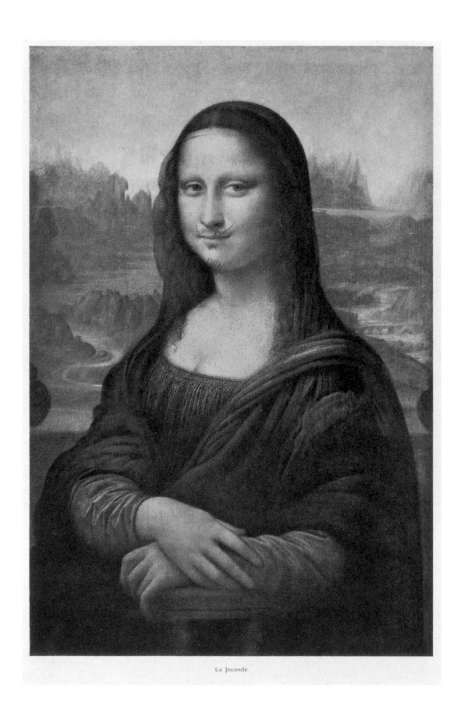

La Joconde

L.H.O.O.Q., 1919/1964

10

Kornelia von Berswordt-Wallrabe

Im Gebrauchsfluß fischen ...

Die Kunst Marcel Duchamps hat das Terrain der Malerei sehr früh verlassen. Die erste bedeutende Ausstellung seiner Arbeiten fiel in eine Zeit, in der der Kubismus seine Bildthemen auf Jahrmärkten und in Kneipen und der Futurismus auf Rennplätzen und in den bewegten Straßen fand. Es war jedoch auch die Zeit, in der der inhaltlich-darstellerische Gegenstandsgehalt der Sujets von den Malern weitgehend aufgelöst wurde. In dieser schrittweisen Auflösung trugen die Künstler einer Entwicklung Rechnung, die sich in der Lebenswelt der Gesellschaft längst vollzogen hatte. Die radikalen Veränderungen in der Warenherstellung, die vom handwerklichen Arbeitsprozeß zur industriellen Massenproduktion in Fabriken führte, bewirkte, daß sich auch die Warenbeschaffung von der individuellen Vergabe eines Auftrages an einen Handwerker zur Auswahl aus einer industriell gefertigten Massenproduktion verlagerte. Nicht das materialbezogene Herstellen bestimmte den Beschaffungsprozeß für den alltäglichen Gebrauch, sondern der konsumptive Akt der Auswahl aus Vorhandenem wurde beim Kauf vollzogen. Dem potentiell endlosen Produktionsfluß immer gleicher industrieller Produkte entspricht auf der Seite der Nutzer der rein zweckorientierte »Gebrauchsfluß«: Eine Schaufel ist eine Schaufel ist eine Schaufel. So wie diese Vorgänge das alltägliche Leben beherrschten, war auch die Rolle des schaffenden, weitgehend handwerklich arbeitenden Künstlers fragwürdig geworden. Deshalb reflektierten Künstler diesen tiefgreifenden Umbruch. Duchamp war der erste unter ihnen, der diesen Veränderungen Rechnung trug. Er mißtraute seit langem der Aussagekraft einer auf Komposition beruhenden Bildlichkeit, die er Willkür nannte, und verweigerte sich der Kategorie des Künstlers im herkömmlichen Sinn. Er wies den Anspruch auf die geniale, gefühlsgesteuerte Künstlerpersönlichkeit ab. Seine Einsicht in den Verlust dieser Werte bewirkte ein selbstironisches, aber klar umrissenes Vorgehen, um die Willkür, die genialische Attitüde des Malers, abzulösen.

Duchamp nimmt einen industriell gefertigten Flaschentrockner aus dem Gebrauchsfluß des Flaschentrocknens und stellt ihn in einen zweckentfremdeten, artifiziellen Zusammenhang als Kunstwerk. In der Unterbrechung des kontinuierlichen Gebrauchsflusses der Dinge entsteht das Werk Duchamps. Seine spielerische und zugleich streng analysierende Art die Welt zu sehen, sie in sich aufzunehmen und daraus, auf der Basis mathematischer wie logischer Gesetzmäßigkeit, künstlerische Schlußfolgerungen zu ziehen, hat Werke zur

Folge, die die Grundlage für den Schock sind, der die Kunst des 20. Jahrhunderts radikal veränderte. Mit ihnen hat die Kunst wieder ein Credo, wie Duchamp dieses der Zeit der Renaissance oder noch der Romantik zusprach. Die Überzeugung, daß eine Veränderung der Malerei mit Hilfe ihrer Technisierung zu erreichen wäre, war ein Gedanke, der zu Gemälden wie *Kaffeemühle*, 1911 (Abb. S. 131), und *Schokoladenmühle*, 1913, führte. Sein Vorgehen, im Arretieren des Gebrauchsflusses innovative, schockierende Werke zu schaffen, stellte das erste Ready-made *Fahrrad-Rad* (Abb. S. 118) im gleichen Jahr vor. Dieser Arbeit lag die Fähigkeit zugrunde, in Distanz zur nahegelegten Gebrauchsbestimmung des Gegenstandes den bestehenden Gebrauchsfluß zu unterbrechen und ihn oder einzelne Teile einem anderen Gebrauchsfluß zuzuführen.

Im Unterschied zu traditionell arbeitenden Künstlern um 1910 sagt Duchamp über diese Zeit von sich selbst:»Ich wollte übergehen zu einer völlig trockenen Zeichnung, einer trockenen Kunstauffassung. Und für mich war die technische Zeichnung die beste Art dieser trockenen Kunstform.«[1]

Hierher gehört auch der Begriff des »toutes faites«, des Ready-mades, 1915 eingeführt. Er entspricht in den Skulpturen Duchamps nicht notwendig dem entstandenen Gesamtgefüge, sondern bezieht sich auf die Qualität der verwendeten Elemente der Skulpturen aus anderen Gebrauchsebenen. In jedem Fall ist er Grundlage nicht nur der Arbeiten, sondern vor allem der Arbeitsweise Marcel Duchamps.

Der Begriff des »toutes faites« bestimmt die den Arbeiten und seinem Leben zugrundeliegende Haltung. Grundsätzlich unterschieden vom Schaffensprozeß in der traditionellen Kunst, der das Kunstwerk – im geistigen und handwerklichen Schaffensakt – als einmaliges generiert, widmet sich Duchamp unter Anwendung seltener Drucktechniken und langwieriger Arbeitsprozesse der kontroversen Verknüpfung von Begriffs- und Dingwelt durch das Arretieren des Gebrauchsflusses.

Zur Tragweite seines Schrittes, die Malerei aufzugeben, befragt, antwortete Duchamp 1959:»Ich brauchte nicht zu verkaufen, um leben zu können. Mein Leben lang war ich imstande, mit sehr wenig Geld auszukommen. Ich verbringe meine Zeit sehr bequem, aber ich wüßte nicht, wie ich Ihnen sagen sollte, was ich tue. Sagen wir ganz einfach, ich verbringe meine Zeit mit Nicht-Malen. Ich habe eine Frau und sie hat eigene Kinder. Ich habe ein Atelier, weil ich mich weigere, vierundzwanzig Stunden mit meiner Frau zu verbringen. Es ist für mich kein Problem, die Zeit auszufüllen.

Ich glaube, man könnte sagen, ich verbringe meine Zeit mit Atmen‹, schloß Duchamp mit einer Fröhlichkeit, die seine Lust am Lebensakt bekräftigte. ›Ich bin ein respirateur – ein Atmer. Ich genieße das ungeheuerlich.‹«[2] Duchamp füllt den alleralltäglichsten Vorgang des Atmens mit Bewußtsein,

12

unterbricht den Automatismus und macht damit jeden Atemzug zum Abenteuer.

Er weiß aber auch, daß ein neuer Gebrauch der Abnutzung unterliegt. Dazu äußert Duchamp gegenüber Richard Hamilton: »... mein wahres Gefühl dabei ist, daß ein Kunstwerk nur Kunstwerk ist für eine sehr kurze Zeitspanne. Ein Kunstwerk hat ein Leben, das kurz ist, kürzer noch als ein Menschenleben. Ich nenne es zwanzig Jahre. Nach zwanzig Jahren hat ein impressionistisches Bild aufgehört, ein impressionistisches Bild zu sein, weil das Material, die Farbe, das Pigment so dunkel geworden ist, daß es nicht mehr das ist, was der Mensch gemacht hat, als er es malte. Gut, das ist eine Art, es zu betrachten. Man übertrage also diese Regel auf alle Kunstwerke, dann sind sie nach zwanzig Jahren erledigt; ihr Leben ist vorbei.«[3]

Unter diesem Blickwinkel ist menschlicher Geist dann gestaltend, wenn er in der Störung des Gebrauchsflusses den achtlosen, den dumpfen Zweck in einen anderen, neuen Gebrauch überführt. Darin ist jeder Gebrauchsfluß zeitlich determiniert. Seine Relevanz erhält er in jedem neuen Abbruch des bestehenden Gebrauchsflusses. Erst im determinierten Gebrauch liegt Geist.

Eine Auffassung von Leben, wie sie Marcel Duchamp hier skizziert, begreift humane Kraft als Bewußtsein in der Zeit. Ein solches Bewußtsein erinnert an die Figur des Flaneurs bei Baudelaire. Dazu schreibt Walter Benjamin: »Die Straße wird zur Wohnung für den Flaneur, der zwischen Häuserfronten so wie der Bürger in seinen vier Wänden zuhause ist. Ihm sind die glänzenden emaillierten Firmenschilder so gut und besser ein Wandschmuck wie im Salon dem Bürger ein Ölgemälde; Mauern sind das Schreibpult, gegen das er seinen Notizblock stemmt; Zeitungskioske sind seine Bibliotheken und die Caféterrassen Erker, von denen er nach getaner Arbeit auf sein Hauswesen heruntersieht.«[4] Baudelaire sagt: »Der Beobachter ist ein Fürst, der überall im Besitz seines Inkognitos ist.«[5]

Der Flaneur unterliegt nicht dem Diktat des Zwecks, sondern hat die nötige Distanz des Bewußtseins und die Freiheit, ein anderes Beziehungsgeflecht über die Dinge zu legen. Der Ausdruck der Distanz und der Wechsel des Gebrauchsflusses finden sich im Werk Duchamps in seinen verschieden lautenden Signaturen, seinem Auftreten als Rrose Sélavy und dem spielerischen Verändern, dem »Zerstören« seiner Arbeiten. Das Arretieren des Gebrauchsflusses ist nur auf der Ebene von Distanz möglich. Seinen Arbeiten liegt die Kategorie der Distanz im Anwesenden zugrunde.

Distanz gehört unabdingbar zum Akt der Auswahl. Gleichzeitig bedarf der Akt der Auswahl einer Menge, aus der ausgewählt wird. Der Akt der Auswahl hat mehrfach oder vielfältig Gegebenes zur Voraussetzung, und er basiert, neben dem vielfältig Gegebenen, auf dessen Bestand in der Zeit. Dazu schreibt

Gabrielle Buffet 1936 in *Cœurs Volants* (Abb. S. 99): »Die eigentliche Substanz seines Werks besteht aus der bewußten Elimination alles dessen, was traditionellerweise den Seinsgrund der Künste ausmacht und ihre Erhabenheit begründet: des empfindenden Ich, des fühlenden Ich, des erinnernden Ich. Jede Phase der schöpferischen Gestaltung entspricht einem langen Prozeß der Überarbeitung und der Verknappung. Sein alles bestimmender Vorsatz, jedes Element seines Werks ständig zu kontrollieren, unerbittlich das auszuschalten, was sich an Traditionellem noch darin verbirgt, erklärt, warum es schmal und langsam war. Er läßt es nur bestehen oder nimmt es nur auf, wenn er es vollständig von jedem reflexhaften Ausdruck freigemacht hat.«[6]

Deutet man das Wiederaufgreifen eines früheren Motives als die Unterbrechung des Gebrauchsflusses eben dieses Werkes durch die neue Arbeit, dann ist der Begriff der Reproduktion im herkömmlichen Sinn nicht anzuwenden. Vielmehr wird das Werk unter dem Gebot beschränkter Haltbarkeit, wie Marcel Duchamp dies gegenüber Richard Hamilton erwähnt, in der Bearbeitung zu einem anderen Werk. Seine formalen und koloristischen Beziehungen werden modifiziert und führen zu einem gänzlich anderen, einem neuen Werk. Das Neue in der bearbeiteten Fassung eines wieder(ge)holten Werkes enthält keinen Fortschritt. Als Kunstwerk wird es – im Bearbeiten mit Distanz zum vorhergehenden aufgeladen – zu einem anderen Werk. Dabei entfernt es sich im Modus der Ähnlichkeit vom vorausgegangenen Werk.

Dies betrifft alle in unterschiedlichen Schritten wieder(ge)holt verwerteten Arbeiten und Gemälde wie *Akt die Treppe heruntersteigend*, 1911, *Akt die Treppe heruntersteigend II*, 1912, *Akt die Treppe heruntersteigend III*, 1916, das Duchamp »Duchamp / Fils / 1912–1916« signierte und humorvoll »Nude… Nr. 3 is the son of Nude… Nr. 2« bezeichnete.[7] *Akt die Treppe heruntersteigend Nr. IV*, 1918, ist eine Miniaturausgabe für das Puppenhaus von Mrs. Carrie Stettheimer. Das Plakat der Ausstellung zum 50. Geburtstag der berühmten internationalen Armory Show 1913 zeigt den Druck des irregulären Ausschnitts auf hellblauem Grund. Der Ausschnitt wirft einen dunkelblauen Schatten. Auf den Schatten in der Mitte fügte er seinem Namen das Datum 1913–1950 hinzu.

Diese Liste kann selbstverständlich auf die unterschiedlichen, gedruckten Versionen, die im Grunde jeweils neue Ausformulierungen einer ähnlichen Formen- und Farbenkonstellation thematisieren, ausgeweitet werden. Auf diese Weise setzt sich das Werk Duchamps selbst fort als Malerei, als Erinnerung der Malerei, als technische Wiedergabe des erinnerten Bildes, als Fotografie der Malerei, als manipulierte Fotografie der Druckversion und so weiter. Marcel Duchamp operiert in gewisser Weise mit den eigenen Arbeiten wie in *Boîte-en-Valise* (Abb. S. 114 u. 115) durchaus nicht, um sein Œuvre transportabel zu

14

halten oder sein eigenes Museum zu schaffen, sondern Duchamp setzt seine Arbeiten, setzt Kunstwerke immer neu in einen immer neuen Bestandsfluß, als Kunstwerke.

Unter solchem Blickwinkel kommt der Dimension der Zeit eine bedeutende Rolle zu. Die Zeit waltet sowohl im Zufall, in dem Bedingungen, Resultate, Strukturen zu-fallen, als auch im Spiel, das Duchamp in einem Vortrag von 1952 *The Main Aspects of Chess* der Kunst gleichsetzt, wenn er sagt: »Objektiv betrachtet, sieht ein Schachspiel einer Tuschezeichnung sehr ähnlich, jedoch mit dem Unterschied, daß der Schachspieler mit schwarzen und weißen Formen malt, die schon fertig sind, anstatt daß er, wie der Künstler, Formen erfindet. Das Muster, das sich so auf dem Schachbrett bildet, hat anscheinend keinen visuellen ästhetischen Wert und ähnelt eher einer musikalischen Partitur, die immer wieder gespielt werden kann. Die Schönheit beim Schach scheint keine visuelle Erfahrung zu sein wie bei der Malerei. Die Schönheit beim Schach steht der Schönheit in der Dichtung näher; die Schachfiguren sind das Alphabet, das Gedanken formt; und obwohl diese Gedanken ein visuelles Muster auf dem Schachbrett ergeben, drücken sie ihre Schönheit abstrakt aus, wie ein Gedicht.

Tatsächlich glaube ich, daß jeder Schachspieler eine Mischung aus zwei ästhetischen Vergnügen erlebt, zunächst das abstrakte Bild, das der poetischen Idee des Schreibens verwandt ist, danach das sinnliche Vergnügen der ideographischen Ausführung dieses Bildes auf den Schachbrettern. Aufgrund meines engen Kontaktes zu Künstlern und Schachspielern bin ich zu der persönlichen Überzeugung gelangt, daß zwar nicht alle Künstler Schachspieler, aber alle Schachspieler Künstler sind.«[8]

Was sind nun die Gemeinsamkeiten von Leben, Kunst und Spiel? Den Spielern sind zwei Konstanten gegeben: das Brett und die Figuren. Die begrenzten Variablen sind die Regeln, die den gemeinsamen Aktionsrahmen bilden – als gemeinsame Sprache gewissermaßen. Sobald die Figuren aufgestellt sind, ist ein Aktionsfeld eröffnet, das eine gegen Unendlich gehende Zahl von möglichen Kombinationen bereithält. Die Entscheidung, welcher Zug in Kombination zur Partneraktion ausgeführt wird, fällt kombinatorisch, sowohl abhängig von diesem als auch unabhängig, da auf der Ebene der Bindung an den Partner jeweils mehrere Entscheidungen möglich sind. In diesem Spielraum wirkt der Zufall. Betrachtet man nun diese Aktionen in Hinblick auf die Sichtweise Duchamps, dann bietet das Spiel die Möglichkeit, zeitlich determinierte Handlungen zum Zwecke des Spiels auszuführen. Das Spiel ist jedoch grundsätzlich zweck-los. Auf diese Weise bietet das Spiel den mühelosen Übergang zu zweckfreier Handlung auf der Basis eingegrenzter zeitlicher Dauer. Das Spiel ist zeitabhängig, zeitlich begrenzt und zweckfrei.

In den Arbeiten *Obligation de Monte-Carlo*, 1924 (Abb. S. 61), *Ready-made rectifié*, 1923, oder *Soins dentaires du Dr Tzanck*, 1919, das Duchamp für seinen Zahnarzt gemacht hat, hinterfragt Duchamp das Prinzip der Echtheit, indem er auch hier den vorausgesetzten Gebrauchsfluß kreuzt.

Zur Frage der Echtheit in Zusammenhang mit dem von ihm angefertigten Scheck, sagt Duchamp: »Voilà. Es ist ein Scheck, aber drei oder vier Mal so groß wie die, die man kennt. Bis auf das Papier habe ich ihn völlig eigenhändig hergestellt.

Der Scheck über vierhundertfünfzig Francs ist ausgestellt für einen Pariser Zahnarzt. Alles ist perfekt nachgeahmt. Nur die Maße sind ungewöhnlich.«

»Und Ihr Zahnarzt hat diese Zahlung akzeptiert?«

»Was denn, es ist kein falscher Scheck, da er vollständig von mir hergestellt worden ist! Und signiert! Echter geht es nicht! Und das jedenfalls konnte nicht als etwas Künstlerisches durchgehen ...«[9] In der hier beschriebenen Arbeit läßt Duchamp das Prinzip der Authentizität als Echtheit und als verabredeten Wert auseinanderfallen. Die scheinbar humorvolle Frage an das bestehende und verabredete Wertesystem entlarvt dieses in der künstlerischen Arbeit als einzig utilitaristisches, monetäres. Die »Signatur« setzt in beiden Systemen, dem der Kunst wie dem des Geldes, den Gebrauchsfluß sowohl in Gang als auch außer Kraft. In der weiteren Bearbeitung unterbricht Duchamp die Dauer des Gebrauchsflusses und überführt sie in einen neuen Gebrauchsfluß als Teile für die Schachteln.

Damit ist er nicht Künstler von Beruf, nicht Spieler, nicht Typograph, noch Kunsthändler. Er ist bereit, den dumpfen Zweck zu hinterfragen und in einen neuen Gebrauchsfluß zu überführen, immer bewußt. Gestalten – damit ist er Mensch, Atmer.

1 Marcel Duchamp, zit. nach: Ecke Bonk, Marcel Duchamp, Die Große Schachtel de ou par Marcel Duchamp ou Rrose Sélavy, München 1989, S. 9.

2 Marcel Duchamp, zit. nach: Marcel Duchamp, Interviews und Statements, Hrsg. Ulrike Gauss, Stuttgart 1992, S. 85.

3 Ebenda, S. 82.

4 Walter Benjamin, Das Paris des Second Empire bei Baudelaire – Der Flaneur, in: Schriften Bd. II, Hrsg. Rolf Tiedemann und Hermann Schweppenhäuser, Frankfurt a.M. 1980, S. 543.

5 Ebenda, S. 539 .

6 Gabrielle Buffet-Picabia, Cœurs Volants, in: Cahiers d'Art 1–2, Paris 1936, zit. nach: Ecke Bonk, Marcel Duchamp, Die Große Schachtel, a.a.O., S. 149–150.

7 Arturo Schwarz, The Complete Works of Marcel Duchamp, New York 1969, 2. Auflage 1970, S. 464.

8 Marcel Duchamp, zit. nach: Ecke Bonk, Marcel Duchamp, Die Große Schachtel, a.a.O., S. 172–173.

9 Ebenda, S. 168.

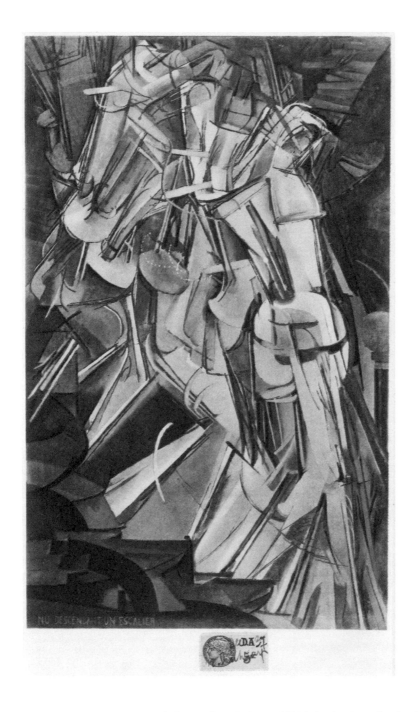

Nude Descending a Staircase, 1937 / *Akt, eine Treppe herabsteigend*

Kornelia von Berswordt-Wallrabe

Fishing in the Stream of Function...

The art of Marcel Duchamp departed the terrain of painting very early on. The first major exhibition of his works came at a time when Cubism was finding its pictorial themes and images at fairs and taverns, Futurism at race-tracks and in bustling city streets. But it was also the time in which painters largely dissolved the substantive-representational object character of their sujets. With this step-by-step process of dissolution, artists were paying tribute to a development that had taken place in society long before. The radical revolution in the manufacture of goods that led away from the manual crafting process and towards industrial-scale factory mass-production resulted in a shift in consumption patterns that replaced the individual award of commissions to craftsmen by a process of selection from a range of mass-produced industrial goods. Material-based fabrication no longer governed the process of procuring things for daily use; instead, the act of consumption involving a selection from the pool of existing object was performed at the time of purchase. From the standpoint of the consumer, the potentially endless stream of production that brought forth an increasingly similar array of products represented an entirely utilitarian "stream of function": a shovel is a shovel is a shovel. As these events gradually took control of everyday life, the role of the creative artist who worked for the most part with his own hands was also called into question, and artists began to contemplate this profound change. Marcel Duchamp was the first of them to heed the signs of the times. Duchamp had long since lost faith in the power of pictorial images based on composition alone, which he viewed as arbitrariness, and he refused to accept the traditional characterisation of the artist. He rejected the idea of the artist as a genius driven by emotions. His insight into the loss of these values prompted his self-ironising but nevertheless clearly plotted course towards the abandonment of arbitrariness and the artist's posturing of genius.

Duchamp pulls an industrially produced bottle-rack from its accustomed stream of function and places it in a totally unfamiliar, artificial context as a work of art. Duchamp's work originates in the interruption of the continuous stream of function of things. His playful and at the same time strictly analytical approach to the world, his manner of taking it into himself and drawing artistic conclusions on the basis of both mathematical and logical laws, produced works that prepared the way for the shock that was to radically change the art

of the 20th century. In these works art regained a credo of the kind Duchamp found present in the Renaissance or the Romantic period. The conviction that one could change painting through the application of technology was an idea that led to paintings such as *Coffee-Mill* (1911, ill. p. 131) and *Chocolate Grinder* (1913). His method of arresting the stream of function to create innovative, shocking works produced the first Ready-made, *Bicycle Wheel* (ill. p. 118), in the same year. This work had its roots in the artist's ability to distance himself from the intended utilitarian purpose of the object and thereby to interrupt the existing stream of function, diverting the object or parts of it into an entirely different stream of function.

In contrast to artists still working in traditional ways around 1910, Duchamp says of himself during this period: "I wanted to move to a completely dry drawing, a dry approach to art. And I saw technical drawing as the best possible form of this dry art."[1]

It is in this context that the concept of "toutes faites", Ready-mades, introduced in 1915, can be understood. In Duchamp's sculptures, the term does not necessarily refer to the entire structure but relates instead to the quality of the elements used in the sculptures as things appropriated from other levels of function. In any event the idea provides a foundation not only for Marcel Duchamp's works but for his working method as well.

The concept of Ready-mades is closely related to the attitude that is implicit in both his works and his life. In a fundamental departure from the traditional conception of the creative process in art, according to which the mental and manual act of creation generates a unique work of art, Duchamp devotes himself in the application of rarely-used printing techniques and time-consuming procedures to the controversial process of linking the conceptual and the visible worlds through the interruption of the stream of function.

Asked about the consequences of his decision to abandon painting, Duchamp commented in 1959: "'I didn't need to sell in order to live. I have always been able to get along with very little money. I spend my time comfortably, but I really don't know how I could tell you what I actually do. Let's just say I spend my time with non-painting. I have a wife, and she has children of her own. I have a studio, because I refuse to spend twenty-four hours a day with my wife. I don't have any problem filling out my time.

I think one could say I spend my time breathing', Duchamp concludes, with a cheerfulness that confirms his love of the act of living. 'I am a respirateur – a breather. I enjoy that tremendously.'"[2] Duchamp fills the most everyday of all activities with consciousness, interrupting the stream of automatism and making every breath an adventure.

But he is also aware that newness of function is subject to deterioration.

Speaking to Richard Hamilton, he states: "[...] the real feeling I have is that a work of art is only a work of art for a very short time. A work of art has a life that is very short, even shorter than that of a human being. I'd put it at twenty years. After twenty years an impressionistic painting ceases to be an impressionistic painting, because the material, the color, the pigment has become so dark that it is no longer what the painter made when he painted it. Good, that is one way to look at it. So if one applies this rule to all art ... works of art, then they're finished after twenty years; their life is over."[3]

Viewed from this perspective, the human mind is being creative when it converts thoughtless, blunt function into a new and entirely different function by interrupting the stream of function. In this sense, every stream of function is determined by time. Its relevance originates in each new interruption of the existing stream. The creative mind is present only in determined function.

An approach to life such as that sketched here by Duchamp comprehends human vitality as consciousness in time. This type of consciousness calls to mind the figure of the flaneur (the city-stroller) in Baudelaire, about whom Walter Benjamin has written: "The streets become the stroller's domicile. He is as at home among the facades of the houses as is the citizen surrounded by his four walls. To him, the brightly polished enamelled company signs are as good, are better wall adornments than the oil paintings hanging in the citizen's salon; stone walls are the writing desk against which he presses his notebook; newspaper stands are his library, and café terraces the oriels from which he gazes down upon his domestic domain after a day's work."[4] And Baudelaire: "The observer is a prince, who travels incognito wherever he goes."[5]

The stroller is not subject to the dictates of function. Instead he possesses the necessary distance of consciousness and the liberty to cast a different web of relationships over the things that he sees.

Expressions of distance and diversions of the stream of function are evident in Duchamp's different signatures, his posing as Rrose Sélavy and his playful alteration, the "destruction" of his works. The stream of function can only be arrested at the level of distance. The quality of distance in that which is present is a fundamental feature of his works.

Distance is inexorably a part of the act of selection. At the same time, the act of selection requires a set of things from which to select. The act of selection presupposes the existence of multiples and varieties and depends upon what is available in diversity and upon its existence in time. Gabrielle Buffet's comment in *Cœurs Volants* in 1936 (ill. p. 99) is relevant: "The actual substance of his work consists in the conscious elimination of everything that traditionally defines art's reason for being and justifies its superiority: the sensing ego, the feeling ego, the remembering ego. Every phase of creative formation involves a

long process of revision and reduction. His overriding intention to control each element of his work at all times, to eliminate unmercifully whatever elements of the traditional still remain, explains why it was so narrow and slow. He allows it to exist, or accepts it, only when it has been freed of every possible expression of the reflexive."[6]

If one can interpret the taking up of an earlier motif as an interruption of the stream of function of that very same work by the new work, then the concept of reproduction cannot be applied in the traditional sense. Instead, according to the dictates of a limited life-span described by Marcel Duchamp in his conversation with Richard Hamilton, it becomes a new work. Its formal and colour relationships are modified to produce a totally different, genuinely new work. The newness in the revised version of a re-produced work implies no progress. As a work of art it becomes – imbued with distance to its predecessor through the process – a different work, one that distances itself in the mode of similarity from the previous work. This applies to all works and paintings reproductively recycled in different steps, such as *Nude Descending a Staircase* (1911), *Nude Descending a Staircase II* (1912) and *Nude Descending a Staircase III* (1916), signed by Duchamp with "Duchamp / Fils / 1912–1916", which he humorously dedicated "Nude … No. 3 is the son of Nude … No. 2".[7] *Nude Descending a Staircase No. IV* (1918) is a miniature version made for a doll house owned by Mrs. Carrie Stettheimer. The poster for the exhibition on the occasion of the 50th anniversary of the famous international Armory Show of 1913, showing the print of the irregular detail on a light-blue background. The detail casts a dark-blue shadow. In the middle of this shadow he added his name and the dates 1913–1950. This list could of course be expanded to include the many different printed versions, each of which basically represents a new articulation of a similar constellation of shapes and colours. In this way, Duchamp's work continuously recreates itself as painting, as memory of painting, as technical rendition of the remembered image, as a photography of painting, as manipulated photography of the printed version, and so on. In his own works, Marcel Duchamp operates in a certain sense much as he does in the case of *Boîte-en-Valise (Box in a Suitcase, ill. p. 114, 115)*, not in order to make his work transportable or to create his own museum, but in order to place his works, his works of art, into a new stream of function, again and again, as works of art.

Viewed from this standpoint, the dimension of time takes on a particularly important role. Time operates in randomness, in which conditions, results and structures co-incide, as well as in play, which Duchamp, in a 1952 lecture entitled *The Main Aspects of Chess*, equates with art when he states: "Viewed objectively, a game of chess looks very much like a drawing in ink. The difference is that the chess player paints with black and white forms that are

already finished, whereas the artist invents forms. The aesthetic pattern that develops on the chessboard seemingly has no visual aesthetic value and is similar to a sheet of music, which can be played over and over. Beauty in chess is apparently not a visual experience, as it is in painting. Beauty in chess is much closer to the beauty of poetry; the chess pieces are the alphabet that shape the thoughts; and although these thoughts form a visual pattern on the chessboard, they express beauty in the abstract, like a poem. I really believe that every chess player experiences a mixture of two aesthetic pleasures; first the abstract image, which is closely related to the poetic idea in writing, and then the sensual pleasure involved in the ideographic representation of that image on the chessboards. Based on my own close contact with artists and chess players, I have come to the personal conclusion that although not all artists are chess players, all chess players are indeed artists."[8]

What do life, art and play have in common? Players operate with two constants: the board and the pieces. The limited number of variables represent the rules that form the shared context of action, a common language in a sense. Once the pieces have been arranged in place, a field of action is revealed in which a nearly infinite number of possible combinations presents itself. The decision about which move to make in response to the opponent's action is based upon combination and is both dependent upon and independent of that action, as at the level of interaction with the opponent-partner a number of decisions are possible. It is within this sphere of freedom of decision that coincidence operates. If one approaches these actions with reference to Duchamp's view, the game offers an opportunity to perform time-dependent actions for the purpose of play. The game, itself, however, is fundamentally devoid of purpose. Thus play offers an effortless transition to non-purposeful action on the basis of a limited time-frame. Play is time-dependent, limited by time and devoid of purpose.

In the works entitled *Obligation de Monte-Carlo* (1924, ill. p. 61), *Ready-made rectifié* (1923) or *Soins dentaires du Dr Tzanck* (1919), made by Duchamp for his dentist, the artist questions the principle of authenticity by nullifying the pre-existing stream of function here as well.

On the question of the genuineness of the cheque he prepared himself, Duchamp states: "Voilà. It's a cheque, but it's three or four times as big as the ones we are familiar with. Except for the paper, I made the whole thing myself. The cheque for 450 francs is issued to a Paris dentist. Everything is imitated perfectly. Only the size is unusual."

"And your dentist accepted the payment?"

"Why not? It's not a fake cheque, since I produced it entirely myself! And signed it! It couldn't be more genuine! And in any case it couldn't have quali-

22

fied as something artistic..."[9] In this work, Duchamp allows the principle of authenticity as genuineness and as mutually accepted value to fall apart. The seemingly humorous questioning of the existing system of shared values in the artist's work reveals it to be something entirely utilitarian, monetary. In both systems, that of art and that of money, the "signature" initiates the stream of function and negates it at the same time. In his further processing he interrupts the chronological continuum of function and diverts it into a new stream of function as parts for his boxes.

Thus he is by profession neither an artist, nor a gambler/chess player nor a typographer nor an art dealer. He is willing to question blunt purpose and to divert it into a new stream of function, always shaping in full consciousness. And so he is a human being, a breather.

1 Marcel Duchamp, in: Ecke Bonk, Marcel Duchamp, Die Große Schachtel de ou par Marcel Duchamp ou Rrose Sélavy, Munich, 1989, p. 9.

2 Marcel Duchamp, in: Marcel Duchamp, Interviews and Statements, edited by Ulrike Gauss, Stuttgart, 1992, p. 85.

3 Marcel Duchamp, in: Marcel Duchamp, Interviews and Statements, p. 82.

4 Walter Benjamin, "Das Paris des Second Empire bei Baudelaire – Der Flaneur", in: Schriften, Vol. II, edited by Rolf Tiedemann and Hermann Schweppenhäuser, Frankfurt a.M., 1980, p. 543.

5 Baudelaire, in: Walter Benjamin, op. cit., p. 539.

6 Gabrielle-Buffet-Picabia, "Cœurs Volants", in: Cahiers d'Art, 1–2, Paris, 1936, cited from Ecke Bonk, Marcel Duchamp, Die große Schachtel, op. cit., pp. 149–150.

7 Arturo Schwarz, The Complete Works of Marcel Duchamp, New York, 1969, 2nd edition, 1970, p. 464.

8 Ecke Bonk, op. cit., pp. 172–173.

9 Ecke Bonk, op. cit., p. 168.

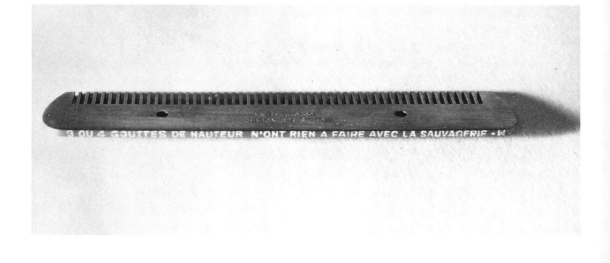

Comb, 1916/1964 / *Kamm*

24

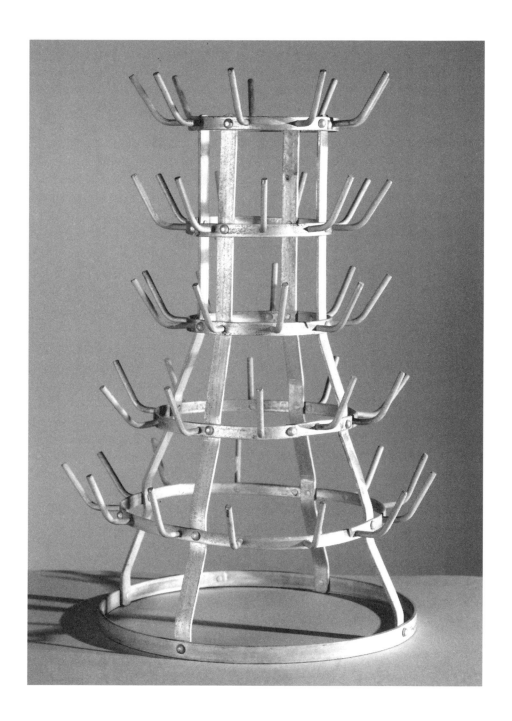

Porte bouteille, 1914/1964 / *Flaschentrockner*

25

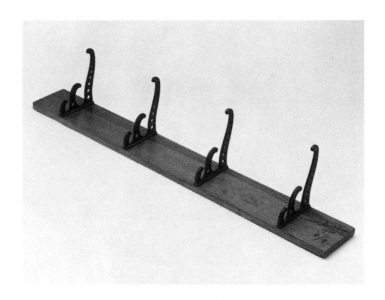

Trébuchet, 1917/1964 / *Stolperfalle*

26

Traveller's Folding Item, 1916/1964 / *Faltbarer Reiseartikel*

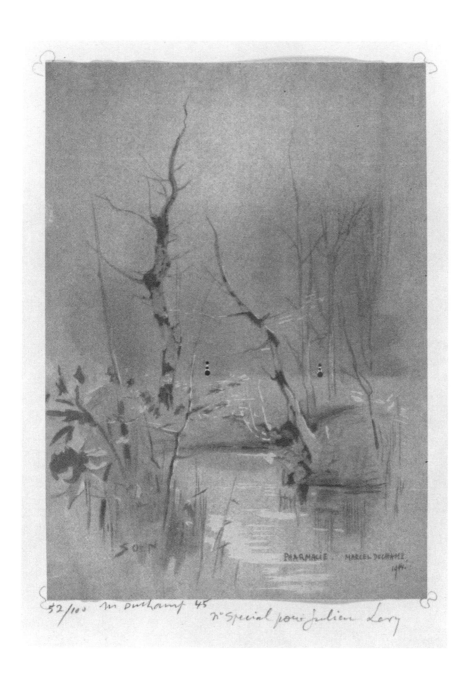

Pharmacie, 1914/1945 / *Apotheke*

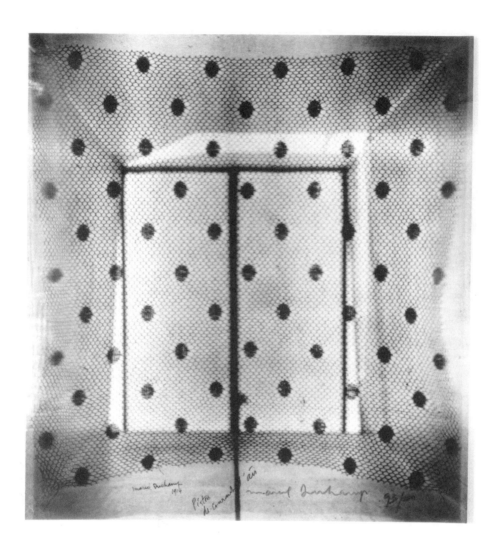

Draft Piston, 1914/1965 / *Durchzugskolben*

»VON MÜNCHEN AN hatte ich die Idee für das Große Glas. Ich war fertig mit dem Kubismus und mit Bewegung – wenigstens mit jener Bewegung, die mit Ölfarbe verbunden war. [...] Nach zehn Jahren der Malerei langweilte sie mich. Eigentlich hatte sie mich schon immer gelangweilt, außer am Anfang, als sie noch das Gefühl gab, mir die Augen für etwas Neues zu öffnen. [...] Ich wollte bloß gegen das reagieren, was die anderen taten – Matisse und die übrigen. All dieses Werk der Hand! Auf französisch gibt es einen alten Ausdruck, la patte, was den Pinselstrich eines Künstlers, seinen persönlichen Stil, seine ›Tatze‹ bezeichnet. Ich wollte loskommen von la patte und von dieser ganzen retinalen Malerei. Die Malerei, die mich umgab, war völlig retinal. Vergiß die Anekdote, vergiß die Erregung für ein Thema – das war die Idee. Konzentriere dich nur auf das, was ins Auge dringt. Der einzige Mann der Vergangenheit, den ich wirklich respektierte, war Seurat, der seine großen Gemälde wie ein Zimmermann, wie ein Handwerker ausführte. Er ließ seinen Geist nicht durch die Hand stören. Aber wie dem auch sei, ab 1912 beschloß ich aufzuhören, ein Maler im professionellen Sinn zu sein.«[1]

"FROM MUNICH on, I had the idea of 'The Large Glass', [...] I was finished with Cubism and with motion – at least motion mixed up with oil paint. [...] After ten years of painting, I was bored with it, except at the very beginning, when there was that feeling of opening the eyes to something new. [...] I just wanted to react against what the others were doing – Matisse and the rest. All that work of the hand. In French, there is an old expression, 'la patte', meaning the artist's touch, his personal style, his 'paw'. I wanted to get away from 'la patte', and from all that retinal painting. The painting around me was completely retinal. Forget about anecdote, forget about emotion in the subject – that was the idea. Just concentrate on what comes in at eye. The only man in the past whom I really respected was Seurat, who made his big paintings like a carpenter, like an artisan. He didn't let his hand interfere with his mind. Anyway, in 1912 I decided to stop being a painter in the professional sense."[1]

34

»ES WURDE 1912, '13, '14 ANGEFANGEN, und ich arbeitete daran vor dem Krieg, und obwohl ich in diesem großen Glas versuchte, einen ganz persönlichen und neuen Ausdruck zu finden, sollte das Endprodukt eine Vermählung von geistigen und visuellen Reaktionen sein. Mit anderen Worten, die Ideen im Glas sind wichtiger als die eigentliche visuelle Ausführung.«[2]

"IT WAS STARTED in 1912,13,14 … and I worked on it before the war … and, even though I tried in that big glass to find a completely personal and new expression, the final product was to be a wedding of mental and visual reactions. In other words, the ideas in the Glass are more important than the actual visual experience!"[2]

«ES WURDE 1912, '13, '14 ANGEFANGEN, und ich arbeitete daran vor dem Krieg, und obwohl ich in diesem großen Glas versuchte, einen ganz persön-lichen und neuen Ausdruck zu finden, sollte das Endprodukt eine Vermählung von geistigen und visuellen Reaktionen sein. Mit anderen Worten, die Ideen im Glas sind wichtiger als die eigentliche visuelle Ausführung.«²

"IT WAS STARTED in 1912,13,14 ... and I worked on it before the war ... and, even though I tried in that big glass to find a completely personal and new expression, the final product was to be a wedding of mental and visual reactions. In other words, the ideas in the Glass are more important than the actual visual experience!"²

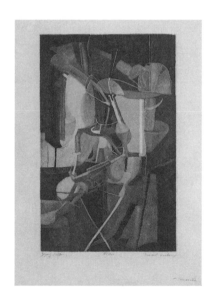

The Bride, 1934 / *Die Braut*

37

«JA, DIESE VERSCHWEISSUNG von zwei verschiedenen Quellen der Inspiration gab mir eine befriedigende Antwort bei meiner Suche nach etwas, das vorher nicht versucht worden war. Als junger Mann, der etwas aus sich heraus machen und nicht die anderen kopieren will, die Tradition nicht zu sehr benützen will, ging meine Suche in die Richtung, einen Weg zu finden, um mich selbst auszudrücken ohne ein Maler zu sein, ohne ein Schriftsteller zu sein, ohne eines dieser Labels anzunehmen, und dennoch etwas zu produzieren, das ein inneres Produkt meiner selbst wäre. Die beiden Dinge vermischend – die Ideen und ihre visuelle Präsentation –, zog mich das an als eine Technik, wenn es schon eine Technik sein mußte. Und diese hybride Form erklärt, weshalb ich niemanden mehr hatte, der mir bestimmte, und ich mehr denn je meine eigenen Wege verfolgte, um das zu betrachten.»[3]

"YES, THIS WELDING of two different sources of inspiration gave me a satisfactory answer to my research for something that had not been previously attempted. Being the young man who wants to do something by himself and not copy the others ... not use too much of the tradition ... my research was in that direction to find some way of expressing myself without being a painter, without being a writer, without taking one of these labels, and yet producing something that would be a ... an inner product of myself. The two things mixing up – the ideas and their visual presentation – attracted me as a technique, if it has to be a technique, after all. And ... this hybrid form explains why I didn't have anyone to agree with me, more as so to follow my own ways of looking at it ..."[3]

»JA, DIESE VERSCHWEISSUNG von zwei verschiedenen Quellen der Inspiration gab mir eine befriedigende Antwort bei meiner Suche nach etwas, das vorher nicht versucht worden war. Als junger Mann, der etwas aus sich heraus machen und nicht die anderen kopieren will, die Tradition nicht zu sehr benützen will, ging meine Suche in die Richtung, einen Weg zu finden, um mich selbst auszudrücken ohne ein Maler zu sein, ohne ein Schriftsteller zu sein, ohne eines dieser Labels anzunehmen, und dennoch etwas zu produzieren, das ein inneres Produkt meiner selbst wäre. Die beiden Dinge vermischend – die Ideen und ihre visuelle Präsentation –, zog mich das an als eine Technik, wenn es schon eine Technik sein mußte. Und diese hybride Form erklärt, weshalb ich niemanden mehr hatte, der mir beistimmte, und ich mehr denn je meine eigenen Wege verfolgte, um das zu betrachten.«[3]

"YES, THIS WELDING of two different sources of inspiration gave me a satisfactory answer to my research for something that had not been previously attempted. Being the young man who wants to do something by himself and not copy the others ... not use too much of the tradition ... my research was in that direction to find some way of expressing myself without being a painter, without being a writer, without taking one of these labels, and yet producing something that would be a ... an inner product of myself. The two things mixing up – the ideas and their visual presentation – attracted me as a technique, if it has to be a technique, after all. And ... this hybrid form explains why I didn't have anyone to agree with me, more as so to follow my own ways of looking at it..."[3]

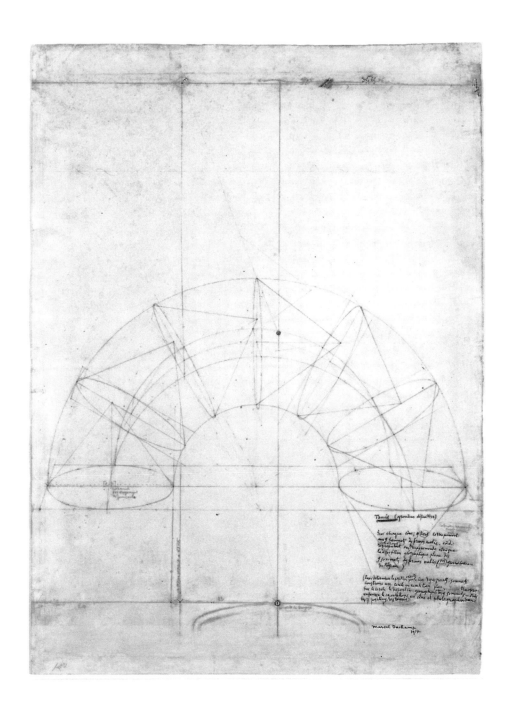

Tamis (grandeur définitive), 1914 / *Haarsiebe (definitive Größe)*

»DIE BRAUT IST eine Art mechanische Braut, wenn Sie so sagen wollen. Sie ist nicht die Braut selbst, es ist ein Konzept einer Braut, das ich auf die eine oder andere Weise auf die Leinwand bringen mußte, aber es war dann eigentlich wichtiger, daß ich es in Wörtern, in verbalen Ausdrücken ausgedacht hatte, bevor ich es tatsächlich zeichnete. Was das Glas wirklich darstellt, ist nicht die Kopie einer Braut in ihren besten Kleidern oder sonst wie, doch es gibt Teile, die die Braut genannt werden, und es gibt andere Teile des Glases, die die Junggesellen genannt werden. Mit anderen Worten, die Junggesellen kann man sehen in einer Art von ... nicht abstrakter Form, zumindest aber nicht in detaillierter Form, also nicht in natürlicher Form. Dasselbe mit der Braut, sie ist eine Art Erfindung einer mir eigenen Braut, ein neues Menschenwesen – halb Roboter und halb vierdimensional. Die Idee der vierten Dimension war ebenfalls sehr wichtig in diesem Zeitabschnitt. Alles, was eine dreidimensionale Form hat, ist die Projektion aus einer vierdimensionalen Welt in unsere Welt [...].«⁴

"THE 'BRIDE' IS a sort of mechanical bride, if you want to say. It's not the 'Bride' itself, it's a ... concept of a bride that I had to put on the ... on the canvas, one way or another. But it was more important than that I should have thought of it in words, in terms of words, before I actually drew it. And what the Glass does represent, is not a copy of a bride in bedclothes? or otherwise, yet there are parts that are called 'The Bride', and there are other parts of the Glass, which are called 'Bachelors'. In other words, you can see the 'Bachelors', in a sort of ... not abstract form, but at least not detailed form, so not natural form. The same with the 'Bride', is a sort of invention of a bride of my own ... a new human being – half robot and half fourth-dimensional. The idea of the fourth dimension also was very important in that period. Anything that has a three-dimensional form is the projection in our world from a fourth-dimensional world, and my bride, for example, would be a three-dimensional projection of a fourth-dimensional bride.⁴

»DIE BRAUT IST eine Art mechanische Braut, wenn Sie so sagen wollen. Sie ist nicht die Braut selbst, es ist ein Konzept einer Braut, das ich auf die eine oder andere Weise auf die Leinwand bringen mußte, aber es war dann eigentlich wichtiger, daß ich es in Wörtern, in verbalen Ausdrücken ausgedacht hatte, bevor ich es tatsächlich zeichnete. Was das Glas wirklich darstellt, ist nicht die Kopie einer Braut in ihren besten Kleidern oder sonst wie, doch es gibt Teile, die die Braut genannt werden, und es gibt andere Teile des Glases, die die Junggesellen genannt werden. Mit anderen Worten, die Junggesellen kann man sehen in einer Art von ... nicht abstrakter Form, zumindest aber nicht in detaillierter Form, also nicht in natürlicher Form. Dasselbe mit der Braut, sie ist eine Art Erfindung einer mir eigenen Braut, ein neues Menschenwesen – halb Roboter und halb vierdimensional. Die Idee der vierten Dimension war ebenfalls sehr wichtig in diesem Zeitabschnitt. Alles, was eine dreidimensionale Form hat, ist die Projektion aus einer vierdimensionalen Welt in unsere Welt [...].«[4]

"THE 'BRIDE' IS a sort of mechanical bride, if you want to say. It's not the 'Bride' itself, it's a ... concept of a bride that I had to put on the ... on the canvas, one way or another. But it was more important than that I should have thought of it in words, in terms of words, before I actually drew it. And what the Glass does represent, is not a copy of a bride in bedclothes? or otherwise, yet there are parts that are called 'The Bride', and there are other parts of the Glass, which are called 'Bachelors'. In other words, you can see the 'Bachelors' in a sort of ... not abstract form, but at least not detailed form, so not natural form. The same with the 'Bride' is a sort of invention of a bride of my own ... a new human being – half robot and half fourth-dimensional. The idea of the fourth dimension also was very important in that period. Anything that has a three-dimensional form is the projection in our world from a fourth-dimensional world, and my bride, for example, would be a three-dimensional projection of a fourth-dimensional bride.[4]

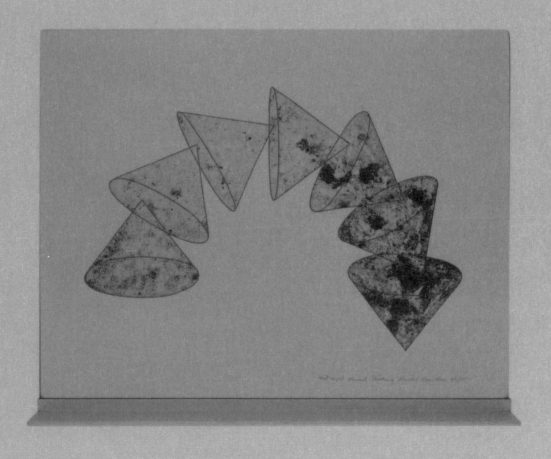

The Sieves, 1968 / *Die Siebe*

45

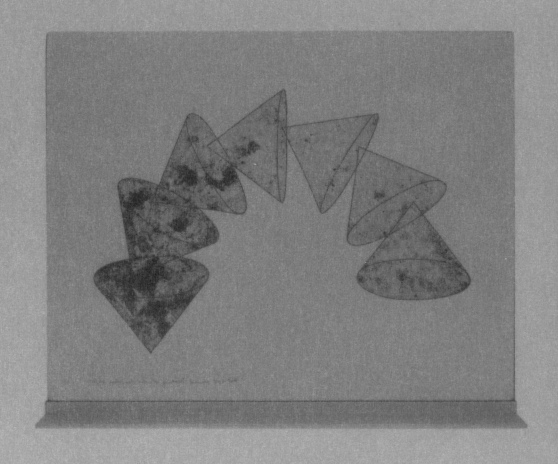

The Sieves, 1968 / Die Siebe

45

»ICH HATTE EINEN TRICK herausgefunden: Statt eine Linie zu ziehen, nahm ich einen Bleidraht und zog daran. Das ergab eine Linie. Für die Kreise hatte ich ebenfalls einen Trick. Immer nur, um die Idee der Hand in Verruf zu bringen, um die Idee des Originals auszumerzen, die weder in der Musik noch in der Poesie existiert . «[5]

"I FOUND A TRICK; instead of drawing a line, I took a plumb line and plucked it. It made a line. I also had a trick for the circles. Always in order to discredit the idea of the hand-made. To wipe out the idea of the original, which exists neither in music, nor in poetry…"[5]

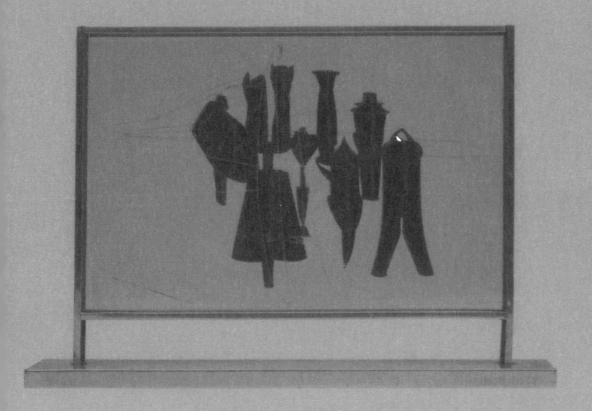

9 Moules Mâlic, 1938 / 9 männische Gußformen

«ICH HATTE EINEN TRICK herausgefunden: Statt eine Linie zu ziehen, nahm ich einen Bleidraht und zog daran. Das ergab eine Linie. Für die Kreise hatte ich ebenfalls einen Trick. Immer nur, um die Idee der Hand in Verruf zu bringen, um die Idee des Originals auszumerzen, die weder in der Musik noch in der Poesie existiert.»[5]

"I FOUND A TRICK; instead of drawing a line, I took a plumb line and plucked it. It made a line. I also had a trick for the circles. Always in order to discredit the idea of the hand-made. To wipe out the idea of the original, which exists neither in music, nor in poetry…"[5]

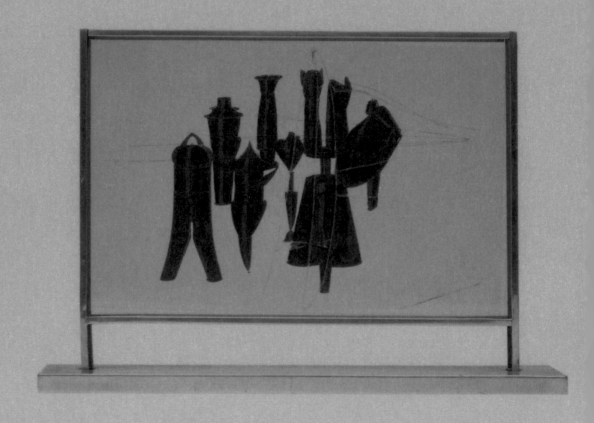

9 Moules Mâlic, 1938 / 9 männische Gußformen

47

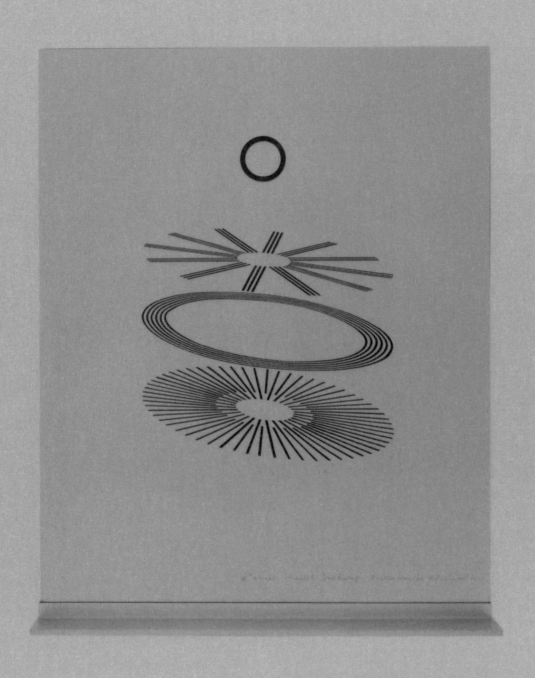

Témoins oculistes, 1920/1950 / *Augenzeugen*

49

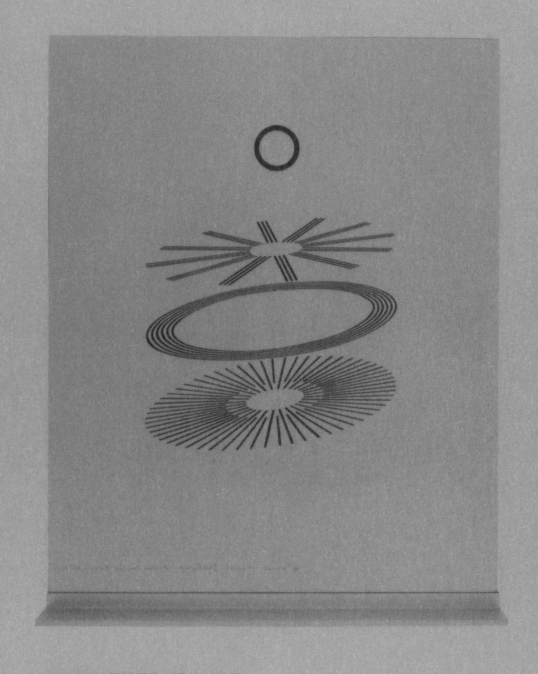

Témoins oculistes, 1920/1950 / Augenzeugen

49

»ICH KAUFTE ZWEI GROSSE Spiegelglasscheiben und fing oben an, mit der Braut. Daran arbeitete ich mindestens ein Jahr. Dann, 1916 oder 1917, arbeitete ich am unteren Teil, den Junggesellen. Es dauerte so lange, weil ich nie länger als zwei Stunden täglich arbeiten konnte. Sehen Sie, es interessierte mich zwar, aber nicht genügend, um gierig darauf zu sein, es zu beenden. Ich bin faul, vergessen Sie nicht! Überdies hatte ich damals nicht die geringste Absicht, es auszustellen oder zu verkaufen. Ich machte es einfach, das war mein Leben. Und wenn ich daran arbeiten wollte, dann tat ich es, und zu anderen Zeiten pflegte ich auszugehen und Amerika zu genießen. Es war mein erster Besuch, erinnern Sie sich! Und ich mußte genauso sehr Amerika sehen, wie an meinem Glas arbeiten.«[6]

"I BOUGHT TWO BIG plateglass panes and started at the top, with the Bride," [...] "I worked at least a year on that. Then, in 1916 or 1917, I worked on the bottom part, the Bachelors. It took so long because I could never work more than two hours a day. You see, it interested me, but not enough to make me eager to finish it. I'm lazy – don't forget that. Besides, I had no intention of showing it or selling it at the time. I was just doing it – that was my life. When I wanted to work on it, I did, and other times I would go out and enjoy America. It was my first visit, remember, and I had to see America as much as I had to work on my 'Glass'."[6]

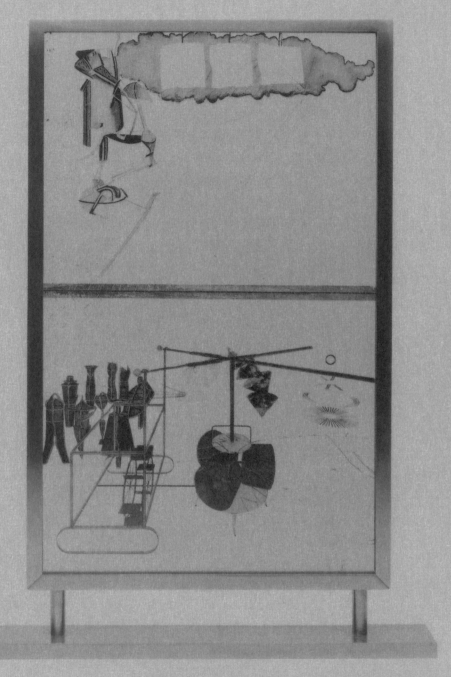

La Mariée mise à nu par ses Célibataires, même (Le Grand Verre), 1938/39
Die Braut von ihren Junggesellen nackt entblößt, sogar (Das Große Glas)

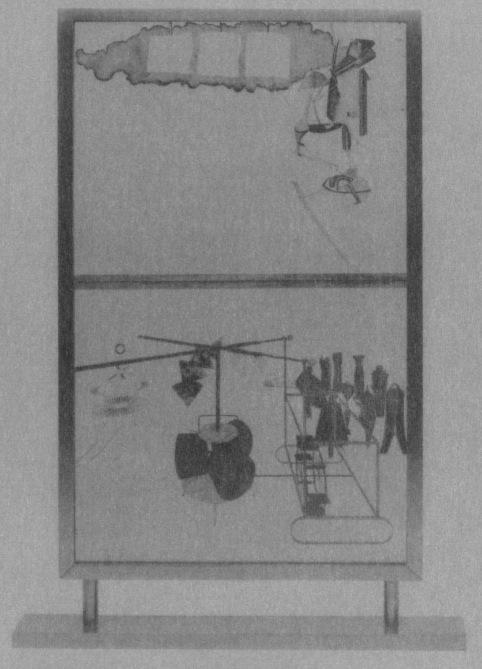

La Mariée mise à nu par ses Célibataires, même (Le Grand Verre), 1938/39
Die Braut von ihren Junggesellen nackt entblößt, sogar (Das Große Glas)

»SÉLAVY – das ist ein Wortspiel mit c'est la vie – so ist das Leben. [...] Rrose ist für mich – oder war es in Frankreich – der gewöhnlichste, nicht der vulgärste, sondern der populärste Name der damaligen Zeit, ein Name, den man kaum einem Mädchen anhängen würde. Das doppelte R amüsierte mich: Einige wenige Wörter fangen mit zwei L an, und ich dachte, es wäre amüsant, ein Wort mit zwei R zu beginnen.«[7]

"SÉLAVY – that's a pun on 'such is life', c'est la vie. [...] Rose is for me – or was, in France – the most common (not vulgar), but the most popular name of the time, one you wouldn't think of giving to a girl. The double R, it amused me. Very few words are started with two Ls, and I thought it would be amusing to start a word with two Rs."[7]

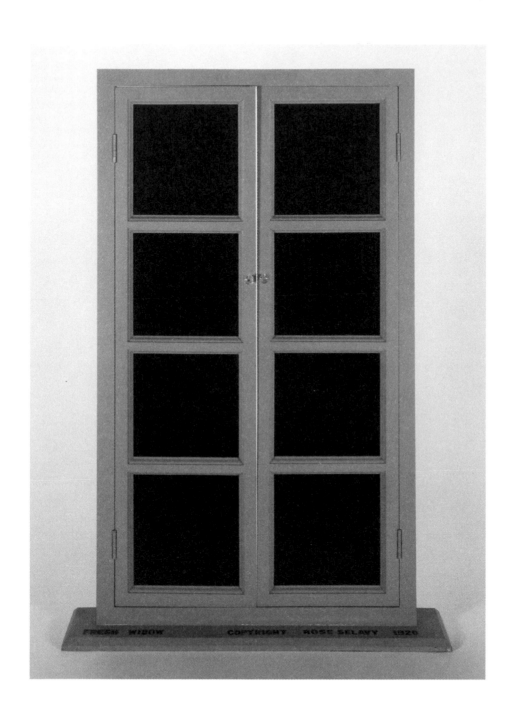

Fresh Widow, 1920/1964 / *Frische Witwe*

New York Dada, 1921

60

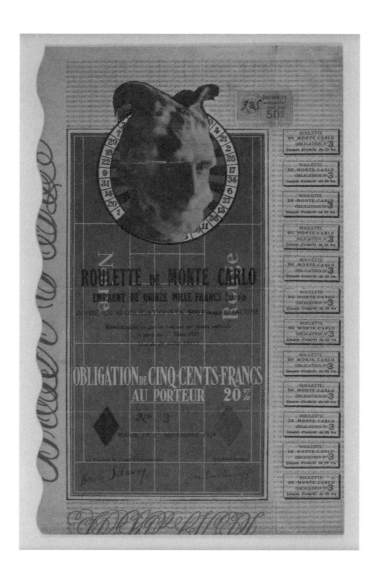

Obligation pour la Roulette de Monte-Carlo, 1924 / *Obligation für das Roulette von Monte Carlo*

»ICH HABE NIE die Malerei zugunsten des Schachs aufgegeben, [...] das ist eine Legende. Aber so ist das immer! Nur weil ein Mensch mit Malen anfängt, heißt das noch lange nicht, daß er fortfahren muß zu malen. Er ist nicht einmal gezwungen, es aufzugeben. Er tut es einfach nicht mehr, so wie einer keine Omelette macht, wenn er Fleisch lieber hat. Ich sehe das Bedürfnis nicht ein, die Leute zu klassifizieren und vor allen Dingen, die Malerei wie eine Profession zu behandeln. Ich sehe nicht ein, weshalb die Leute aus den Malern Staatsdiener zu machen versuchen, Beamte im Ministerium der Schönen Künste. Da sind die, die Medaillen empfangen, dort sind die, die Bilder malen.«[8]

"I NEVER ABANDONED painting for chess, [...]. That is a legend. It is always that way. Just because a man starts to paint doesn't mean he has to go on painting. He isn't even obliged to abandon it. He just doesn't do it any more, just as one doesn't make omelets if he prefers meat. I do not see the need to classify people, and, above all, to treat painting as a profession. I don't see why people try to make civil servants out of painters, officials of the Ministry of Fine Arts. There are those who obtain medals and those who make paintings."[8]

»ICH HABE NIE die Malerei zugunsten des Schachs aufgegeben, […] das ist eine Legende. Aber so ist das immer! Nur weil ein Mensch mit Malen anfängt, heißt das noch lange nicht, daß er fortfahren muß zu malen. Er ist nicht einmal gezwungen, es aufzugeben. Er tut es einfach nicht mehr, so wie einer keine Omelette macht, wenn er Fleisch lieber hat. Ich sehe das Bedürfnis nicht ein, die Leute zu klassifizieren und vor allen Dingen, die Malerei wie eine Profession zu behandeln. Ich sehe nicht ein, weshalb die Leute aus den Malern Staatsdiener zu machen versuchen, Beamte im Ministerium der Schönen Künste. Da sind die, die Medaillen empfangen, dort sind die, die Bilder malen.«[8]

"I NEVER ABANDONED painting for chess, […] That is a legend. It is always that way. Just because a man starts to paint doesn't mean he has to go on painting. He isn't even obliged to abandon it. He just doesn't do it any more, just as one doesn't make omelets if he prefers meat. I do not see the need to classify people, and, above all, to treat painting as a profession. I don't see why people try to make civil servants out of painters, officials of the Ministry of Fine Arts. There are those who obtain medals and those who make paintings."[8]

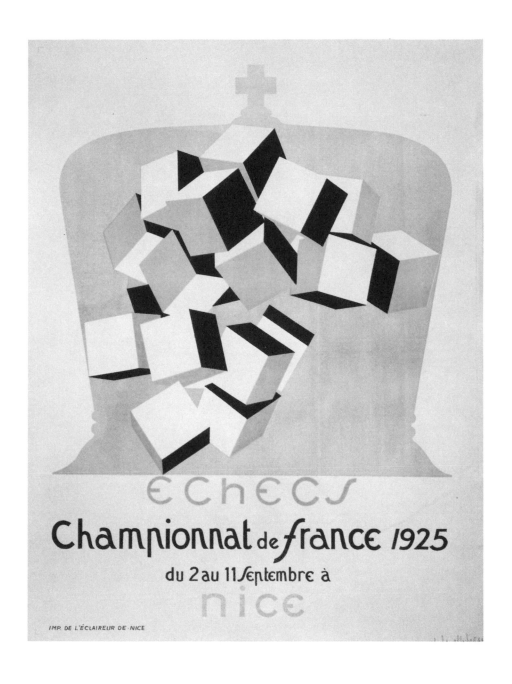

Poster for the Third Chess Championship, 1925 / *Plakat für die dritte Schachmeisterschaft*

Paper wrapper and Layout of L'Opposition et les cases conjuguées sont réconciliées par M. Duchamp et V. Halberstadt, 1932
Umschlag und Layout von L'Opposition et les cases conjuguées sont réconciliées von M. Duchamp und V. Halberstadt

»ICH SCHRIEB EINST ein Buch über Schach, das dreisprachig – französisch, deutsch und englisch – publiziert wurde. Es wurden tausend Exemplare davon gedruckt. Es heißt ›Opposition et cases conjuguées, Opposition und Schwesterfelder, Opposition and Sister Squares‹ und handelt von blockierten Figuren, wenn man nur noch mit dem König gewinnen kann. Auf tausend Male tritt das höchstens einmal auf. Heute denke ich nicht viel über den Zustand der Malerei nach. Mit der Mehrheit der jungen Maler stehe ich nicht mehr im Einklang. Als ich malte, sprach niemand davon, ausgenommen die Maler, Sammler und Händler. Jetzt haben wir Kritiker, die die Sprache vulgär machen, indem sie von Dynamismus reden! Wenn die Malerei so tief sinkt, daß Laien über sie sprechen, interessiert sie mich nicht. Wagen wir etwa, über Mathematik zu sprechen? Nein! Die Malerei sollte nicht zu einer Modesache werden. Und wenn dann noch money, money, money dazukommt, wird sie zu einer Wall Street-Affäre.«[9]

"I ONCE WROTE a book about chess, which was published in three languages – French, German, and English. A thousand copies were printed. It is called 'Opposition et Cases Conjugées, Opposition und Schwesterfelder, Opposition and Sister Squares', and it has to do with blocked pawns, when our only means of winning is by moves of kings. This happens only once in a thousand times. I don't think much to the state of painting today. I am not too much in accord with the crop of young painters. When I painted, no one spoke about it except painters, collectors, and dealers. Now we have critics vulgarizing the language by talking about dynamism! When painting becomes low that layman talks about it, it doesn't interest me. Do we dare to talk about mathematics? No! Painting shouldn't become a fashionable thing. And money, money, money, comes in and it becomes a Wall Street affair."[9]

»ICH SCHRIEB EINST ein Buch über Schach, das dreisprachig – französisch, deutsch und englisch – publiziert wurde. Es wurden tausend Exemplare davon gedruckt. Es heißt ›Opposition et cases conjuguées‹, Opposition und Schwesterfelder, Opposition and Sister Squares‹ und handelt von blockierten Figuren, wenn man nur noch mit dem König gewinnen kann. Auf tausend Male tritt das höchstens einmal auf. Heute denke ich nicht viel über den Zustand der Malerei nach. Mit der Mehrheit der jungen Maler stehe ich nicht mehr im Einklang. Als ich malte, sprach niemand davon, ausgenommen die Maler, Sammler und Händler. Jetzt haben wir Kritiker, die die Sprache vulgär machen, indem sie von Dynamismus reden! Wenn die Malerei so tief sinkt, daß Laien über sie sprechen, interessiert sie mich nicht. Wagen wir etwa, über Mathematik zu sprechen? Nein! Die Malerei sollte nicht zu einer Modesache werden. Und wenn dann noch money, money, money dazukommt, wird sie zu einer Wall Street-Affäre.«[9]

"I ONCE WROTE a book about chess, which was published in three languages – French, German, and English. A thousand copies were printed. It is called ›Opposition et Cases Conjugées‹, Opposition und Schwesterfelder, Opposition and Sister Squares,‹ and it has to do with blocked pawns, when our only means of winning is by moves of kings. This happens only once in a thousand times. I don't think much to the state of painting today. I am not too much in accord with the crop of young painters. When I painted, no one spoke about it except painters, collectors, and dealers. Now we have critics vulgarizing the language by talking about dynamism! When painting becomes low that layman talks about it, it doesn't interest me. Do we dare to talk about mathematics? No! Painting shouldn't become a fashionable thing. And money, money, money, comes in and it becomes a Wall Street affair."[9]

»UND WARUM ist Schachspielen keine künstlerische Betätigung? [...] Ein Schachspiel ist sehr plastisch. Sie konstruieren es. Es ist eine mechanische Plastik, und mit dem Schach kreiert man schöne Probleme. Und diese Schönheit ist mit dem Kopf und den Händen gemacht. Überdies ist es, sozial betrachtet, reiner als die Malerei, denn aus dem Schach können Sie kein Geld ziehen, hmm?«[10]

"AND WHY ISN'T my playing chess an art activity? [...] A chess game is very plastic. You construct it. It's mechanical sculpture, and with chess one creates beautiful problems, and that beauty is made with the head and hands. Besides, it's purer, socially, than painting, for you can't make money out of chess, eh?"[10]

»UND WARUM ist Schachspielen keine künstlerische Betätigung? [...] Ein Schachspiel ist sehr plastisch. Sie konstruieren es. Es ist eine mechanische Pla-stik, und mit dem Schach kreiert man schöne Probleme. Und diese Schönheit ist mit dem Kopf und den Händen gemacht. Überdies ist es, sozial betrachtet, reiner als die Malerei, denn aus dem Schach können Sie kein Geld ziehen, hmm?«[10]

"AND WHY ISN'T my playing chess an art activity? [...] A chess game is very plastic. You construct it. It's mechanical sculpture, and with chess one creates beautiful problems, and that beauty is made with the head and hands. Besides, it's purer, socially, than painting, for you can't make money out of chess, eh?"[10]

Pocket Chess Play, 1943 / *Taschenschachspiel* Chessboard, 1937 / *Schachbrett*

»IN MEINEM LEBEN stehen Schachspiel und Kunst an entgegengesetzten Polen, machen sich aber gegenseitig nichts vor. Schach ist nicht nur eine mechanische Funktion. Es ist gewissermaßen plastisch. Jedesmal, wenn ich auf dem Brett eine Figur ziehe, kreiere ich eine neue Form, ein neues Muster, und auf diese Weise werde ich befriedigt durch die ständig wechselnde Kontur. Das heißt nicht, daß es beim Schach keine Logik gibt. Schach zwingt Sie zur Logik. Die Logik steckt darin, aber Sie können sie eben nicht sehen.«[1]

"IN MY LIFE", chess and art stand at opposite poles, but do not be deceived. Chess is not merely a mechanical function. It is plastic, so to speak. Each time I make a movement of the pawns on the board, I create a new form, a new pattern, and in this way I am satisfied by the always changing contour. Not to say that there is not logic in chess. Chess forces you to be logical. The logic is there, but you just don't see it."[1]

»IN MEINEM LEBEN stehen Schachspiel und Kunst an entgegengesetzten Polen, machen sich aber gegenseitig nichts vor. Schach ist nicht nur eine mechanische Funktion. Es ist gewissermaßen plastisch. Jedesmal, wenn ich auf dem Brett eine Figur ziehe, kreiere ich eine neue Form, ein neues Muster, und auf diese Weise werde ich befriedigt durch die ständig wechselnde Kontur. Das heißt nicht, daß es beim Schach keine Logik gibt. Schach zwingt Sie zur Logik. Die Logik steckt darin, aber Sie können sie eben nicht sehen.«[11]

"IN MY LIFE, chess and art stand at opposite poles, but do not be deceived. Chess is not merely a mechanical function. It is plastic, so to speak. Each time I make a movement of the pawns on the board, I create a new form, a new pattern, and in this way I am satisfied by the always changing contour. Not to say that there is not logic in chess. Chess forces you to be logical. The logic is there, but you just don't see it."[11]

»SCHACH, auf der anderen Seite, umfaßt eine rein kartesianische Übung, oder die Entscheidung, die Sie treffen müssen, ist von einer anderen Art und auch das Resultat ist von einer anderen Art. In der Kunst gelangte ich schließlich an den Punkt, wo ich keine Entscheidungen mehr treffen wollte, gewissermaßen Entscheidungen künstlerischer Art. Im Schach wie in der Kunst finden wir eine Form von Mechanik, weil Schach als die Bewegung von Figuren beschrieben werden könnte, die einander auffressen.«[12]

"CHESS, on the other hand, involves a purely Cartesian exercise or the decision you have to make is of a different order and the result is of a different order. In art I came finally to the point where I wished to make no more decisions, decisions of an artistic order, so to speak. In chess, as in art, we find a form of mechanics, since chess could be described as the movement of pieces eating one another."[12]

«SCHACH, auf der anderen Seite, umfaßt eine rein kartesianische Übung, oder die Entscheidung, die Sie treffen müssen, ist von einer anderen Art und auch das Resultat ist von einer anderen Art. In der Kunst gelangte ich schließlich an den Punkt, wo ich keine Entscheidungen mehr treffen wollte, gewissermaßen Entscheidungen künstlerischer Art. Im Schach wie in der Kunst finden wir eine Form von Mechanik, weil Schach als die Bewegung von Figuren beschrieben werden könnte, die einander auffressen.»[12]

"CHESS, on the other hand, involves a purely Cartesian exercise or the decision you have to make is of a different order and the result is of a different order. In art I came finally to the point where I wished to make no more decisions, decisions of an artistic order, so to speak. In chess, as in art, we find a form of mechanics, since chess could be described as the movement of pieces eating one another."[12]

Étude pour les joueurs d'échecs, 1911/1965 / *Studie für Schachspieler*

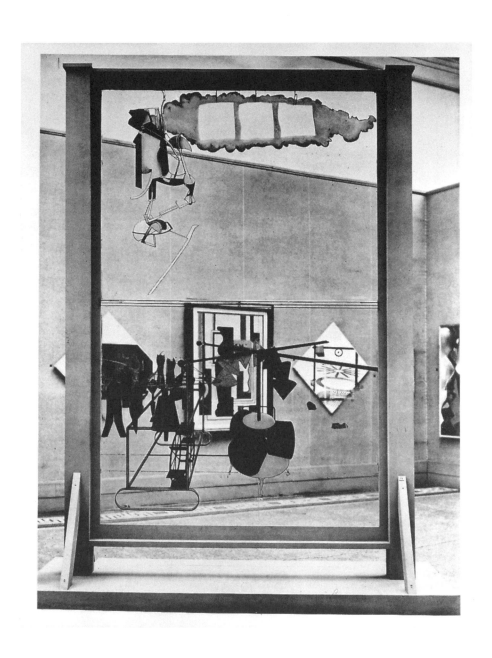

Man Ray
Le Grand Verre, non cassé, 1926 / *Das Große Glas, unzerstört*

78

Gerhard Graulich

Weder visuell noch zerebral
Duchamp als Anreger eines konzeptuellen Kunstbegriffs

Marcel Duchamps Werke, die nach seinem Bruch mit der Malerei ab 1913 entstanden sind, werden mit Selbstverständlichkeit in den Zusammenhang der Ready-mades gestellt und vor dieser Folie diskutiert. Zweifelsohne geschieht dies zurecht, stammt doch der Begriff Ready-made von Marcel Duchamp selbst. In seinen vielfältigen Äußerungen über diese Objektgruppe hat er immer wieder den Aspekt der Wahl betont, die für ihn eine Grundkategorie der Kunst darstellt. Schwierig sei es vor allem, so Marcel Duchamp, »ein Objekt auszuwählen, weil man es meist nach zwei Wochen entweder lieb gewinnt oder plötzlich satt hat«.[1] Bei der Wahl müsse im Vordergrund stehen, dem Eindruck des Modischen, des »Look« zu entgehen, nur so könne ein anhaltendes Interesse erreicht werden. Demzufolge vermeidet es Marcel Duchamp, sich von Geschmacksmomenten leiten zu lassen. Seine Objektwahl beruht deshalb auf der Basis visueller Gleichgültigkeit sowie der Indifferenz von gutem und schlechtem Geschmack.

Der Terminus Ready-made sagt sicherlich Treffendes über Duchamps Objekte aus, allerdings legt er diese wiederum auch fest, da der Begriff inzwischen auf ein sehr spezifisches Bedeutungsfeld innerhalb der Avantgarde-Diskussion verweist.[2] Dieser Umstand hat weniger mit Duchamp und seiner eigenen Deutung als vielmehr mit der Rezeption der Ready-mades zu tun. Aufgrund der Festlegungen bleiben die formalen und konzeptuellen Qualitäten der Objekte unberücksichtigt, zumal für diesen Diskussionsstrang Gesichtspunkte etwa der Form, Materialität und Präsentation keine entscheidende Rolle spielen. Der Diskurs der historischen Avantgarde, wonach die Bedeutung des Ready-made primär in der dadaistischen Provokation beziehungsweise der Negation des autonomen Kunstbegriffs liegt, überlagert den Diskurs der formalen Innovation. Letztere Perspektive aber, mag sie auch dem Fürsprecher der historischen Avantgarde marginal erscheinen, offenbart im Falle Duchamps eine Position radikaler Grenzerweiterung, die für die Entwicklung der Kunst des 20. Jahrhunderts mehr als folgenreich war. Wie kein zweiter hat Duchamp den Freiheitsraum von Kunst genutzt und den Begriff des Kunstwerkes erweitert. Natürlich brauchte es Zeit, Distanz und auch Gewöhnung, um seine Innovationen vorurteilsfrei einschätzen zu können. Und vielleicht konnten Duchamps Werke überhaupt erst retrospektiv in ihrer vollen Qualität wahr-

genommen werden; zu sehr irritierte seine Haltung den etablierten Kunstbetrieb. Ein Künstler, dessen ästhetisches Credo in der Auswahl von bereits existierenden Dingen liegt, konnte unter den Bedingungen des traditionellen Kunstwerkes nur schwer akzeptiert werden.

Duchamps Ready-mades, und natürlich kann sein Œuvre nicht darauf reduziert werden, stehen am Anfang einer »Kunst jenseits der Gattungen«[3] (Thomas Zaunschirm). Insofern ist die Zuordnung zur Antikunst-Bewegung mehr als verständlich, beabsichtigten doch diese Strömungen, mit den Inhalten und Formen des etablierten Kunstbetriebs zu brechen, um die Legende vom Künstler zu entlarven. Seit Duchamp kann Kunst nicht mehr allein unter dem Stichwort des schönen Scheins rubriziert werden, künstlerische Tätigkeit sich nicht mehr auf Malen, Zeichnen oder Bildhauern reduzieren. Schon die Wahl, der Entschluß oder letztlich das Konzept transformieren die ins Auge gefaßten Gegenstände zu Kunstwerken, mit Werner Hofmann zu reden: »Demonstration ersetzt die formale Metamorphose.«[4] Duchamp selbst fungiert dabei als »Medium«, bei dem Leben und künstlerisches Handeln nicht mehr voneinander zu trennen sind: Seine Kunst wurde konzeptuell und hatte demzufolge »nur noch wenig mit der Netzhaut zu tun«.[5] Entsprechend dieser Aussage geht es um Ideen, um die Lösung ästhetischer Probleme, während herkömmliche künstlerische Formen und Materialien ihre Bedeutung verlieren: »Jede gelebte Sekunde, jeder Atemzug ist ein Kunstwerk, ein Kunstwerk, daß nirgendwo seinen Ausdruck findet, das weder visuell noch zerebral erkennbar ist, das vielmehr eine Art unausgesetzten Hochgefühls darstellt.«[6]

Marcel Duchamps selbstbezügliche Auffassung von Kunst legte es nahe, auch die eigene Person und den eigenen Körper zu thematisieren. Über die Wahl eines weiblichen alter ego, das er Rrose Sélavy nennt, schafft er sich ab 1919/20 eine Kunstfigur, die ihm als Projektionsfläche seiner künstlerischen Absichten dient. Das kreierte Wesen, ganz und gar seiner Kontrolle unterliegend, ermöglicht ihm ein außergewöhnliches Verwirrspiel, das die Rätselhaftigkeit seiner Person erhöht. Unterschiedliche Lebenszeichen von Rrose tauchen im fast jährlichen Rhythmus immer wieder auf. Kofferschildchen und Visitenkarten, versehen mit der fiktiven Adresse von Rrose, gibt Duchamp in Druck, das Ready-made *Air de Paris / Pariser Luft*, 1919, signiert er mit »R. S.«, den Initialen von Rrose Sélavy, später läßt er gar sein Geschöpf wie einen Straftäter suchen – und natürlich ist er selbst es, der auf dem Plakat *Wanted, $ 2000 Reward / Gesucht, 2000 $ Belohnung*, 1923 (Abb. S. 87), abgebildet ist. Man Ray fotografiert ihn in Frauenkleidern, sein Gesicht und die Geste der Hände vereinigen sowohl weibliche als auch männliche Merkmale. Wie bei seiner *Mona Lisa*, 1919 (Abb. S. 10), der er mit dadaistischer Frechheit einen Kinn- und Schnurrbart anmalt, um die androgynen Qualitäten der Dargestellten hervor-

zuheben, bleibt auf dem Foto sein eigenes Geschlecht in der Schwebe. Zu seinem Identitätswechsel erläutert Duchamp, daß er zuerst die Idee gehabt habe, »einen jüdischen Namen anzunehmen. Ich war ja katholisch, und dieser Religionswechsel allein bedeutete schon eine Veränderung. Ich fand aber keinen jüdischen Namen, der mir gefiel oder der mich irgendwie reizte, und da kam mir plötzlich eine Idee: Warum sollte ich eigentlich nicht mein Geschlecht wechseln? Das war doch viel einfacher! Und daher stammt auch der Name Rrose Sélavy. Heute klingt das vielleicht ganz gut, weil ja auch die Vornamen sich mit den Zeiten ändern, aber damals war Rose ein blöder Name. Das Doppel-R hängt mit dem Bild von Picabia ›Œil Cacodylate‹ zusammen, das in der Bar ›Le Bœuf sûr le Toit‹ hängt … und das auf Picabias Wunsch alle seine Freunde signierten … Ich glaube, ich schrieb … Pi Qu'habilla Rrose Sélavy.«[7] Phonetisch gelesen bedeutet das: »Picabia l'arrose c'est la vie«. »Arroser la vie« meint darüber hinaus: »auf das Leben trinken«. Außerdem spielt die Sentenz auf: »Éros c'est la vie« an, also: »Eros ist das Leben«. Vieldeutigkeit erweist sich fortan als ausgeklügeltes künstlerisches Prinzip, das er der Ambivalenz des Lebens, der Offenheit der Sprache entnimmt. Vor dieser Folie gerinnen die Sprachspiele zu Gleichnissen über das Leben und die Kunst, die es ermöglichen, zwischen den verschiedensten Bedeutungsebenen hin und her zu springen. In den kombinatorischen Möglichkeiten der Sprache sieht Duchamp auch eine Verwandtschaft zur Malerei: »Manchmal kommen vier oder fünf verschiedene Bedeutungsebenen durch. Wenn Sie ein wohlvertrautes Wort in eine fremde Atmosphäre verlegen, so haben sie etwas, das mit der Verzeichnung in der Malerei vergleichbar ist, etwas Unerwartetes und Neues.«[8]

Unter der Collage *Obligation pour la Roulette de Monte-Carlo / Obligation für das Roulette von Monte Carlo,* 1924 (Abb. S. 61), finden sich zwei Unterzeichner: »Rrose Sélavy« und »M. Duchamp«. Sein anderes Ich und er selbst firmieren gemeinsan, als seien beide Verwalter desselben Aktienfonds. Ursprünglich initiierte Duchamp den Fond, um seine Spielleidenschaft zu befriedigen. Für 500 Franc bot er Anteile der Gesellschaft an. Wie ernst auch immer die »Obligation« gemeint war, letztlich stellt sie doch eine Symbiose von Aktie und Kunstwerk (Grafik) dar. Ironischerweise erhebt sich Duchamp mittels der Collage in die Sphäre des Gottes Merkur – ersichtlich an dem geflügelten Haarschopf –, dem Handel und Wissenschaft gefügig sind, der aber ebenfalls Gaunern und Betrügern seine Gunst nicht zu verwehren scheint. Auf dieser Ebene liegen auch seine Sympathien für Dada und später dann für den Surrealismus. Man Ray und insbesondere die Freundschaft zu Francis Picabia sorgen für ein interessiertes Wohlwollen gegenüber beiden Strömungen, obgleich er sich mit keinem der Programme wirklich identifizierte. Seine späteren grafischen Gestaltungen, zum Beispiel für Man Rays 1945 erschienenen Katalog der Julien Levy Gallery

in New York und *The First Papers of Surrealism / Die ersten Texte des Surrealismus,* 1942 (Abb. S. 100), oder André Bretons Publikation *Young Cherry Trees Secured Against Hares / Junge Kirschbäume vor Hasen geschützt,* 1946 (Abb. S. 103), sind noch in diesem Kontext zu sehen.

Innovation findet sich, wenn man Duchamps konzeptuellen Kunstbegriff anhand der Ready-mades durchspielt, nicht allein in der Wahl der Gegenstandsformen, sondern immer auch in den mitgewählten Materialien sowie den Objektpräsentationen. So bizarr einerseits die Gegenstände anmuten, so variationsreich erscheinen andererseits die Werkstoffe. Naturgemäß bleiben diese am Gebrauchsgegenstand unbefragt, weil dort die Funktion im Vordergrund steht. Ändert sich jedoch der Kontext, werden die Objekte im Zusammenhang von Kunst gezeigt, gewinnen sie durchaus skulpturale Qualitäten. So besehen, kommt Duchamps *Porte bouteilles / Flaschentrockner,* 1914 (Abb. S. 25), wenn zunächst auch ungewollt, die Ehre zu, eine der ersten Eisenskulpturen zu sein. Noch vor dem Spanier Julio Gonzales hat Duchamp Eisen als Ausgangsmaterial entdeckt und damit Zeichen gesetzt. Unter den Bedingungen des ästhetischen Blicks vermag darüber hinaus das Gebilde, sich in eine architektonische Plastik zu verwandeln; die funktional gebogenen Haken, über die im alltäglichen Gebrauch Flaschen zum Trocknen gestülpt werden, könnten ihrerseits als phallische Formen interpretiert werden usw. Der Assoziation sind keine Grenzen gesetzt. Entgegengesetzt dem *Flaschentrockner* und seiner transparenten Form bietet sich die undurchsichtige, scheinbar etwas verbergende Arbeit *Pliant ... de voyage / Zusammenfaltbarer Reiseartikel,* 1916 (Abb. S. 27), dar. Ausgewählt worden ist eine schwarze Kunststoffhülle, die als Schutz gegen Staub für eine Reiseschreibmaschine der Marke »Underwood« diente. Auf einem Ständer hängend, gleichsam das Darunterbefindliche verbergend, stimuliert die Kunststoffhülle den Wunsch, das Verdeckte zu betrachten. Der Name »Underwood«, also Unterholz, verweist auf Natur, läßt sich aber auch durchaus mit anderen Konnotationen verbinden. Mit diesem Faltobjekt, losgelöst von der Schreibmaschine, hat Duchamp die erste weiche und instabile Plastik geschaffen; aus dem Akzidentellen, der verbergenden Hülle, ist der eigentliche Gegenstand geworden.

Nicht aber allein in der Wahl der Materialien seiner Objekte, sondern auch in der Präsentation war Duchamp äußerst kreativ. Das Ready-made *Trébuchet / Stolperfalle,* 1917 (Abb. S. 26), ein schlichtes Garderobenbrett, das üblicherweise an der Wand befestigt wird und woran Kleider aufgehängt werden, hat Duchamp in völliger Verkennung seines Gebrauchs auf den Fußboden gelegt, wo es in der Tat als Stolperfalle begegnet. Die Idee dazu hat er aus der wirklichen Erfahrung gewonnen, da permanent Besucher seines Studios über die achtlos am Boden liegenden Haken fielen. Auch hier findet sich ein neues

Paradigma: die sockellose, bodenbezogene Plastik. *Hat rack / Huthalter,* 1917, stellt seinerseits das genaue Gegenstück zu *Trébuchet* dar, da der Huthalter schwerelos von der Decke herab an einem Faden hängt. Rack bedeutet auch »ziehendes Gewölk«, das spinnenartig Bedrohung von oben hervorruft. Die Innovation, die in dieser Präsentation für die spätere Hängeplastik eines Alexander Calder und dessen Mobiles liegt, ist mehr als offensichtlich.

Mit dem *Roue de bicyclette / Fahrrad-Rad,* 1913 (Abb. S. 118), schließlich hat Duchamp den wohl wichtigsten Beitrag zur Plastik des 20. Jahrhunderts geliefert. In der Überwindung des statischen Kunstwerkes kulminierend, stellt das auf den Kopf gestellte und auf einen Küchenhocker montierte Fahrrad den Prototyp der Kinetischen Plastik dar (vgl. dazu den Beitrag von Herbert Molderings). Die Beschäftigung mit den Bewegungsphänomenen setzt sich in den optischen Versuchen wie etwa *Rotative-plaque-verre / Rotierende Glasplatten,* 1920 (Abb. S. 170 u. 171), sowie den *Rotoreliefs,* 1935 (Abb. S. 173), fort. Betrieben mit einem Motor, erzeugen die zweidimensionalen Scheiben ein virtuelles Relief, das sich aufgrund der Bewegung in Richtung des Betrachters bewegt, bis sich schließlich eine dritte Dimension, ein Volumen, einstellt.

La Mariée mise à nu par ses Célibataires, même / Die Braut von ihren Junggesellen nackt entblößt, sogar, 1915–23 (Abb. S. 78), auch das *Große Glas* genannt, ist nicht allein wegen seiner inhaltlichen Komplexität und Tiefe, sondern ebenfalls unter Objektgesichtspunkten wegweisend gewesen. Vor dem Hintergrund der Ready-mades könnte es zwar als Rückschritt gewertet werden, da Duchamp erneut zum eigenhändig ausgeführten Kunstwerk zurückkehrte. Wie sich jedoch zeigte, formulierte er über das *Große Glas* ein vielleicht noch wesentlicheres künstlerisches Problem: das der Beteiligung und Verantwortung des Betrachters. Die verwendeten Materialien sind Glas und Metall – Werkstoffe, die an sich an moderner Architektur, an Schaufenstern und Vitrinen Verwendung finden. Die irritierenden Perspektiven, die sich aufgrund des Glases und seiner Bezüge zum Raum ergeben, lassen die Linien und Formen je nach Standort vieldeutig, vor allem auf den Umraum bezogen erscheinen. In dem Maße, wie sich das Dargestellte einer bildhaften Festlegung verweigert, bietet sich das *Große Glas* als Gebilde ständig wandelnder Konstellationen dar. Ermöglicht wird sowohl der Blick auf die Kunst als auch auf die Welt: Glas und Welt sind unauflöslich miteinander verquickt. Die Formen können zudem in gleicher Weise von vorne wie von hinten betrachtet werden, der Zwang zur Vorderansicht des Tafelbildes besteht nicht mehr. Duchamp hebt mit Stolz an dem Glas hervor: »Diesen ganzen Hintergrund auf der Leinwand, den man überdenken mußte, diesen taktilen Raum wie Tapeten, diesen ganzen Plunder wollte ich hinwegfegen. Mit dem Glas können Sie sich auf die Figur konzentrieren, wenn Sie wollen, und Sie können den Hintergrund verändern, wenn

Sie wollen, indem Sie das Glas bewegen. Die Transparenz des Glases spielt für Sie. Die Frage, wie man den Hintergrund malen soll, ist für einen Maler erniedrigend. Das, was man ausdrücken will, liegt nicht im Hintergrund.«[9] Mit dem Glas gibt Duchamp die vom Künstler definierte Ansichtsseite des Werkes auf. Entschiedener als je zuvor erzwingt er die Selbstbezugnahme und Mitverantwortung des Betrachters. Dieser muß letztlich seine eigene Perspektive einnehmen und finden, wie er das Objekt und vor allem, was er von ihm wahrnehmen will.

In seiner Schachtel von 1914 setzte sich Marcel Duchamp mit dem eigenen Werk und den Bedingungen seiner Entstehung auseinander. Eine Zeichnung und unausgearbeitete Arbeitsnotizen, die sich im Laufe der Zeit angesammelt hatten, ließ er fotografisch wiedergeben. Der Aufwand der Reproduktionen stand dabei in keinem erkennbaren Verhältnis zur Beiläufigkeit der Entwürfe. Faszinierend ist für Duchamp der Zustand des Unfertigen, das transitorische Moment, das sich normalerweise dem Fertigen unterordnet oder in ihm aufgeht. Diesen Zustand nennt er »à l'état brut«, Zustand des Rohen, oder auch den »Kunst-Koeffizienten«. In einem 1957 gehaltenen Vortrag referiert er: »Beim kreativen Akt gelangt der Künstler von der Absicht zur Verwirklichung durch eine Kette völlig subjektiver Reaktionen. Sein Kampf um die Verwirklichung ist eine Serie von Bemühungen, Leiden, Befriedigungen, Verzichten, Entscheidungen, die, zumindest auf ästhetischer Ebene, jedenfalls nicht völlig bewusst sein können und bewusst sein müssen.«[10] Hierdurch bekommen die Entwicklungsschritte einen künstlerischen Eigenwert. Duchamp reproduziert die Notizen, hebt sie auf eine andere Stufe und schafft ihnen einen neuen Wahrnehmungsstatus. Aufgrund der Reproduktion werden sie Teile eines neuen Werkes, wobei nacheinander Geschaffenes durch die Reproduktion homogenisiert wird. »Das Œuvre, das die Schachtel konstituiert, ist längst verschwunden, der Anfang, den sie offenbart, ist eine Fiktion. Kunst, so muß der Betrachter lernen, entspringt keinem mythischen Ursprung, sondern immer nur Vermittlungen«,[11] bemerkt Stefan Germer treffend. Sicherlich ist auch das eine der Lektionen, die Duchamp dem verwöhnten Betrachter traditioneller Kunst erteilt. Kunst baut sich ganz allmählich mental und gestalterisch auf, Schritt für Schritt, in einem fortwährenden Prozeß der Aktion und Reaktion. Wann ein Kunstwerk abgeschlossen ist, basiert in der Regel auf Vereinbarungen oder Definitionen. Duchamp zeigt allerdings, daß der Entwicklung keine Grenzen gesetzt sind, daß das Kunstwerk eine prospektive Potenz besitzt.

La Mariée mise à nu par ses Célibataires même / Die Braut von ihren Junggesellen nackt entblößt, sogar (Abb. S. 113) hat Duchamp 1934 in der sogenannten *Grünen Schachtel* reproduziert, und zwar in einer Auflage von 320 Exemplaren. Nachdem das *Große Glas* wegen starker Beschädigung nicht mehr ausstellbar

war, trat die Schachtel mit den Reproduktionen zerrissener Notizen, die seine Entwicklung dokumentieren, an die Stelle des Glases. Die minutiöse Reproduktion hat Duchamp selbst übernommen. Den Aspekt des Entzuges verkehrt er über die Schachteln in sein Gegenteil: in Multiplikation. Entzug und Multiplikation verhalten sich geradezu umgekehrt proportional. Wesentlich dabei ist aber, daß Duchamp das Werk zwar nachschafft und an ihm festhält, aber eine völlig andere Strategie bei der Realisierung verfolgt, die dazu führt, daß das Werk in einer neuen Daseinsform begegnet. Die Ambivalenz der visuellen Wahrnehmung ist vertauscht worden durch die Ambivalenz der Sprache.

Nach der *Grünen Schachtel* entstand die sogenannte *Boîte-en-Valise / Schachtel im Koffer* (Abb. S. 114 u. 115) ab 1938. Duchamp hat damit ein tragbares Miniaturmuseum, vergleichbar einem mittelalterlichen Reisealtar, aus den eigenen Arbeiten zusammengestellt und reproduziert. Alle wichtigen Werke, inklusive der frühen Malerei, sind durch Wiedergaben versammelt. Fotografien und Miniaturen der Ready-mades gruppieren sich um eine Reproduktion des *Großen Glases*. Duchamp gibt selbst an, welche Werke zu seiner Wahl, seinem musée imaginaire gehören. Die Multiplikation zielt auf das Œuvre, die Vorstellung vom Ganzen. Damit ermöglicht er dem Betrachter, seine für ihn wichtigen Werke wie in einer Ausstellung vor sich zu sehen; paraphrasiert wird somit das inzwischen eigene, geschichtlich gewordene Werk. Der zur Kunst transformierte Gegenstand erfährt durch den zweiten Akt der Auswahl eine erneute Nobilitierung: Er wird durch die Kunst als Kunst bestätigt. Daß Duchamp an diesem Meta-Spiel Gefallen fand, zeigt auch die humorvolle Antwort auf seine schnurrbärtige Mona Lisa: *L.H.O.O.Q. rasée,* 1965 (Abb. S. 10), der in einem fiktiven Akt der Rasur die Barttracht wieder abgenommen wurde.

Das Prinzip der Schachtel basiert auf dem Spannungsverhältnis von Abwesenheit und Gegenwart. Wie bei der Fotografie oder beim Film wird etwas zur Präsenz gebracht, was selbst nicht da ist. Über den Entzug kommt eine Dimension zum Vorschein, die die ursprüngliche Realität zurückläßt. Duchamp besetzt damit eine Leerstelle zwischen dem vermeintlichen Original und der bloßen Reproduktion, wobei die Abwesenheit des Originals bei gleichzeitiger Anwesenheit der Reproduktion ein Paradoxon bewirkt: die Erhöhung der Aura. Mittels Absenz, die als solche schmerzlich empfunden wird, stimuliert Duchamp, seine Objekte als Fetische zu betrachten, denn unwillkürlich dient der Ersatz zur Imagination des Originals. Das Interesse daran bleibt wach, so lange das vermeintliche Original abwesend ist. Die Abwesenheit gehört folglich zum Konzept.

Duchamps ästhetische Kritik zielt auf die Kunst als einem System der Darstellung von Realität. Seine Leistung ist, daß er sich mittels des Ready-made von der traditionellen Abbildung löste und die Realität über die Objekte einbe-

zog. Dies geht einher mit der Mißachtung jeglicher künstlerischer Konventionen. Was bei Duchamp als Kunst erscheint, ist zugleich immer auch Realität und umgekehrt.[12] Kritik manifestiert sich darüber hinaus als Kunst, die gleichsam die Bedingungen von Kunst, Künstlertum, Material und Präsentation befragt. In welchem Ausmaß Duchamp als Anreger eines konzeptuellen Kunstbegriffs, der sich eher als Haltung denn als Stil fortsetzte, gelten kann, offenbart sich in dem Bereich der erweiterten Kunst, angefangen mit Joseph Beuys über den Nouveau Réalisme und Pop Art hin zu Bruce Nauman, Jeff Koons und Rosemarie Trockel. Duchamp hat mit Witz, Charme, Ironie und Lust die Kunstlandschaft inspiriert – Qualitäten, die heute mehr denn je vonnöten sind.

1 Marcel Duchamp zit. nach: Pierre Cabanne, Gespräche mit Marcel Duchamp, Spiegelschrift 10, Köln 1972, S. 67.

2 Dazu z. B. Peter Bürger, Theorie der Avantgarde, Frankfurt a.M. 1974, S. 71 ff.

3 Vgl. dazu den Beitrag von Thomas Zaunschirm, Kunst jenseits der Kunstgattungen: DAS READYMADE, in: ders. Distanz, Dialektik in der modernen Kunst, Bausteine einer Paragone-Philosophie, Wien 1982, S. 29–56.

4 Werner Hofmann, Grundlagen der modernen Kunst, Stuttgart 1978, S. 333.

5 Marcel Duchamp, zit. nach: Pierre Cabanne, a.a.O., S. 51.

6 Ebenda, S. 109.

7 Ebenda, S. 96.

8 Marcel Duchamp zit. nach: Marcel Duchamp, Interviews und Statements, herausgegeben von Ulrike Gauss, Stuttgart 1992, S. 119; das Zitat ist entnommen dem Gespräch zwischen M. D. und Katherine Kuh in: The Artist´s Voice – Talks with 17 artists, New York und Evanston 1962, S. 89.

9 Marcel Duchamp, a.a.O., S. 154; das Zitat ist dem Interview zwischen M.D. und T. Roberts entnommen in: Francis Roberts, Interview with Marcel Duchamp, Art News, New York, LXVII/8, S. 46 f.

10 Marcel Duchamp, zit. aus dem Vortrag »Der kreative Akt«, 1957, in: Marcel Duchamp, Die Schriften, Bd. 1, übersetzt und herausgegeben von Serge Stauffer, Zürich 1981, S. 239.

11 Stefan Germer, Das Jahrhundertding, Ansätze zu einer Theorie und Geschichte des Multiples, in: Zdenek Felix, Das Jahrhundert des Multiples, Von Duchamp bis zur Gegenwart, Kat. Deichtorhallen, Hamburg 1994, S. 21.

12 Vgl. Gottfried Boehm, Das Werk als Prozeß, in: Willi Oelmüller (Hrsg.), Kolloquium Kunst und Philosophie III, Das Kunstwerk, Paderborn/München/Wien/Zürich 1983, S. 338.

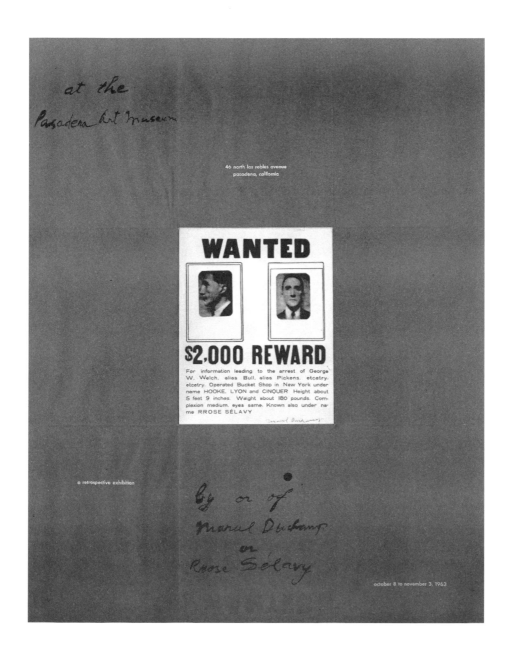

Wanted, $ 2000 Reward, 1923/1963 / *Gesucht, 2000 $ Belohnung*

Gerhard Graulich

Neither Visual nor Cerebral
Duchamp as a Pioneer of a Conceptual Approach to Art

The works of Marcel Duchamp which originated after 1913, following his aban-
donment of painting, are quite naturally associated with the Ready-mades and
usually discussed in that context. Such a view is undoubtedly appropriate, as it
was Marcel Duchamp himself who coined the term "Ready-made". In his many
statements about this group of objects he rarely failed to emphasize the aspect
of selection, a fundamental category of art in his opinion. It is particularly dif-
ficult, says Duchamp, "to select an object, because after two weeks one usually
either grows fond of it or suddenly cannot stand to see it anymore."[1] In his
view, the most important consideration in making a selection is to avoid the
impression of trendiness, of the "look". Only in this way could lasting interest
be achieved. Consequently, Marcel Duchamp avoids the influence of momen-
tary expressions of taste. His choice of objects is based upon both visual indif-
ference and the absence of distinction between good and bad taste.

The term "Ready-made" certainly says a great deal about Duchamp's
objects, although he determines these as well, since the term now refers to a
very specific field of meaning within the avant-garde discussion? This has less
to do with Duchamp and his own interpretation than with the particular recep-
tion of the Ready-mades. According to conventional definitions, formal and
conceptual qualities of the objects are not taken into account, especially since
aspects such as form, materiality and presentation are not of particular impor-
tance in this line of discussion. The discourse of the historical avant-garde,
according to which the significance of the Ready-mades lies primarily in the
Dadaist provocation against, or rejection of, the concept of art as autonomous,
overshadows the discourse of formal innovation. The latter standpoint, how-
ever, while perhaps only of marginal importance to advocates of the historical
avant-garde, reveals in Duchamp's case a radical extension of boundaries
which profoundly influenced the development of 20th-century art. Like no
other artist before him, Duchamp exploited the freedoms permitted by art and
expanded the concept of the work of art. This took time, of course, and one
needed to gain distance and grow accustomed to his innovative work in order
to judge it without prejudice. And perhaps the full quality Duchamp's works
could only be appreciated in retrospect – so much did his attitude irritate the
artistic establishment. An artist whose aesthetic credo consisted in the selec-

tion of things that already existed could hardly gain easy acceptance under the terms governing the traditional work of art.

Duchamp's Ready-mades, and certainly his œuvre cannot be reduced to those only, stand at the beginning of an "art beyond all genres" (Thomas Zaunschirn).[3] Thus his assignment to the "nonart" movement is more than understandable, as these tendencies firmly intended to dispense with the forms and contents embraced by the art establishment in order to reveal the myth of the artist for what it was. After Duchamp, we can not longer approach art from the standpoint of the "beautiful illusion" alone, nor can we limit our understanding of artistic activity to painting, drawing or sculpture. It is the selection, the decision or ultimately the concept itself that transforms the objects of our vision into works of art. In the words of Werner Hofmann: "Demonstration replaces formal metamorphosis".[4] Duchamp himself acted in the process as a "medium", rendering the life and creative work of the artist inseparable from that point on. His art became conceptual and thus had "little left to do with the retina".[5] As this statement indicates, the crucial issue is ideas, the solution of aesthetic problems, and conventional forms and materials of art are no longer meaningful. "Every second lived, every breath is a work of art, a work of art that finds expression nowhere, that is neither visually, nor cerebrally recognisable, but represents instead a kind of unceasing elation."[6]

Marcel Duchamp's self-centred view of art naturally led him to deal thematically with his own person and his own body. In choosing a female alter ego, whom he named Rrose Sélavy, in 1919/20, he created a fictional character upon which to project his artistic intentions. This invented being, totally subject to his control, allowed him to play an extraordinary game of bewilderment that heightened the mystery surrounding his own person. A variety of signs of life appear in an almost annual rhythm. Duchamp had suitcase labels and visiting cards bearing Rrose's fictional address printed. He signed his Ready-made entitled *Air de Paris* (1919) with the initials "R.S.", for Rrose Sélavy. Later, he even had his creation sought like a criminal, but of course it is he, himself, whose face appears on the poster *Wanted, $ 2000 Reward* of 1923 (See ill. p. 87). Man Ray photographed him wearing women's clothes, his face and hand gestures combining both feminine and masculine features. As in his *Mona Lisa* of 1919 (ill. p. 10), to which in naughty Dadaist style he added a chin-beard and moustache in order to stress the androgynous character of the subject, his own gender remains ambiguous in the photo. Of this change of identity Duchamp said that he first thought of "using a Jewish name. I was Catholic, you see, and this change of religion was an alteration in itself. But I couldn' t come up with a Jewish name that I liked or that appealed to me in any way. And then suddenly an idea occurred to me: Why not change my sex? That was much sim-

pler! And thus the name Rrose Sélavy. That may sound quite nice today, since first names change with the times, but back then Rose was a stupid name. The double "R" relates to Picabia's painting, *Œil Cacodylate,* that hangs in the Bar named "Le Bœuf sur le Toit", and which Picabia asked all of his friends to sign... I think I wrote... 'Pi Qu'habilla Rrose Sélavy'". Read phonetically, that means "Picabia l' arrose c'est la vie". "Arroser la vie" means "to drink to life". The phrase is also a play upon "Éros c´est la vie" – "Eros that is life". Multiplicity of meaning developed into a sophisticated artistic principle drawn by Duchamp from the ambivalence of life and the openness of language. Against this background, his word games become similes about life and art that enable him to leap back and forth between different levels of meaning. Duchamp also sees affinities to painting in the combinative possibilities of language: "Sometimes four or five different levels of meaning come through. If you introduce a familiar word into an alien atmosphere you have something comparable to distortion in painting, something surprising and new."[8]

Two signatures appear beneath the collage *Obligation pour la Roulette de Monte-Carlo* of 1924 (ill. p. 61): "Rrose Sélavy" and "M. Duchamp" – his second ego and his real self as business partners, as if both managed the same mutual fund. Originally, it was Duchamp who initiated the fund in order to support his gambling urge. He offered shares in the fund for 500 francs. However serious he may have been about these "obligations", they nevertheless suggest a symbiotic relationship between shares of stock and the work of art (graphic print). Ironically, Duchamp uses the collage to elevate himself into the sphere of the god Mercury – identified by a winged head of hair – who commands science and commerce, but who appears to bestow favor upon scoundrels and conmen as well. It is at this level that his Dadaist, and later Surrealist sympathies may be understood. His friendships with Man Ray and in particular with Francis Picabia were instrumental in ensuring that he continue to regard both movements with interest and benevolence, although he never truly identified with either program. His later graphics, including for example those that appeared in Man Ray's 1945 catalogue by the Julien Levy Gallery in New York and the *First Papers of Surrealism* of 1942 (ill. p. 100) or in André Breton's 1946 publication entitled *Young Cherry Trees Secured Against Hares* (ill. p. 103) can be viewed within this context.

Innovation is always evident, if one consistently applies Duchamp's concept of art as expressed in his Ready-mades, not only in the selection or the forms of his objects but in the other materials used and in the presentation of the objects as well. As bizarre as some objects may seem, the materials are so much richer in variation. Quite naturally, such variations are of little relevance to utilitarian objects, as these are primarily functional. Viewed in from a differ-

ent perspective, however, namely that of art, they take on genuine sculptural qualities. Seen in this way, Duchamp's *Porte bouteilles / Bottle-Rack* of 1914 (ill. p. 25) earns the honour – albeit undesired at first – of being the first sculptures in metal. Even before the Spaniard Julio Gonzales, Duchamp had discovered iron as a material for sculpture, thereby breaking new artistic ground. Viewed in aesthetic terms, the structure is also capable of turning itself into an architectural sculpture; the functional curved hooks ordinarily used for drying bottles can be interpreted as phallic shapes, etc. The possibilities for association are limitless.

A contrast to the *Bottle-Rack* and its transparent form is presented by the opaque, seemingly concealing work entitled *Pliant . . . de voyage / Traveller's Folding Item* of 1916 (ill. p. 27). The object selected is a black plastic mantel used as a dust-cover for an "Underwood" portable typewriter. Hanging on a stand, concealing, so to speak, what is beneath it, the plastic cover stimulates the desire to see what is hidden. The name "Underwood" alludes to nature, but permits other associations as well. With this folding object, independent of the typewriter, Duchamp created the first soft, unstable sculpture; from the accessory, the concealing cover, the actual object emerges.

Duchamp demonstrated exceptional creativity not only in the selection of his materials for his objects but in their presentation as well. The Ready-made *Trébuchet / Stumbling Block* of 1917 (ill. p. 26), is a simple coat-rack board, similar to those ordinarily affixed to a wall and used to hang garments, which Duchamp laid on the floor, totally ignoring its normal function, where it indeed became a stumbling block. His idea for this work came from actual experience, as visitors to his studio were constantly stumbling over the hooks carelessly left lying on the floor. And we find here yet another new paradigm: the floor-based sculpture without a pedestal. *Hat-rack,* a 1917 work, is a fitting complement to *Trébuchet,* as the hat-rack hangs weightless on a thread suspended from the ceiling. The word "rack" denotes "moving clouds", suggesting, spider-like, an impending threat from above. The innovative impulse this presentation provided for the later hanging sculpture of an Alexander Calder and his mobiles is impossible to overlook.

Duchamp's *Roue de bicyclette / Bicycle Wheel* of 1913 (ill. p. 118) represents what is probably his most important contribution to 20th-century sculpture. Culminating in total liberation from the static work of art, the bicycle wheel mounted upside-down upon a kitchen stool is a prototype of the kinetic sculpture (see the essay by Herbert Molderings). His concern with the phenomena of motion saw its continuation in optical experiments such as the *Rotative Plaque Verre / Rotative Glass Plaques* of 1920/1961 (ill. p. 170, 171) and the *Roto-Reliefs* of 1935/1965 (ill. p. 173). The motor-driven two-dimensional discs create a virtual

relief that appears to move towards the viewer as it spins, finally generating a third dimension, an illusion of volume.

La Mariée mise à nu par ses Célibataires, même / The Bride Stripped Bare by her Bachelors, Even of 1915–1923 (ill. p. 78), also called *The Large Glass,* was a milestone, not only because of its substantive complexity and depth but because of its object qualities as well. Against the background of the Ready-mades it may appear as a step backward, as Duchamp's return to the self-made work of art. It became clear, however, that Duchamp employed *The Large Glass* to articulate a problem of even more fundamental importance to art: that of the involvement and the responsibility of the viewer. The components are glass and metal – materials found in modern architecture, in shop windows and showcases. Depending upon the location, the disturbing perspectives produced by the glass and its relationship to surrounding space produce a multiplicity of lines and shapes that appear to refer specifically to that space. To the extent that the representation defies description in figurative terms, *The Large Glass* presents itself as a structure of constantly changing constellations. It suggests both a view of art and a view of the world: Glass and the visible world are inseparably interconnected. The forms may be viewed in the same way from the front or the rear; one is no longer confined to the frontal view demanded by traditional painting. Proudly, Duchamp emphasises the glass: "All that background on the canvas that had to be thought about, tactile space like wallpaper, all that garbage, I wanted to sweep it away. With the glass you can concentrate on the figure if you want and you can change the background if you want by moving the glass. The transparency of the glass plays for you. The question of painting the background is degrading for the painter. The thing you want to express is not in the background."[9] In using glass, Duchamp dispenses with a viewing perspective defined by the artist. More decisively than ever before he forces the viewer to establish his own point of view and to accept his share of responsibility. Ultimately, the viewer must establish his own perspective and find out for himself how he wishes to perceive the object and in particular what it is that he wishes to perceive.

In his *Box* of 1914, Marcel Duchamp examined his own work and the conditions governing in its creation. He had a drawing and several uncompleted working notes reproduced photographically, an effort that appears quite disproportionate to the rather casual nature of the drafts themselves. Duchamp is fascinated by the unfinished, by the transitory moment that is ordinarily secondary to the finished product or is subsumed within it. He refers to this condition as "à l'état bruit", a state of rawness, or as the "art-coefficient". Lecturing in 1957, he observed that: "In the creative act, the artist proceeds from intention to realisation along a chain of totally subjective reactions. His struggle for real-

isation is a series of efforts, sufferings, satisfactions, sacrifices, decisions, which in any event, at least on an aesthetic level, cannot and need not be conscious."[10] Thus the stages of the development process take on an artistic value of their own. In reproducing the notes, Duchamp elevates them to another level and gives them a new status in perceptual terms. Through reproduction they become parts of a new work in which elements created in chronological sequence are homogenised in the reproduction. "The work constituted by the Box has long since disappeared; the origin it reveals is a fiction. Art, as the viewer must learn, originates not in myth but always in mediation",[11] as Stefan Germer correctly observes. That is certainly one of the lessons Duchamp wishes the complacent viewer of traditional art to learn. Art develops gradually, mentally, formally, in a continuous, step-by-step process of action and reaction. Determining when a work of art is completed is ordinarily a matter of applying conventions and definitions. But Duchamp shows us that there are no limits to development, that the work of art always harbours a prospective potential.

In 1934 Duchamp reproduced *The Bride Stripped Bare by her Bachelors, Even* (ill. p. 113) in an edition of 320 copies in the so-called *Green Box*. When *The Large Glass* had been damaged to the extent that it could no longer be shown, the box containing the reproduction of the torn notes documenting its development was introduced as its replacement. Duchamp himself performed the time-consuming reproduction. Using the boxes, he converted the aspect of disappearance into its opposite: multiplication. Disappearance and multiplication behave in proportional opposition to one another. What is important, however, is that while Duchamp recreates and preserves the work, he pursues a totally different strategy in doing so, a strategy that causes the work to appear in an entirely new form. The ambivalence of visual perception is replaced by the ambivalence of language.

Following the *Green Box*, Duchamp produced the so-called *Boîte-en-Valise / Box in a Case* (ill. p. 114, 115) after 1938. In this work he created and reproduced a portable miniature museum, much like a medieval travelling altar, from items of his own work. All of his important works, including the early paintings, are gathered together in these reproductions. Photographs and miniature versions of the Ready-mades are grouped around a reproduction of *The Large Glass*. And Duchamp himself indicates which works belong to his selection, to his musée imaginaire. The multiplication effect is aimed at the entire work, at the presentation of the whole. Thus Duchamp enables the viewer to see the works he considers important in a kind of exhibition, while paraphrasing his own, now historical œuvre. Through the second act of selection the object transformed into art is nobilised once again: it is confirmed by art as art. Duchamp's enjoyment of this meta-game is evident in his humorous response to his own moustached

Mona Lisa: *L.H.O.O.Q. rasée* of 1965 (ill. p. 10), in which the lady is relieved of her moustache in a fictional act of shaving.

The principle of the box is based upon the tension between presence and absence. As occurs in photography and film, something is made present that is not actually there. In the absence a dimension appears in which the original reality is left behind. In this way Duchamp fills the void between the presumed original and the mere reproduction, whereby the absence of the original and the simultaneous presence of the reproduction create a paradox: a heightening of aura. With absence, thus perceived as a painful loss, Duchamp encourages a view of his objects as fetishes, for the substitutes unavoidably stimulate the viewer to imagine the original. Interest is maintained as long as the presumed original is absent; absence thus becomes an integral part of the concept.

Duchamp's aesthetic criticism is aimed at the perception of art as a system for the representation of reality. His great achievement lies in his abandonment, with the help of his Ready-mades, of traditional depiction and in his emphasis upon the reality of the objects themselves. And all of this goes hand in hand with his disrespect for all of the conventions of art. What appears as art in Duchamp's work is always reality as well, and the same is true in reverse.[12] Additionally, criticism is manifested in an art which questions, so to speak, the conditions governing art itself, the work of the artist and the materials and presentation of art. The extent to which Duchamp can be regarded as a pioneer of a conceptual approach to art, which has endured rather as an attitude than as a style, becomes clear in the realm of expanded art, beginning with Joseph Beuys and continuing through Nouveau Réalisme and Pop Art to Bruce Nauman, Jeff Koons and Rosmarie Trockel. Duchamp has inspired the art landscape with humour, irony and enthusiasm – qualities needed now more than ever before.

1 Marcel Duchamp, cited from Pierre Cabanne, "Gespräche mit Marcel Duchamp", Spiegelschrift 10, Cologne, p. 67 (translation J. Southard).

2 See for example Peter Bürger, Theorie der Avantgarde, Frankfurt a.M., 1974, p. 71 ff.

3 See Thomas Zaunschirm's contribution, "Kunst jenseits der Kunstgattungen: DAS READYMADE" in: Distanz, Dialektik in der modernen Kunst, Bausteine einer Paragone-Philosphie, Vienna, 1982, p. 29–56.

4 Werner Hofmann, Grundlagen der modernen Kunst, Stuttgart, 1978, p. 333.

5 Marcel Duchamp, cited from Pierre Cabanne, op. cit., p. 51 (translation J. Southard).

6 Ibid, p. 109.

7 Ibid, p. 96.

8 Cited from the interview M.D. and Katherine Kuh, in: The Artist's Voice – talks with 17 artists, New York/Evanstown 1992, p. 89.

9 Cited from Francis Roberts, I propose to strain the laws of physics, Interview with Marcel Duchamp, in: Art News, vol. 67, no. 8, New York, Dec. 1968, p. 46–47.

10 Marcel Duchamp cited from Marcel Duchamp, Die Schriften, vol. 1, Serge Stauffer (ed.), Zurich 1994), p. 239 (translation J. Southard).

11 Stefan Germer, "Das Jahrhundertding. Ansätze zu einer Theorie und Geschichte des Multiples", in: Zdenek Felix, Das Jahrhundert des Multiples. Von Duchamp bis zur Gegenwart, Hamburg, Deichtorhallen, 1994, p. 21.

12 See Gottfried Boehm, "Das Werk als Prozeß", in: Willi Oelmüller (ed.), Kolloquium Kunst und Philosophie III, Das Kunstwerk, Paderborn, Munich, Vienna, Zurich, 1983, p. 338.

»DADA UND DEN SURREALISMUS habe ich unterstützt, weil sie hoffnungs-volle Zeichen waren, aber sie besaßen nie genügend Anziehung, um mich voll zu absorbieren. Ich wollte dem Menschen den beschränkten Platz seines Ver-standes aufzeigen, aber Dada wollte den Unverstand dafür einsetzen. Diese Einsetzung war keine große Verbesserung. Sie glaubten viel zu ändern, indem sie ›Un‹ hinzufügten, dem war aber nicht so. Der Surrealismus gab sich ande-ren Dingen hin, Kommunismus, Freud, zum Beispiel. Es war eine Schande. Hier war eine Gruppe gescheiter junger Menschen, die unzufrieden waren und etwas tun wollten. Doch sie verloren ihren Sinn für Freiheit. Sie hätten ihre eigenen Utopien erfinden, ihre eigenen Theorien formulieren sollen, statt die Ideen anderer Leute zu übernehmen. So hätten sie vielleicht etwas getan.«[13]

"I HAVE SUPPORTED Dada and Surrealism because they were hopeful signs, but they never had attraction enough to absorb me. I wished to show man the limited place of his reason, but Dada wanted to substitute unrea-son. The substitution was not a great improvement. By adding 'un,' they thought they changed a great deal, but they had not. Surrealism gave itself to other things, communism, and Freud, for instance. It was a shame. Here was a group of bright young men who were dissatisfied and wished to do something. But they lost their sense of freedom. They should have invented their own utopias, and formulated their own theories instead of taking other people's ideas. Then they might have done something."[13]

»DADA UND DEN SURREALISMUS habe ich unterstützt, weil sie hoffnungs-
volle Zeichen waren, aber sie besaßen nie genügend Anziehung, um mich voll
zu absorbieren. Ich wollte dem Menschen den beschränkten Platz seines Ver-
standes aufzeigen, aber Dada wollte den Unverstand dafür einsetzen. Diese
Einsetzung war keine große Verbesserung. Sie glaubten viel zu ändern, indem
sie ›Un‹ hinzufügten, dem war aber nicht so. Der Surrealismus gab sich ande-
ren Dingen hin, Kommunismus, Freud, zum Beispiel. Es war eine Schande. Hier
war eine Gruppe gescheiter junger Menschen, die unzufrieden waren und
etwas tun wollten. Doch sie verloren ihren Sinn für Freiheit. Sie hätten ihre
eigenen Utopien erfinden, ihre eigenen Theorien formulieren sollen, statt die
Ideen anderer Leute zu übernehmen. So hätten sie vielleicht etwas getan.«[13]

"I HAVE SUPPORTED Dada and Surrealism because they were hopeful
signs, but they never had attraction enough to absorb me. I wished to show
man the limited place of his reason, but Dada wanted to substitute unrea-
son. The substitution was not a great improvement. By adding 'un' they
thought they changed a great deal, but they had not. Surrealism gave itself
to other things, communism, and Freud, for instance. It was a shame. Here
was a group of bright young men who were dissatisfied and wished to
do something. But they lost their sense of freedom. They should have
invented their own utopias, and formulated their own theories instead of
taking other people's ideas. Then they might have done something."[13]

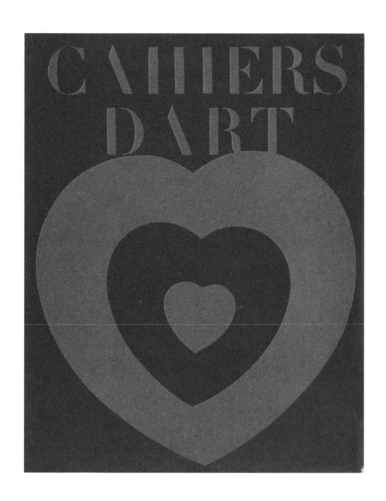

Fluttering Hearts, 1936 / *Flatternde Herzen*

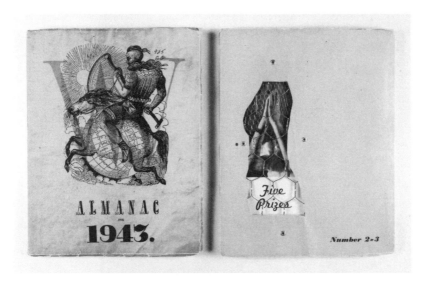

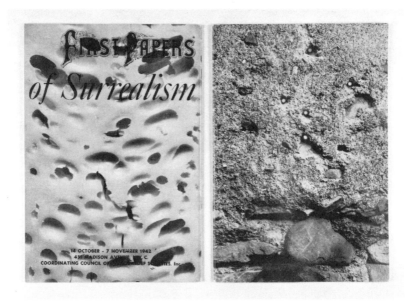

Cover for VVV, Almanac for 1943, No. 2–3, 1943 / *Einband für VVV, Almanach 1943, Nr. 2–3*

Cover for the catalogue First Papers of Surrealism, 1942 / *Einband des Kataloges First Papers of Surrealism*

Cover for the catalogue of the Man Ray Exhibition Objects of My Affection, 1945
Einband des Kataloges der Man Ray Ausstellung Objects of My Affection

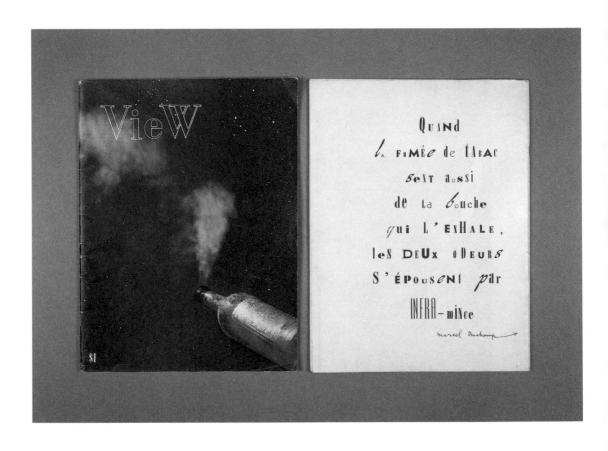

Cover for View, Marcel Duchamp Number, V, No. 1, 1945
Umschlag für View, Ausgabe für Marcel Duchamp, V, Nr. 1

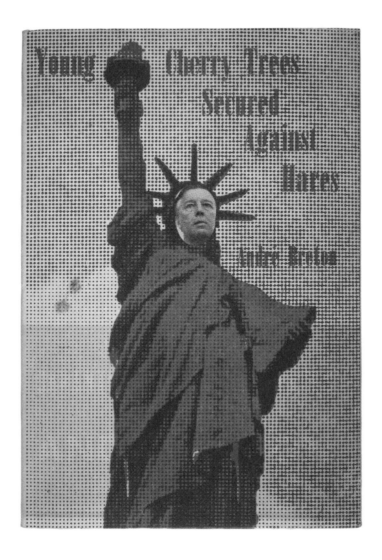

Cover and Jacket for Young Cherry Trees Secured Against Hares by André Breton, 1946
Titel und Umschlag für Young Cherry Trees Secured Against Hares von André Breton

PRIÈRE

DE

TOUCHER

Cover for the catalogue Le Surréalisme en 1947, 1947 / *Umschlag des Kataloges Le Surréalisme en 1947*

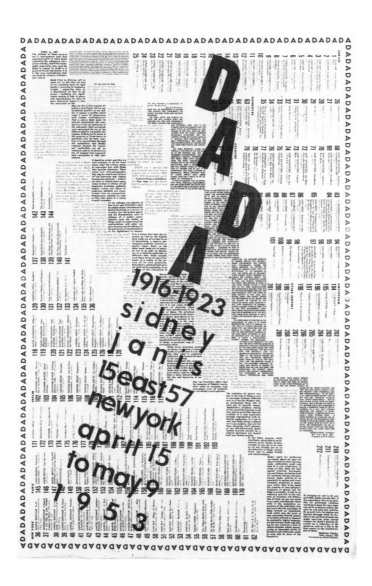

Layout for the catalogue Dada 1916–1923, 1953
Gestaltung für den Dada-Katalog 1916–1923

107

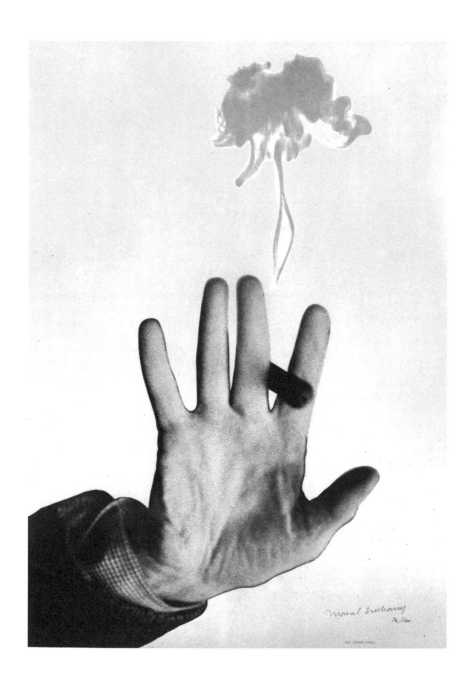

Poster for the exhibition Ready-mades et Editions de et sur Marcel Duchamp, 1967
Plakat der Ausstellung Ready-mades et Edition de et sur Marcel Duchamp

»[...] IN MEINEN NOTIZEN in der Grünen Schachtel erwähnte ich einige [Ready-mades], die gemacht werden konnten. Eines davon ist ... ich nenne es ein reziprokes Ready-made: Sie nehmen ein Bild von Rembrandt und statt es einzurahmen, verwenden Sie es einfach als Bügelbrett. Sie bügeln Ihr kleid dar-auf, also wird es ein reziprokes Ready-made ...«[14]

»BUT IN MY NOTES in the ‚Green Box,' I mentioned some that could be made. One is ... I call it ‚a reciprocal Ready-made.' You take a painting by Rembrandt and, instead of looking at it, you use it plainly as an ironing-board. You, your ... iron your cloth on it, so it becomes a ‚Ready-made reciprocal.'«[14]

»[...] IN MEINEN NOTIZEN in der Grünen Schachtel erwähnte ich einige [Ready-mades], die gemacht werden könnten. Eines davon ist ... ich nenne es ein reziprokes Ready-made: Sie nehmen ein Bild von Rembrandt, und statt es anzusehen, verwenden Sie es einfach als Bügelbrett. Sie bügeln Ihr Kleid darauf, also wird es ein reziprokes Ready-made ...«[14]

"BUT IN MY NOTES in the 'Green Box', I mentioned some that could be made. One is ... I call it 'a reciprocal Ready-made': You take a painting by Rembrandt and, instead of looking at it, you use it plainly as an ironing-board. You, you ... iron your cloth on it, so it becomes a 'Ready-made reciprocal'."[14]

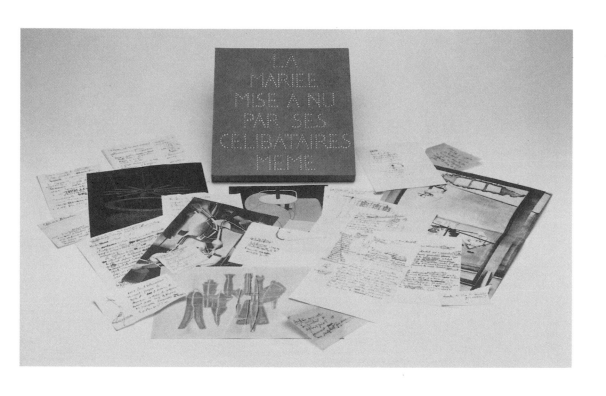

La Mariée mise à nu par ses Célibataires, même, 1934
Die Braut von ihren Junggesellen nackt entblößt, sogar
The Green Box / *Die Grüne Schachtel*

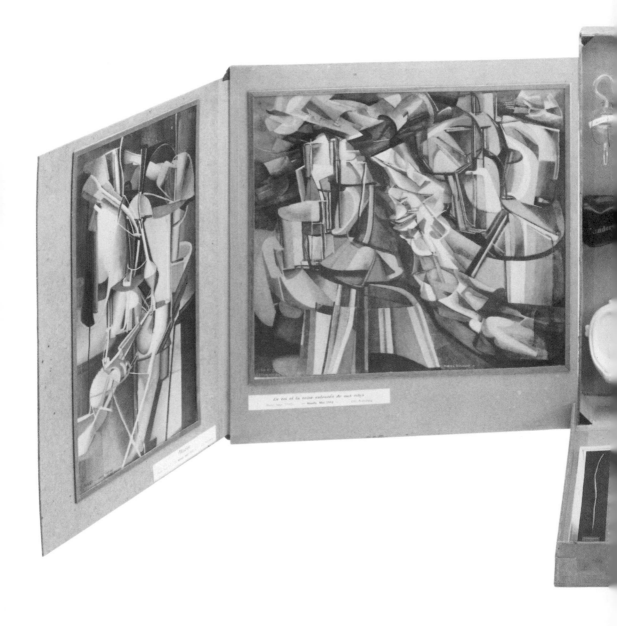

La Boîte-en-Valise, 1941 / *Die Schachtel im Koffer*
de ou par Marcel Duchamp ou Rrose Sélavy / *entweder von Marcel Duchamp oder Rrose Sélavy*

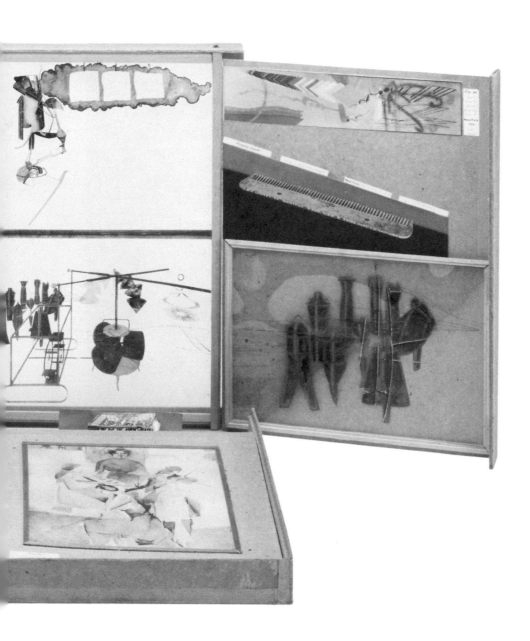

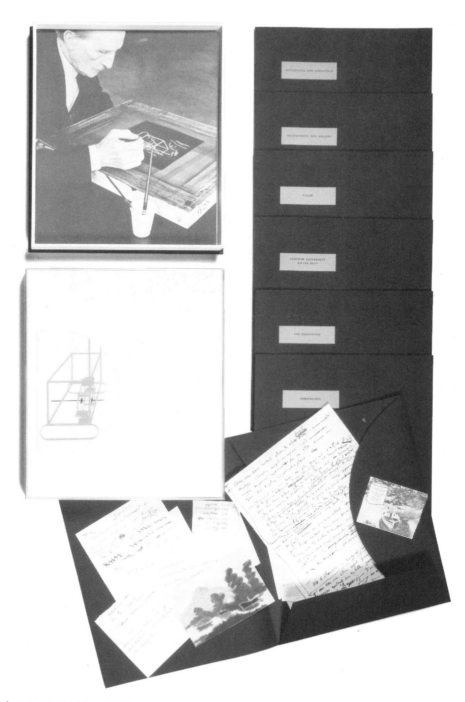

À l'infinitif, 1966 / *Im Infinitiv*
The White Box / *Die Weiße Schachtel*

116

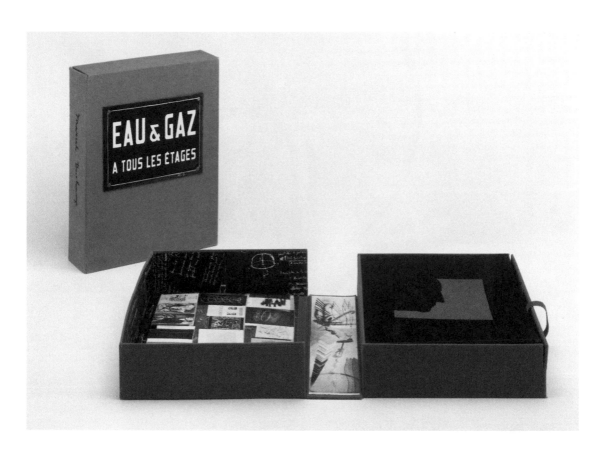

Eau & Gaz à Tous les Étages, 1958 / *Wasser & Gas auf allen Etagen*

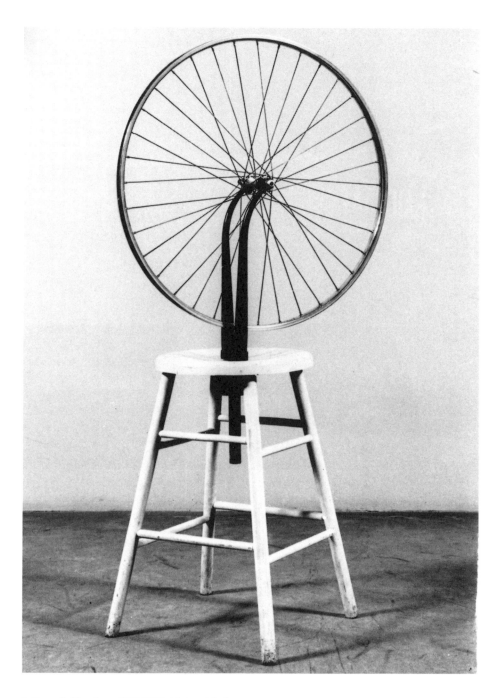

1 Roue de bicyclette, 1913/1951 / *Fahrrad-Rad*
The Museum of Modern Art, New York, The Sidney and Harriet Janis Collection

118

Herbert Molderings

Fahrrad-Rad und Flaschentrockner Marcel Duchamp als Bildhauer*

Marcel Duchamp hat die Kunst des 20. Jahrhunderts in einem Maße geprägt
wie sonst nur noch Pablo Picasso. Ohne sein Werk, so läßt sich mit Fug und
Recht behaupten, wäre der Verlauf der Kunstgeschichte ein anderer gewesen.
Duchamp und Picasso, das sind die beiden Gesichter der janusköpfigen Kunst
unseres Jahrhunderts. Auf der einen Seite ein ganz und gar malerisches Tempe-
rament, ein Virtuose der Hand, der jede bildnerische Ausdrucksform be-
herrschte und sie den visuellen Erfahrungen der modernen Zeit gemäß anzu-
passen wußte. Die künstlerische Tradition der gesamten Menschheitsge-
schichte diente ihm als Vorlage; es gibt kaum eine Stilform, weder der europä-
ischen noch der afrikanischen oder ozeanischen Kunst, die zu verwerten und
zu erneuern Picasso nicht unternommen hätte. Auf der anderen Seite ein intel-
lektueller Künstler, ein Asket, der sich von den Schönheiten der Formen und
Farben des malerischen Handwerks nicht verführen lassen wollte, für den ein
Gemälde oder eine Skulptur in erster Linie keine Aufgabe der Hand, sondern
des Geistes waren. Lebte in Picasso die Leidenschaft des Malers, die Menschen
durch Linien und Farben zu bezaubern, so in Duchamp die Lust des Destruk-
teurs, die sich im Erlebnis des Schocks erfüllte, der Durchbrechung von Kon-
ventionen, der maliziösen Enttäuschung jedweder in die Kunst gesetzten
Erwartungen. Beide suchten den Betrachter zu faszinieren, der eine durch über-
sprudelnde Formphantasie, der andere durch ästhetische Verblüffung. Picasso,
der Sensualist, der der Physis der Malerei und der Skulptur unablässig neue
Wege eröffnete – Duchamp, der Verneiner, der Skeptizist, der für die »Haltung«
in der Kunst (und im Leben) neue Bahnen gebrochen hat. Die für die moderne
Kunstgeschichte folgenreichste Idee im Gesamtwerk Duchamps war zweifellos
das Ready-made. Laut André Bretons Definition im »Wörterbuch des Surrealis-
mus« von 1938 ist das »ein Gebrauchsgegenstand, der durch die bloße Wahl
des Künstlers in den Rang eines Kunstwerks gehoben wird«.[1] Bretons Erklärung
hat sich in ihrer ganzen Simplizität historisch durchgesetzt, und sie leitet das
Verständnis der Ready-mades bis heute. Ihr zufolge werden die Ready-mades
nicht als geistige Sinnbilder, sondern als bloße Vehikel künstlerischer Strate-
gien begriffen, die auf die Subversion der Institution Kunst und die Demontage
auch noch der letzten, für unabänderlich und absolut gehaltenen Kunstkrite-
rien hinauslaufen. Für Bretons verengte Sicht der Ready-mades gibt es hand-
feste geschichtliche Gründe. Darauf will ich im folgenden nicht eingehen.

Stattdessen möchte ich am Beispiel der beiden ersten Ready-mades, des *Fahr-rad-Rads* und des *Flaschentrockners* von 1913 beziehungsweise 1914 demonstrieren, daß es sich bei diesen Objekten nicht um Gags eines sensationslüsternen Künstlers und notorischen »farceur« handelt – davon haben sie natürlich auch etwas –, sondern um moderne Skulpturen.

Gegen die weitverbreitete Deutung, bei den Ready-mades handele es sich um eine Umwandlung von Gebrauchsgegenständen in Kunst durch einen bloß lokalen Tranfer, spricht zweierlei: Erstens gab es 1913 weder eine Theorie noch den Begriff des Ready-mades bei Duchamp. Diese Bezeichnung taucht das erste Mal in New York im Herbst 1915 auf. »Ready-made« bedeutet »gebrauchsfertig«. Das Wort bezeichnet industriell hergestellte Gegenstände, Massenwaren, die der Käufer fertig vorfindet, die also nicht erst auf individuelle Bestellung hergestellt werden. Nach unserem bisherigen Wissensstand benutzte Duchamp diesen Ausdruck zum ersten Mal, als er in New York eine Schneeschaufel zum Erstaunen seiner versammelten Künstlerfreunde mitbrachte und sie durch die Beschriftung »In Advance of the Broken Arm« aus der Masse der übrigen Warenhausartikel heraushob. Zweitens steht dieser Intrepretation die einfache Tatsache entgegen, daß beispielsweise das *Fahrrad-Rad* erst 1951, also 38 Jahre nach seiner Entstehung, zum ersten Mal öffentlich ausgestellt worden ist. Dies geschah im Januar/Februar 1951 in der Ausstellung "Climax in XXth Century Art: 1913–1951" in der New Yorker Sidney Janis Gallery. Das ausgestellte Werk war weder das »Original« von 1913 noch die erste Replik von 1916. Duchamp hatte die früheren Versionen bei Wohnungswechseln von Paris nach New York und zurück von New York nach Paris stets auf den Müll geworfen oder werfen lassen, so daß er nun erneut eine Replik herstellen mußte. Die für die Ausstellung in der Janis-Galerie verfertigte Replik ist die älteste erhaltene Version des *Fahrrad-Rades* (Abb. 1). Sie befindet sich heute in der Kathedrale der modernen Kunst, im New Yorker Museum of Modern Art.[2]

Seitdem uns Duchamps Schriften vorliegen – er hat sie als in Schachteln verpackte Zettelsammlungen veröffentlicht: 1934 die sogenannte *Grüne Schachtel*, 1966 folgte die sogenannte *Weiße Schachtel*[3]; hinzukommen die 1980 von seinem Stiefsohn Paul Matisse posthum publizierten *Notizen*[4] – , können wir die geistige und ästhetische Entwicklung rekonstruieren, die ihn von der Malerei zur Erfindung einer Ready-made-Skulptur geführt hat.

Die ersten beiden Ready-mades, das kopfüber auf einen Küchenschemel montierte *Fahrrad-Rad* von 1913 und der *Flaschentrockner* von 1914 sind das Resultat von Duchamps Ausflügen auf das Gebiet der Skulptur. Als Duchamp Anfang 1913 begann, die Ölmalerei als veraltete, noch dem Mittelalter angehörende Ausdrucksform abzulehnen, fielen alle Gattungsgrenzen für ihn weg. Auf der Suche nach neuen unverbrauchten Ausdrucksformen in der Zei-

chensprache der modernen Zivilisation bewegte er sich ebenso neugierig in die Richtung der sachlichen, emotionslosen »Grafik« des technischen Zeichners wie in die der skulpturalen Ästhetik des industriellen Artefakts. So wie die »mechanische Zeichnung« auf den beiden ca. 2,70 x 1,75 Meter großen Glasplatten mit dem Titel *Die Braut, von ihren Junggesellen nackt entblößt, sogar* die traditionelle Ölmalerei negierte, so radikal verhielten sich die Ready-mades zur Tradition der Skulptur. Wobei die Ready-mades für die Geschichte der modernen Skulptur allerdings weit folgenreicher waren als das *Große Glas* für die der modernen Malerei.

In den hinterlassenen Notizen und Skizzen Duchamps aus den Jahren 1913 bis 1915, die sich alle in der einen oder anderen Weise auf das *Große Glas* beziehen, finden sich zahlreiche Entwürfe für Skulpturen, sowohl in literarischer als auch in zeichnerischer Form. So entwirft er eine »musikalische Skulptur« (»Töne, die von verschiedenen Punkten ausgehen und eine sonore Plastik bilden, welche dauert«)[5] und notiert sich im Zusammenhang mit Überlegungen zum Thema Schwerkraft[6]: »Bild oder Skulptur: Flacher Rezipient aus Glas – alle Arten von gefärbten Flüssigkeiten, Holz-, Eisenstücke, chemische Reaktionen (aufnehmend); den Rezipienten schütteln und in der Durchsicht betrachten.«[7] Die großartigste Idee in diesem Zusammenhang aber ist zweifellos die Skulptur eines *Schwere-Maklers,* auch *Schwere-Pfleger* genannt (Abb. 2). Der Skizze zufolge sollte es sich dabei um eine frei schwingende spiralförmige Metallfeder handeln, die oben in einer kugelförmigen Verdickung endet und sich unten auf einem hockerartigen Sockel erhebt. Duchamp hat diese Skulptur seinerzeit nicht realisiert. Erst mehr als dreißig Jahre später, in der Pariser Ausstellung »Le Surréalisme en 1947«, hat er sie unter tätiger Mithilfe des Malers Roberto Matta in veränderter Form verwirklicht (Abb. 3).[8]

Doch eine dem *Schwere-Pfleger* durchaus verwandte Skulptur, eine Skulptur, der genauso wie für die Metallfeder des *Schwere-Pflegers* ein Hocker als Sockel dient, entstand im Jahre 1913: Es ist dies das erste dreidimensionale Ready-made, eine Fahrradfelge, die kopfüber, mit der Gabel nach unten, und – allem Anschein nach mit einer freien beweglichen Achse in der Vertikalen – auf einen Küchenschemel montiert ist. Es ist offenkundig, daß sich hier die Idee der Bewegung, um deren Darstellung in der Malerei Duchamp sich fast zwei Jahre lang bemüht hatte, in der Form eines dinghaften skulpturalen Aufbaus fortsetzt. Inspiriert von den Ideen des italienischen Futurismus und der Formenwelt der naturwissenschaftlichen Chronofotografie hatte Duchamp in den Jahren 1911 bis 1913 ungefähr ein Dutzend Bilder gemalt, auf denen der Konflikt zwischen den statischen Bildmitteln und dem Wunsch, den Bildgegenstand in Bewegung darzustellen, bis zum äußersten Widerspruch getrieben ist. Die bekanntesten Werke aus dieser Periode sind das kleine Gemälde der *Kaf-*

feemühle von 1911 (Abb. 4) und das großformatige Bild *Akt, eine Treppe herab-*
steigend von 1912. So wie die Chronofotografie einen Bewegungsablauf in eine
ununterbrochene Folge von statischen Momenten (Abb. 5 und 6) oder im Falle
der nach den Fotos angefertigten Diagrammen (Abb. 7) in einen Fächer von
Linien zerlegt, so kann der Fächer der Speichen, den die Fahrradfelge in Ruhe-
stellung bildet, als Momentfoto einer kontinuierlichen Bewegung begriffen
werden. Die Linien der Speichen können jedoch real in Bewegung gesetzt, das
heißt im Bilde der Chronofotografie gesprochen, die Aufeinanderfolge der star-
ren Momente kann in einen filmischen Effekt überführt werden. Tatsächlich
finden sich in Duchamps publizierten beziehungsweise hinterlassenen Schrif-
ten mehrere Notizen, die von einer neuartigen, nämlich skulpturalen Nutzung
kinematografischer Effekte handeln. So heißt es auf einem Zettel in der *Weißen*
Schachtel: »ein Bild oder eine Skulptur machen wie man eine Kino-Film-Spule
aufwickelt« oder auf einem anderen: »versuchen über die plastische Dauer zu
diskutieren« (chercher à discuter sur la durée *plastique*),[9] eine kryptische Bemer-
kung, die Duchamp gegenüber dem Herausgeber der *Weißen Schachtel*, Cleve
Gray, mit den Worten erläuterte: »Ich meine damit Zeit im Raum«[10], also die
Übersetzung von Zeitempfindung in bildnerische Raumerfahrung.

Die Fahrradfelge, mit der Gabel nach unten auf einen Ständer montiert,
ist im Grunde nichts anderes als eine chronofotografische Plastik, in der Spra-
che der Futuristen: eine Skulptur der Bewegung. Und in der Theorie und Praxis
der futuristischen Skulptur lassen sich denn auch die konkreten ästhetischen
Voraussetzungen dieses Werks nachweisen. Robert Lebel, hat in seiner wegwei-
senden Monografie über Marcel Duchamp von 1959 entschieden die Sicht des
Fahrrad-Rades als einer futuristischen Skulptur zurückgewiesen, und die mei-
sten späteren Autoren sind ihm in dieser Bewertung gefolgt: »Er zeichnete das
Rad eines Fahrrads nicht um dessentwillen aus, was ein Futurist an moderner
Schönheit in ihm sehen mochte, er wählte es nur deshalb aus, weil es ›x-belie-
big‹ ist … Verkehrt auf einen Küchenschemel als Sockel montiert, gewinnt es
augenblicklich ein unerwartetes und Spott herausforderndes Aussehen, das es
nur und ganz durch die Wahl erhält. Es verfällt einer fast feierlichen Weihe«.[11]
Wenn aber die futuristische Ästhetik einmal aus dem Weg geräumt ist, dann ist
weit und breit keine bildnerische Tradition in Sicht, auf die Duchamp bei der
Konstruktion der Skulptur mit Fahrradfelge 1913 hätte aufbauen können. Das
Werk muß dem Interpreten dann notgedrungen als ein enigmatischer Akt der
Auswahl erscheinen, als ein absolutes, außerhalb der historischen Zeit und der
konkreten geschichtlichen Erfahrung vollzogenes subjektives Ereignis. Wer die
Fahrradfelge aus diesem Blickwinkel betrachtet, dem erscheint der Künstler mit
magischen Kräften ausgestattet, und so fährt denn Lebel gleich einem antiken
Hierophanten in seiner Beschreibung fort: »Es genügt ihm (Marcel Duchamp),

seinen Stempel den Objekten aufzudrücken, welche allein durch das Auflegen seiner Hände seine Werke werden … Niemals war er der Magie so nahe wie in diesen Fetischen, die er mit offensichtlicher Macht ausstattete, da sie sich mit ihrer ›Weihe‹ eine aufmerksame Kultgemeinde erhalten konnten.«[12] Lebel bewegt sich hier in der Tradition der Fetisch-Deutung der Ready-mades, die die surrealistischen Künstler, allen voran deren Theoretiker André Breton, in den zwanziger und dreißiger Jahren lanciert hatten.

Als Duchamp 1913 das *Fahrrad-Rad* und im Jahr darauf den *Flaschentrockner* »schuf«, gab es weder den Begriff des Ready-mades noch der Objektkunst, noch der Assemblage, noch einen anderen kunstkritischen Fachausdruck für diese Art künstlerischen Vorgehens. In welchen Begriffen also wurden sie gedacht und erdacht? Daß Duchamp diese beiden Objekte nicht rein vorbegrifflich geschaffen hat, sondern sie durchaus zu benennen wußte, beweist ein Brief, den er am 15. Januar 1916 aus New York an seine Schwester Suzanne in Paris richtete. Am 15. Juli des Jahres endete der Mietvertrag für Duchamps Atelier in Neuilly am Stadtrand von Paris. Er schlägt der Schwester vor, das Atelier doch zu übernehmen und schreibt in diesem Zusammenhang: »Wenn du also zu meiner Wohnung gegangen bist, so hast du in meinem Atelier ein Fahrrad-Rad und einen Flaschentrockner gesehen. Ich habe das als eine *sculpture toute faite* (fertig vorgefundene Skulptur, Hervorhebung d. Verf.) gekauft.«[13] Dieser Brief macht deutlich, daß Duchamp die beiden ersten plastischen Ready-mades als Skulpturen begriffen hat. *Fahrrad-Rad* und *Flaschentrockner* konnten 1913/14 in keiner anderen künstlerischen Kategorie konzipiert werden als der der Skulptur. Auch bei der ersten Ausstellung eines Ready-mades, der Präsentation der Schneeschaufel *In Advance of the Broken Arm* und des Schreibmaschinenbezugs »Underwood« in der »Exhibition of Modern Art« der New Yorker Stephan Bourgeois Gallery von April 1916 figurieren sie mit dem Titel »2 Ready-mades« im Katalog in der Abteilung »Skulpturen«.

Diese Hinweise allein sollten genügen, um die künstlerischen Voraussetzungen für diese neuartigen Werke in der avantgardistischen Skulptur von 1913–14 zu suchen.

Was die neuen Materialien in der Skulptur angeht, so waren diese zuerst von Umberto Boccioni lautstark gefordert worden, und zwar bereits 1912. Im *Technischen Manifest der futuristischen Bildhauerkunst* vom 11. April 1912 hatte er proklamiert: »Wir wollen die rein literarische und traditionelle Vornehmheit des Marmors und der Bronze zerstören … Wir behaupten, daß auch zwanzig verschiedene Materialien in einem einzigen Werk zur Erreichung der bildnerischen Emotion verwendet werden können. Wir zählen nur einige davon auf: Glas, Holz, Pappe, Eisen, Zement, Roßhaar, Leder, Stoff, Spiegel, elektrisches Licht usw. usw.«[14] An anderer Stelle heißt es: »Die neue Skulptur wird … die

3 Marcel Duchamp und Roberto Matta
Dem »Soigneur de Gravité« gewidmeter Altar in der Ausstellung »Le surréalisme en 1947«
The altar dedicated to the "Soigneur de Gravité" in the exhibition "Le surréalisme en 1947"
Galerie Maeght, Paris
Foto: Willy Maywald-ADAGP

Übertragung der atmosphärischen Ebenen, die die Dinge binden und durch-
dringen, in Gips, Bronze, Glas, Holz und in jedes beliebige andere Material
sein ...«[15] Die Verwendung »unkünstlerischer«, industrieller Materialien – man
könnte im sozialen Sinne geradezu von proletarischen Materialien sprechen –
würde natürlich unmittelbar Konsequenzen für das Sujet, den Darstellungsin-
halt der Plastiken haben, das sah Boccioni sehr deutlich. Deshalb geht er in die
Offensive und erklärt unmißverständlich, daß »in den geraden Linien eines
Streichholzes, im Rahmen eines Fensters mehr Wahrheit liegt als in den Mus-
kelbündeln, in all den Busen und Schenkeln der Helden und Liebesgöttinnen,
die die Idiotie der modernen Plastik inspirieren«. Aus diesem Grunde »wollen
wir in der Skulptur genau wie in jeder anderen Kunstgattung das traditionell
Erhabene der Sujets abschaffen«.[16]

Es gibt keinen Künstler, der die zentralen Forderungen des *Manifestes der
futuristischen Bildhauerkunst* vor dem Ersten Weltkrieg so radikal erfüllt hat wie
Marcel Duchamp, der bis dahin nur als Maler bekannt geworden war. Was die
ästhetische Emotion des Erhabenen betrifft, die in der Tradition der großen
Skulpturen der Renaissance und des Barock von der zeitgenössischen akademi-
schen Plastik 1913 durchaus noch gefordert wurde, so ließ der Anblick des kopf-
über auf einem Schemel befestigten *Fahrrad-Rades* davon nichts mehr beste-
hen. Kein anderer Künstler hat die aristokratisch-bürgerlichen Ansprüche an
die Skulptur, die aus den ewigen Materialien des Marmors und der Bronze zu
bestehen hatte, so ins Lächerliche gezogen, wie Duchamp mit der Aufrichtung
einer metallischen Fahrradfelge als Skulptur und der eines abgenutzten
Küchenhockers als Sockel. Diese Position war in der damaligen Pariser Kunst-
welt so weit vorgeschoben, daß Duchamp seine »sculpture toute faite« weder
ausstellen, noch auch nur Freunden oder Bekannten aus der Kunstszene in sei-
nem Atelier zeigen konnte. Es ist nicht ein mündlicher oder schriftlicher Hin-
weis überliefert, der besagt, daß irgend jemand diese eigenartige Skulptur in
Paris zwischen 1913 und 1915 gesehen hat. Duchamp selbst war offenbar von
dem Resultat seines Suchens so überrascht, daß er nicht wußte, ob er dieses
eigenartige Ding als Kunstwerk betrachten sollte oder nicht. Unter seinen
nachgelassenen Papieren fand sich ein auf 1913 datierter Zettel mit der perple-
xen Frage:»Kann man Werke schaffen, die nicht ›Kunst‹ sind?« (Peut-on faire
des œuvres qui ne soient pas »d'art«?)[17], eine Frage, die er in einem Interview
fünfzig Jahre später direkt auf das *Fahrrad-Rad* bezog. »1913 hatte ich in mei-
nem Atelier ein Fahrrad-Rad, das sich ohne jeden Grund drehte. Und ich wußte
nicht einmal, ob ich es zu meinen übrigen Werken zählen sollte, ja, ob ich es
überhaupt ein Werk nennen sollte.«[18]

Natürlich ging es in Boccionis Manifest der futuristischen Plastik in erster
Linie um die Darstellung von Bewegung. »In der Skulptur wie in der Malerei

kann man nichts erneuern«, so schreibt er, »wenn man nicht den ›Stil der Bewegung‹ sucht ...«[19] Diesen findet er in der Schönheit bestimmter alltäglicher außerkünstlerischer Erfahrungen. »Wir dürfen nicht vergessen, daß das Tick-Tack und die sich drehenden Zeiger einer Uhr, das Auf und Ab eines Kolbens in einem Zylinder, das Ineinandergreifen von Zahnrädern mit dem ständigen Erscheinen und Verschwinden ihrer stählernen Zähne, daß die Wucht eines Lenkrades oder der Wirbel eines Propellers alles bildnerische und malerische Elemente sind, deren sich eine futuristische Plastik bedienen muß. Das Öffnen und das Schließen eines Ventils schafft einen ebenso schönen, aber unendlich viel neueren Rhythmus als der des Augenlides eines Tieres!«[20] In dieser Gedankenwelt war Duchamp zu Hause. Zahlreiche Notizen aus den Jahren 1912 bis 1915 handeln von dem stakkatohaften Rucken des Zeigers einer Bahnhofsuhr und der Bewegungsmechanik von Verbrennungsmotoren und Zahnradapparaturen, Maschinen, die Duchamp abstrahiert und umgewandelt in seine Entwürfe zu dem großen Glasbild *La Mariée mise à nu par ses Célibataires, même* (Die Braut von ihren Junggesellen nackt entblößt, sogar) integriert hat. Auch das entfunktionalisierte, kopfüber rotierende Fahrrad-Rad gehört werkchronologisch zu jenen kleinen primitiven Rotationsmaschinen, die Duchamp in der unteren Hälfte des Bildes, die die Domäne der Junggesellen darstellt, untergebracht hatte.[21]

Wenn Boccioni in der oben zitierten Passage auf die unvergleichliche Schönheit des Propeller-Wirbels eines Flugzeuges hinweist, so führt uns das unmittelbar zu jener berühmten Anekdote hin, in deren Mittelpunkt erneut Duchamp steht. Im Oktober/November 1912 besuchte Duchamp mit Fernand Léger und Constantin Brancusi den 4. Luftfahrtsalon im Grand Palais. Während des Rundgangs an den neuesten Flugzeugen vorbei blieb Duchamp vor einer der hölzernen Luftschrauben stehen und bemerkte zu dem Bildhauer Brancusi (in dessen Besitz sich natürlich ein Exemplar von Boccionis *Technischem Manifest der futuristischen Bildhauerkunst* vom April des Jahres befand[22]): »Die Malerei ist am Ende. Gibt es etwas Vollendeteres als einen solchen Propeller? Sag, kannst du so etwas machen?«[23] Hier spricht Duchamp zwar nur vom Ende der Malerei, doch ist die Skulptur zweifellos mitgemeint. Auch diese ist am Ende, ja, insofern Duchamp die Frage nach dem Ende der klassischen künstlerischen Ausdrucksmedien hier im Anblick eines skulpturalen Gegenstandes erhebt, läßt sich behaupten, daß er zu diesem Zeitpunkt die Skulptur bereits ebenso im Sinne hatte wie die Malerei. In dieser rhetorischen Frage an den Bildhauer Brancusi im Luftfahrtsalon des Grand Palais vom Spätherst 1912 war bereits der Keim zur »sculpture toute faite« des *Fahrrad-Rades* ein Jahr später, zum Ready-made also, angelegt.

Sich auf die Alltagserfahrungen in einer modernen industriellen und

technischen Zivilisation berufend, hatte Boccioni im *Manifest der futuristischen Bildhauerkunst* unter Punkt 3 seiner Schlußfolgerungen schließlich auch die Einführung der realen Bewegung in die traditionell statische Plastik angekündigt. »Wenn wir also die Körper und ihre Teile als bildnerische Zonen ansehen, werden wir in einer futuristischen plastischen Komposition für einen Gegenstand Flächen aus *Holz oder Metall* [verwenden], die unbeweglich *oder mechanisch beweglich sein können*.« (Hervorhebung d. Verf.)[24] In diesem Text vom 11. April 1912 wird zum ersten Mal in der Kunst des 20. Jahrhunderts eine real bewegliche Skulptur konzipiert. Aber realisiert hat diese nicht Boccioni, sondern Marcel Duchamp. Er schuf mit der Konstruktion aus Fahrradfelge und Küchenschemel die erste real bewegliche futuristische Plastik. Er hatte keine Scheu, aus den radikalsten ästhetischen Gedanken seiner Zeit die äußersten praktischen Schlußfolgerungen zu ziehen. Die Fahrradfelge auf dem Küchenschemel entsprach geradezu buchstäblich der von Boccioni in seinem Manifest beschriebenen Skulptur aus »Holz und Metall«, deren Teile »mechanisch beweglich sein können«.

Boccioni selbst arbeitete in den Jahren 1912 und 1913 zunächst weiter in Gips und Bronze und blieb damit weit hinter seinen eigenen Ideen zurück. Eine erste große Ausstellung seiner Skulpturen fand im Juni–Juli 1913 in der Pariser Galerie La Boétie statt. Dort konnte Duchamp Skulpturen wie *Entfaltung einer Flasche im Raum*, 1912, und *Urformen der Bewegung im Raum*, 1913, sehen, beides Plastiken in den von Boccioni theoretisch als veraltet abgelehnten Materialien Gips und Bronze. Während es sich bei der *Entfaltung einer Flasche im Raum* um die Übersetzung eines kubistischen Flaschenstillebens in die dritte Dimension handelt, nehmen die *Urformen der Bewegung im Raum* das Thema der Rodinschen Skulptur des *Schreitenden Mannes* von 1877 wieder auf, deren Oberflächen quasi aufgerissen sind. Wie die Bildwerke Rodins fordern die Skulpturen Boccionis den Betrachter auf, sich selbst zu bewegen, das heißt, um die Skulptur herumzugehen. Besonders deutlich wird das im Anblick der sich spiralförmig drehenden Oberflächen von *Entfaltung einer Flasche im Raum*. In diesem Zusammenhang ist eine Bemerkung Duchamps zum *Fahrrad-Rad* aufschlußreich, die er 1955 als mögliche »Erklärung« seiner mittlerweile mehr als dreißig Jahre zurückliegenden skulpturalen Konstruktion vorbrachte: »Ich habe damals wahrscheinlich die Bewegung des Rades mit viel Freude als eine Art Gegenmittel gegen die gewöhnliche Bewegung des Individuums um den betrachteten Gegenstand akzeptiert«, antwortete er auf die Frage nach der Grundidee dieses Werks.[25]

Die revolutionären Form- und Materialfragen des futuristischen Manifests der Skulptur waren im Jahr 1913 in Duchamps unmittelbarer Umgebung geradezu täglich präsent, und zwar in der Arbeit seines um elf Jahre älteren

Bruders, des Bildhauers Raymond Duchamp-Villon.[26] Dieser hatte im Sommer 1912 in Paris die Bekanntschaft Boccionis gemacht und sich ganz den Ideen seines italienischen Kollegen verschrieben. 1914 schuf er sein skulpturales Meisterwerk, das sogenannte *Große Pferd* (Musée National d'art moderne, Centre Georges Pompidou, Paris), eine nach einem Gipsmodell in Bronze gegossene Plastik. Indem diese Skulptur die Dynamik eines Pferdes nicht impressionistisch als Ablauf von Bewegung, sondern als Potential, als stillgestellte, jedoch zum äußersten angespannte Möglichkeit, materialisiert, indem sie mechanische und anatomische Formen des Pferdekörpers sich durchdringen läßt und ihn zugleich von innen heraus gestaltet, übersetzt sie genau jene Forderungen, die Boccioni in seinem Manifest an die skulpturale Realisierung eines »Stils der Bewegung« gestellt hatte: »Eine futuristische plastische Komposition wird die modernen technischen Gegenstände in die Darstellung integrieren ... So kann aus der Achselhöhle eines Mechanikers das Rad eines Triebwerkes hervorragen...«[27] Bei der Skulptur des *Großen Pferdes* ragen aus den Muskelsträngen des Pferdes die Treibräder und die Pleuelstange einer Lokomotive hervor. »Reißen wir die Figur auf und schließen wir die Umwelt in sie hinein«, hatte Boccioni proklamiert. Eben dies hatte Raymond Duchamp-Villon mit dieser Plastik verwirklicht und damit die berühmteste futuristische Skulptur in der modernen französischen Kunstgeschichte hervorgebracht. Was das Material betrifft, so blieb er ebenso wie sein Vorbild Boccioni hinter den theoretischen Ansprüchen des Futurismus zurück und verwendete weiterhin die als vornehm und »idiotisch« denunzierten Stoffe Gips und Bronze.

Ob Marcel Duchamp vor seiner Übersiedlung nach New York möglicherweise je Boccionis Skulptur *Dynamik eines Rennpferdes und eines Hauses* von 1914/15 (Sammlung Peggy Guggenheim, Venedig) oder Vorarbeiten aus dem Umfeld dieser Skulptur zu Gesicht bekommen hat, wissen wir nicht. Bei der Verfertigung dieses Werks hatte Boccioni zum ersten Mal jene neuen Materialien eingesetzt, deren Verwendung er im *Technischen Manifest der futuristischen Bildhauerzunft* 1912 eingefordert hatte: Holz, Kupfer und mit Öl- und Gouachefarben bemaltes Eisenblech. Was die materialästhetischen Voraussetzungen der Skulptur aus Fahrradfelge und Holzschemel betrifft, so waren sie zumindest theoretisch seit Boccionis Manifest von April 1912 in allen Einzelheiten gegeben. Man wird davon ausgehen dürfen, daß sie seinerzeit den Inhalt für manche Debatte zwischen dem jungen Marcel Duchamp und den Bildhauern Brancusi und Duchamp-Villon abgegeben haben, wie allein schon die Anekdote anläßlich des gemeinsamen Besuchs des »Salon de la locomotion aérienne« in jenem Jahr nahelegt. Doch nicht nur in der Beschreibung, sondern auch praktisch-künstlerisch gab es 1913 in Paris bereits Skulpturen, die aus Eisenblech und Draht gefertigt waren. Ihr Autor war Pablo Picasso, der seit 1912

derartige Assemblagen hergestellt hatte.[28] Diese wurden zwar seinerzeit nicht öffentlich ausgestellt, doch wird Duchamp von diesen Werken über Guillaume Apollinaire, mit dem er seit dem Herbst 1912 eng vertraut war, ausreichend Kenntnis gehabt haben. Apollinaire, mit Picasso befreundet und ein ständiger Besucher in dessen Atelier, hat in seinen Kritiken von 1912/13 fast jeden neuen Schritt in Picassos Kunst sofort veröffentlicht und ausführlich kommentiert.[29]

Nun wäre es außergewöhnlich, wenn Marcel Duchamp, dessen ästhetisches Interesse so sehr darauf gerichtet war, »die Kunst wieder in den Dienst des Geistes zu stellen«,[30] bei der Skulptur mit Fahrradfelge allein die retinalen Erfahrungen der Bewegung des *Fahrrad-Rades* und der Schönheit primitiver Materialien im Auge gehabt hätte. Auch was Duchamps damals sich ausbildende Überzeugung angeht, daß die Kunst nicht nur eine abstrakte Konstruktion von Formen und Farben, Raum und Volumen, Massen und Oberflächen zu sein, sondern Ideen auszudrücken habe, stand ihm die theoretisch-naturwissenschaftliche Ausrichtung des Futurismus näher als der pragmatische Kubismus eines Picasso oder Braque. In diesem Zusammenhang sei ein letztes Mal auf ein zentrales Postulat des *Technischen Manifests der futuristischen Bildhauerkunst* verwiesen. »Eine futuristische plastische Komposition«, hatte Boccioni geschrieben, »wird die wunderbaren mathematischen und geometrischen Elemente einschließen, aus denen die Gegenstände unserer Zeit gebildet sind.«[31] Das *Fahrrad-Rad* war genau ein derartiger Gegenstand, und wir finden unter Duchamps Notizen von 1913/14 zahlreiche mathematische und geometrische Spekulationen, die mit dessen skulpturaler Verwendung in Verbindung stehen könnten. Sie handeln meist von der Erzeugung geometrischer Formen durch Rotation, mithin einem altbekannten Prinzip geometrischen Denkens. Der Erscheinung des Rades auf dem Küchenschemel kommt eine zwei Seiten lange Notiz aus der *Grünen Schachtel* am nächsten, in der in einer verklausulierten Diktion davon die Rede ist, daß, so wie bei der Rotation von Linien um eine Achse die Unterscheidung in rechts und links ihre Bedeutung verliert, in einem vierdimensionalen Kontinuum die Kategorien innen und außen austauschbar werden (Abb. 8). Eine kleine Skizze auf der Vorderseite des Notizblattes stellt eine Situation dar, die dem *Fahrrad-Rad* durchaus vergleichbar ist: die Erzeugung eines Kreises durch die Rotation einer Geraden. Die vollständige Notiz lautet in der Übersetzung von Serge Stauffer: »Rechts und links werden erhalten, indem man einen Anflug von Persistenz in der Situation hinter sich nachschleppt. Dieses symmetrische Einrichten der beidseitig der vertikalen Achse verteilten Situation ist nur gültig praktisch (als rechts verschieden von links) als Rückstand von Erfahrungen auf äußeren Fixpunkten. Und im Gegenteil: die vertikale Achse, für sich betrachtet, die um sich selber rotiert, eine rechtwinklige Erzeugende z. B. (hier folgt die kleine Skizze mit der Definition der Achse

130

4 Moulin à café, 1911 / *Kaffeemühle*
Sammlung Mrs. Robin Jones, Rio de Janeiro

131

und der Drehrichtungspfeile A und B, Anm. d. Verf.) wird stets einen Kreis determinieren in den 2 Fällen 1. sich drehend in der Richtung A, 2. Richtung B. – Also, wenn es noch möglich wäre, im Falle der vertikalen Achse in Ruhe, für die erzeugende G 2 entgegengesetzte Richtungen in Betracht zu ziehen, kann die erzeugte Figur (wie immer sie auch sei) nicht mehr als links oder rechts der Achse bezeichnet werden. – In dem Maße, als man weniger unterscheidet zwischen Achse und Achse, das heißt, in dem Maße, als sämtliche Achsen im Vertikalitätsgrau verschwinden, nehmen Vorder- und Rückseite, Revers und Avers eine zirkuläre Bedeutung an; rechts und links, als die 4 Arme der Vorder- und Rückseite, resorbieren sich längs der Vertikalen. – Innen und außen (für Ausdehnung 4[32]) können eine ähnliche Identifikation erhalten, aber die Achse ist nicht mehr vertikal und hat keine unidimensionale Apparenz mehr.«[33] Die poetische Wendung des »Vertikalitätsgrau«, in dem laut Duchamp die im Ruhezustand getrennten Achsen oder Geraden verschwinden, sobald sie in Rotation versetzt sind, beschreibt sehr anschaulich das Bild eines sich rasch drehenden Fahrrad-Rades, dessen Speichen eben jene halb transparente, halb opake graue Fläche erzeugen, vor der es einem Beobachter schwerfällt, eindeutig zwischen Vorder- und Rückseite zu unterscheiden. Dennoch möchte ich diese Notiz hier keineswegs als eine Art Konstruktionsanleitung oder gar »Erklärung« dieses ersten Ready-mades heranziehen. Sie bildet lediglich *ein* Element unter mehreren zur Beschreibung jenes imaginativen Energiefeldes, in dem eine »sculpture toute faite« wie die Fahrradfelge auf einem Ständer, die weder rein begrifflich noch rein sinnbildlich zu erklären ist, denkbar, also möglich geworden ist.

Ein jeder weiß aus eigener Anschauung, daß die Rotation der Linien, sprich der Speichen, das Bild einer kreisförmigen Fläche erzeugt. Würde man die kreisförmige Fläche, die Fahrradfelge also, schnell um die freie vertikale Achse rotieren lassen, entstünde das Bild eines dreidimensionalen Volumens, einer Kugel. Soweit befinden wir uns noch ganz auf dem sicheren Boden einer durch Experiment überprüfbaren Geometrie. Duchamp greift diesen Gedanken jedoch in einem völlig spekulativen Kontext auf: im Zusammenhang der Frage nämlich, wie sich die räumliche Ausdehnung einer zwar unsichtbaren, mathematisch aber vollkommen denkbaren vierdimensionalen Wirklichkeit wohl sichtbar machen lassen könnte.

Die Frage der Visualisierung des vierdimensionalen Hyperraums war die zentrale Frage, um die die Mehrzahl seiner Notizen und Texte aus den Jahren 1913 bis 1915 sich drehen. Darauf bildnerische Antworten zu finden, sowohl materialmäßig als auch in grafischer Hinsicht, war der Mittelpunkt seiner Entwürfe zu dem Glasbild *Die Braut von ihren Junggesellen nackt entblößt, sogar,* handelte es sich dabei doch um die Darstellung einer unsichtbaren, aber durch-

aus möglichen Realität, um das Bild eines Schnittes durch eine vierdimensionale Welt.

Die Rotation einer Linie erzeugt eine Fläche, die einer zweidimensionalen Fläche einen dreidimensionalen Körper. Die Rotation eines dreidimensionalen Körpers, fährt Duchamp auf dem Wege der Analogie fort, muß somit ein vierdimensionales Kontinuum, in Duchamps Sprache »die Ausdehnung 4«, erzeugen. Die Linie ist, sobald man den Gedanken der Rotation einführt, eine virtuelle Fläche, die Fläche ein virtueller Körper, der Körper eine virtuelle vierdimensionale Ausdehnung. Wie aber soll man sich deren räumliche Erstreckung vorstellen, insbesondere, wie ließe sich diese künstlerisch sichtbar machen? Wollte man Duchamps pseudowissenschaftliches, aber dennoch streng analoges Denken auf das Objekt des *Fahrrad-Rades* anwenden, so ließe sich folgende Behauptung aufstellen: So wie die Chronofotografie oder das danach gezeichnete Diagramm die Bewegung dreidimensionaler Gegenstände in eine Folge von Linien auf einer Fläche übersetzen, so kann das sich drehende *Fahrrad-Rad* als eine Art dreidimensionale Chronofotografie der Bewegung eines unsichtbaren vierdimensionalen Gegenstandes angesehen werden.[34]

Daß die Konstruktion eines Fahrrad-Rades im Jahre 1913 nicht nur von Marcel Duchamp, sondern ebenso von der berühmtesten Pariser Futuristin, von Valentine de Saint-Point[35], mit Spekulationen über die Struktur des vierdimensionalen Raums in Verbindung gebracht worden ist, hat soeben Gladys Fabre in ihrer Studie über den literarischen Kreis der Abbaye de Creteil nachgewiesen[36], zu dem Duchamp vielfältige Beziehungen unterhielt.[37] 1912 publizierte Gaston de Pawlowski den Roman *Le voyage au pays de la quatrième dimension*, eine Mischung aus populärwissenschaftlicher Dimensionstheorie und Science fiction. Vorabdrucke daraus waren bereits seit 1908 in der Zeitschrift »Comœdia« erschienen, und Marcel Duchamp hat nicht nur zu ihren interessierten Lesern gehört, sondern darin nachweislich zahlreiche Inspirationsquellen für sein *Großes Glas – Die Braut, von ihren Junggesellen nackt entblößt, sogar* gefunden.[38] In einer Rezension des Romans in der Zeitschrift »Montjoie« vom 14. April des Jahres lobt Valentine de Saint-Point die »Verschmelzung des modernen Szientismus mit dem zeitlosen Idealismus« als äußerst aktuell, und beschreibt den Aufbau der *Reise in das Land der Vierten Dimension* mit folgenden Worten: »Die Konstruktion des Werks an sich ist bereits originell. Es ist aufgebaut wie ein Rad, mit einer Nabe, mit Speichen und einer Felge und nicht deduktiv, wie das gewöhnlich der Fall ist. Die Nabe ist die Idee der Einheit von Zeit und Raum, dies ist der zentrale Begriff der vierten Dimension, die Speichen sind die mannigfaltigen Wege, die sich logisch alle auf der gleichen Ebene bewegen *und hinauslaufen auf das bislang unerforschte Unbekannte*, der Felge dieses idealen Rades« (Hervorhebung d. Verf.).[39] Wir wissen nicht, in welchem

Monat Duchamp die »sculpture toute faite« des *Fahrrad-Rades* montiert hat – in Wirklichkeit ist sie ja nicht »toute faite«, denn schließlich mußte das Rad erst einmal kopfüber mit einem Schemel, einem klassischen Sockel also, kombiniert werden –, doch ist es durchaus denkbar, daß die von Valentine de Saint-Point beschriebene Analogie zwischen dem Aufbau des Fahrrad-Rades und dem Roman Pawlowskis in den Prozeß ihrer Entstehung damals eingegangen ist.

Hier ist es nun an der Zeit, die Definition des *Fahrrad-Rades* als einer futuristischen Skulptur einzuschränken. Denn anders als Marcel Duchamp kennt der Futurist weder Humor noch Ironie. Wenn Duchamp mit Boccioni darin übereinstimmte, das Erhabene der traditionellen Sujets der Skulptur abzuschaffen, so trennte ihn von seinem italienischen Kollegen dessen emphatische Bewunderung der modernen Technik. Statt der Glorifizierung von Bewegung, Maschinenrhythmik und Naturwissenschaften in Boccionis Plastiken treffen wir bei der Skulptur mit Fahrradfelge auf eine ironische und humorvolle, kurz: eine »pataphysische« Auseinandersetzung mit den geometrischen und mathematischen Ideen, die den modernen industriellen Artefakten zugrunde liegen. Einflüsse von Alfred Jarrys 1911 mit der Erzählung *Gestes et Opinions du Docteur Faustroll* publizierter »Pataphysik« lassen sich im Œuvre Duchamps seit 1913 nachweisen. »Die Pataphysik«, so lautete die Definition Jarrys, »ist die Wissenschaft imaginärer Lösungen, die den Grundmustern die Eigenschaften der Objekte, wie sie durch ihre Wirkung (virtualité, Anm. d. Verf.) beschrieben werden, symbolisch zuordnet.«[40] Die Hauptfigur der Erzählung, Dr. Faustroll, eine Karikatur des modernen Naturwissenschaftlers, nimmt – nicht anders als Duchamp in seinen Notizen zum *Großen Glas* und zu den ersten »sculptures toutes faites« von 1913 bis 1915 – wiederholt geometrische Überlegungen über virtuelle Volumen und Liniendiagramme zum Ausgangspunkt, um zur Erkenntnis dessen zu gelangen, was er die unbekannte Dimension des Universums nennt. Jarrys Definition der Physik neuen Typs enthält bei allem Nonsens einige rationale Elemente, eine Mischung, die charakteristisch ist sowohl für Jarrys als auch Duchamps Umgang mit dem naturwissenschaftlichen Weltbild. Es handelt sich dabei nie nur um dessen absolute Ablehnung und den Übergang in den Irrationalismus, vielmehr um den Versuch ihrer Poetisierung durch Humor und Ironie. Die Gegenstände sind gemäß der Definition der Pataphysik stets nie nur sie selbst, sondern zugleich als Möglichkeit eines anderen zu betrachten, das nicht unmittelbar sichtbar ist. Die Aufgabe der Pataphysik soll darin bestehen, den »linéaments«, einem Muster von Linien, die Eigenschaften der imaginierten Objekte symbolisch zuzuordnen. Betrachtet man das *Fahrrad-Rad* auf dem Küchenschemel vor dem Hintergrund dieser Definition und der mit ihm korrespondierenden hinterlassenen Notizen Duchamps, so kann dieses Werk als eine »pataphysische Plastik« angesprochen

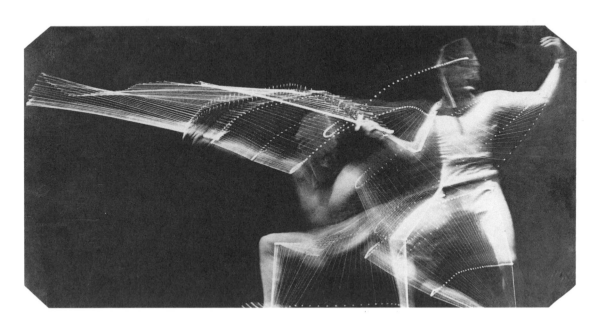

5 Étienne-Jules Marey
Chronofotografie eines Fechters, um 1890 / *Chronophotograph of a Fencer*
Sammlung Thomas Walther, New York

werden, deren Ästhetik die Schönheit der Bewegung ist und deren »Thema« das von Valentine de Saint-Point evozierte »unerforschte Unbekannte« ist.

Können wir aus den hinterlassenen Notizen Duchamps in der *Grünen* und der *Weißen Schachtel* das spekulative, »vierdimensionale« Assoziationsfeld rekonstruieren, in dem sich diese merkwürdige Skulptur materialisierte, so verdanken wir der Niederschrift eines Gesprächs von Duchamp mit Arturo Schwarz einen Hinweis auf sein spezifisch ästhetisches Interesse an ihr. »Das Fahrrad-Rad hatte noch sehr wenig mit der Idee des Ready-mades zu tun«, heißt es da. »Es hatte eher etwas mit der Idee des Zufalls zu tun. In gewisser Weise handelte es sich darum, die Dinge einfach laufen zu lassen und eine Art schöpferischer Atmosphäre im Atelier zu haben oder in dem Apartement, in dem man lebt. Wahrscheinlich damit diese ihnen hilft, auf Ideen zu kommen. Zu sehen, wie dieses Rad sich drehte, war sehr beruhigend, sehr tröstlich, in gewisser Hinsicht ein Sich-Öffnen zu anderen Dingen als den materiellen des täglichen Lebens. Ich mochte die Idee, ein Fahrrad-Rad in meinem Atelier zu haben. Ich genoß es, es anzuschauen, genauso wie ich es genieße, die tanzenden Flammen im Kaminfeuer zu betrachten. Es war, als ob ich einen offenen Kamin in meinem Atelier hätte, die Bewegung des Rades erinnerte mich an die tanzenden Flammen in einem Kamin.«[41] (Abb. 9) »To see that wheel turning was very soothing ..., a sort of opening of *avenues on other things than material life of everyday*« (Hervorhebung d. Verf.) evoziert unmittelbar den Satz der Valentine de Saint-Point in ihrer Eloge auf Pawlowskis *Reise ins Land der Vierten Dimension,* wo von den Speichen als den »Wegen« die Rede ist, die im »bislang unerforschten Unbekannten enden« (»les voies ..., qui aboutissent à l'Inconnu inexploré«).

Den Vergleich des sich drehenden Rades mit der Bewegung von Flammen in einem offenen Kamin hat Duchamp in fast allen seinen Äußerungen zum *Fahrrad-Rad* zwischen 1955 und 1967 wiederholt,[42] und er unterstrich damit die meditative und kontemplative Funktion, die diese Skulptur bei all ihrer Radikalität für ihn besaß. Sie unterscheidet sich darin keineswegs von bestimmten traditionellen Kunstwerken der Malerei oder der Plastik, waren doch auch diese stets Gegenstände der Meditation und der Kontemplation. Die ästhetische Erfahrung Duchamps, der diese erste »sculpture toute faite« sich verdankte: Die beruhigende, die Gedanken von allem unmittelbar Praktischen lösende Wahrnehmungsweise der kreisenden Bewegung des Rades war also das gerade Gegenteil der schockierenden und provokativen Wirkung, die Robert Lebel als angebliche Intention Duchamps für diesen Gegenstand behauptet hat. Die absichtslose Bewegung des Rades war ein idealer Anblick, um die Gedanken schweifen zu lassen, eine Erfahrung, die natürlich an die individuelle Begegnung mit dieser Skulptur in der Abgeschlossenheit des Ateliers oder

136

der Wohnung gebunden ist. In der lauten Öffentlichkeit des Museums Ludwig oder des Centre Georges Pompidou kann sich diese heute nicht mehr einstellen. Es scheint dieses ureigene ästhetische Erlebnis gewesen zu sein, daß Duchamp an dieser skulpturalen Konstruktion am meisten geschätzt hat, denn ebenso, wie er das *Fahrrad-Rad* bei jedem Wohnungswechsel auf den Müll geworfen hat, ebenso hat er es in jedem neuen Atelier stets wieder aufgebaut. Es ist keine Wohnung und kein Atelier Duchamps bekannt, in dem er diesen künstlerischen Kamin-Ersatz nicht aufgebaut hätte.

Die zweite »fertig vorgefundene Skulptur«, von der Duchamp in dem oben erwähnten Brief an seine Schwester Suzanne von Januar 1916 spricht, ist ein Flaschentrockner, ein damals von fast jeder französischen Familie benutzter Haushaltsgegenstand aus galvanisiertem Eisen. Duchamp hatte ihn 1914 in dem großen Pariser Warenhaus »Bazar de l'Hotel de Ville« gekauft, wo bis heute ähnliche in der Haushaltswarenabteilung angeboten werden.

Während die kopfüber auf den Küchenschemel montierte Fahrradfelge von 1913 noch eine »skulpturale Konstruktion« war, eine Zusammenfügung von zwei vorgefundenen plastischen Elementen, ist der *Flaschentrockner* ein völlig unverändertes industrielles Artefakt, das erste dreidimensionale Readymade im Werk Duchamps, oder, wie es der Künstler zum Zeitpunkt der Entstehung benannte: die erste »sculpture toute faite« im eigentlichen Wortsinn.

Wie die futuristisch inspirierte, pataphysische Plastik des auf den Kopf gestellten *Fahrrad-Rades* hatte auch der *Flaschentrockner* ursprünglich keinen literarischen Titel. Die Inschrift als charakterischer Bestandteil eines Readymades kommt im Werk Duchamps erst zwei Jahre später in New York ins Spiel.[43] Es waren also keine literarischen Ideen, die ihn ursprünglich zur Auswahl dieses Objekts veranlaßt hatten, sondern bildnerisch-formale, also ästhetische Überlegungen. Der *Flaschentrockner* erschien ihm als eine ganz und gar vollendete Skulptur, der nichts mehr hinzuzufügen war. In der Tat kann man diesem stacheligen Objekt eine bizarre Schönheit nicht absprechen, so daß die Behauptung des amerikanischen Malers Robert Motherwell, der *Flaschentrockner* »besäße eine schönere Form als alles, was 1914 an Skulptur gemacht worden sei«, nicht ganz von der Hand zu weisen ist.[44]

Will man sich den ästhetischen Überlegungen nähern, die Duchamps Faszination von diesem Objekt 1914 geweckt haben, so wird man auf das einzige authentische historische Dokument des *Flaschentrockners* zurückgreifen müssen, das überliefert ist, auf die von Duchamp selbst mit großem Arbeitsaufwand vorbereitete Reproduktion, die er Ende 1936 für seinen Œuvrekatalog *La Boîte-en-Valise* herstellen ließ (Abb. 10). Die Skulptur erscheint auf diesem Bild ohne Standfläche, ohne Aufhängung, unter Vermeidung jedes raumdefinierenden Details. Auch mit Hilfe des prägnanten Schlagschattens ist die unge-

fähre Lage des Körpers im Raum nicht zu orten. Der Schatten erweist sich bei genauerer Betrachtung als falsch. Er ist die mit Hilfe einer Schablone gedruckte, direkte Wiederholung der Figur des Flaschenständers, die um einige Zentimeter nach unten versetzt ist (Abb. 11). Die dadurch herbeigeführte Verwirrrung der räumlichen Wahrnehmung provoziert unweigerlich die Frage: Was ist hier Schatten, was ist Abbild? Ist der dunkle Flaschentrockner der Schlagschatten des hellen, oder ist der helle die Projektion des dunklen?

Erneut, wie bereits im Falle der skulpturalen Konstruktion mit Fahrradfelge, ist es die Idee eines unsichtbaren Hyperraums, die am Ursprung dieser »sculpture toute faite« steht. Bei seinen Spekulationen über die visuellen Darstellungsmöglichkeiten einer hypothetischen Welt in der 4. Dimension bezieht sich Duchamp ausdrücklich auf die Dimensionstheorie des damals populärsten französischen Mathematikers, Henri Poincaré.[45] Dieser hatte in seinem klassischem Werk *Der Wert der Wissenschaft* von 1905 die Bestimmung der Anzahl von Dimensionen eines Kontinuums auf den Begriff des Schnittes gegründet. »Um den Raum zu teilen, braucht man Schnitte, die man Flächen nennt; um die Flächen zu teilen, braucht man Schnitte, die man Linien nennt; um die Linien zu teilen, braucht man Schnitte, die man Punkte nennt; man kann nicht weitergehen, und ein Punkt kann nicht geteilt werden.«[46] Poincaré erkannte den Vorteil dieser neuen Definition darin, daß sie »nicht nur auf den Raum anwendbar ist; wir finden bei allem, was unsere Sinne wahrnehmen, die charakteristischen Eigenschaften des physischen Kontinuums wieder, und es wäre überall die gleiche Einteilung erlaubt; auch könnte man leicht Beispiele von Kontinuen finden, die im Sinne der vorhergehenden Definition vier oder fünf Dimensionen haben; diese Beispiele bieten sich dem Geiste von selbst.«[47] Duchamp übernahm Poincarés Definition der Dimensionen als Schnitte und entwickelte sie nach allen möglichen Seiten, um eine Antwort auf die Frage zu erhalten: Wenn der dreidimensionale Raum ein Schnitt durch ein vierdimensionales Kontinuum ist, wie ist dann diese vierdimensionale Welt künstlerisch darstellbar? Daß ihre Darstellung nicht nur möglich, sondern sogar eine Leichtigkeit sein sollte, hatte der berühmte Mathematiker bereits 1902 in *Wissenschaft und Hypothese* behauptet. »So wie man auf einer Leinwand die Perspektive einer dreidimensionalen Figur zeichnen kann, so kann man auch die Perspektive einer vierdimensionalen Figur auf eine drei- (oder zwei-) dimensionale Leinwand zeichnen. Das ist für den Geometer nur ein leichtes Spiel.«[48] Obwohl ein leichtes Spiel, hat Poincaré selbst es nie praktiziert. Er hat in keinem seiner Bücher einen Hinweis darauf gegeben, wie diese vierdimensionale Perspektive auf einer dreidimensionalen Leinwand denn aussehen könnte. Bei seinen Überlegungen, die imaginäre Welt der Vierten Dimension sichtbar zu machen, kam Duchamp zu dem Schluß, daß die dreidimensionale Leinwand

138

nur ein Spiegel oder eine Glasscheibe sein kann. So wie der dreidimensional sehende Mensch eine Linie, die zwei Ebenen trennt, nicht als eine unüberwindliche Mauer wahrnimmt, als die sie zweidimensional sehende Wesen erleben, die nur in der Fläche leben, so wird das vierdimensionale Auge, vermutete Duchamp, den dreidimensional ausgedehnten Körper nicht als ein geschlossenes, undurchdringliches Hindernis erblicken, sondern gleichzeitig von allen Seiten und als transparenten Gegenstand. In der vierdimensionalen Perspektive, schreibt er, wird »das dreidimensionale Objekt gesehen durch Umfassungskreishyperhyposicht (vu à l'embrasse circhyperhypovu, Anm. d. Verf.).«[49] Ein künstlerisches Mittel zur Veranschaulichung dieser Perspektive könnte ein dreiteiliger Spiegel sein. »Der 4 dmsl. Eingeborene«, heißt es in einem langen Text der *Weißen Schachtel*, »der diesen 4 dmsl. symmetrischen Körper wahrnimmt, wird von einem Teil zum zweiten Teil übergehen, indem er den mittleren Raum 3 augenblicklich durchquert – Man kann sich diese augenblickliche Durchquerung eines Raumes 3 vorstellen, indem man sich an gewisse Effekte von 3-teiligen Spiegeln erinnert, in welchem die Bilder hinter neuen Bildern verschwinden.«[50] Im Kontext solcher Überlegungen findet sich nicht nur die Begründung für Duchamps Verwendung von Glas als Bildträger seines neuartigen Transparenzgemäldes *Die Braut, von ihren Junggesellen nackt entblößt, sogar* – »Das durchsichtige Glas und den Spiegel verwenden für die Perspektive 4«, notierte er sich damals[51] –, sondern ebenso für seine Faszination von der ästhetischen Erscheinungsweise des *Flaschentrockners*. Charakteristisch für die vierdimensionale Perspektive sei, so Duchamp, daß der dreidimensionale Körper, im vierdimensionalen Kontinuum gesehen, stets als Ganzes wahrgenommen wird. Es waren derartige Gedanken, die ihn beschäftigten, als sich sein Blick bei einem Einkaufsbummel im Pariser »BHV« zufällig auf die eigentümliche geometrische Gestalt eines Flaschentrockners heftete. Der *Flaschentrockner* erschien Duchamp als ideale Konfiguration seiner Spekulationen über die Struktur des vierdimensionalen Blicks.[52] Nichts brauchte diesem Werk hinzugefügt, nichts an ihm verändert werden, eine wirkliche »sculpture toute faite«. Der *Flaschentrockner* ist ein dreidimensionaler, fast spiegelsymmetrischer Körper, der mit einem Blick, rundum und zugleich transparent wahrzunehmen ist, alles Eigenschaften, die Duchamp eben als typische Kennzeichen einer vierdimensionalen Perspektive herausgearbeitet hatte.

Was nun die eigentümliche Darstellungsweise des *Flaschentrockners* auf dem Druck in der *Boîte-en-Valise* betrifft, so findet sich eine Erklärung dafür in den Gesprächen Duchamps mit Pierre Cabanne von 1966. »Ich fand heraus«, heißt es da, »daß der Schatten eines dreidimensionalen Objekts eine zweidimensionale Form konstituiert – so wie ja die Sonne zweidimensionale Projektionen auf der Erde hervorruft – und schloß daraus, auf analogischem Weg, daß

die Vierte Dimension ein Objekt mit drei Dimensionen projizieren könne, d. h. daß alle dreidimensionalen Gegenstände, die wir so arglos betrachten, Projektionen von uns unbekannten vierdimensionalen Formen sind«.[53] Und er fügt verschmitzt hinzu: »Eine sophistische Argumentation zwar, aber immerhin im Bereich des Möglichen«. Anders formuliert: Alles, was in der dreidimensionalen Welt existiert, ist laut Duchamp nur die »Projektion«, die »Abbildung«, der »Reflex« von unsichtbaren, in einer anderen Welt mit einer höheren Dimension existierenden Dingen. Da unsere Wahrnehmungsorgane auf drei Dimensionen beschränkt sind, ist dieses höher dimensionierte Kontinuum nur der Imagination zugänglich, also eine künstlerische Welt par excellence. Der Begriff der Vierten Dimension, der Brennpunkt von Duchamps pataphysischen Überlegungen in den Jahren 1913 bis 1915, dient zur Bezeichnung dieser hypothetischen anderen Wirklichkeit. Alle Gegenstände sind Bilder von anderen, unsichtbaren Gegenständen, die selbst wieder Bilder sind. Denn auch die Welt »in der vierten Ausdehnung« ist nicht die wirkliche, wahre Welt. Gilt die Analogie für den Übergang von der zweiten in die dritte und von der dritten in die vierte Dimension, dann gilt sie ebenso für den Übergang von der vierten in die fünfte Dimension und so weiter ohne Ende. In Duchamps Vorstellung ist die Welt ein endloser Tunnel aus Spiegeln, Projektionen und Trugbildern. Da unser Verstand immer nur mit dem Schein der Dinge, nie mit den wirklichen Gegenständen selbst konfrontiert ist, ist das, was manche Philosophen objektive Wirklichkeit nennen, prinzipiell unerkennbar. Als skulpturale Manifestation dieser agnostischen Weltanschauung wählte Duchamp 1914 den *Flaschentrockner*.

»Jeder gewöhnliche dreidimensionale Körper, Tintenfaß, Haus, Fesselballon ist die Perspektive, gerichtet auf das dreidimensionale Milieu durch zahlreiche vierdimensionale Körper.«[54] Diesen Gedanken hat Duchamp auf der Reproduktion des *Flaschentrockners* in der *Schachtel im Koffer* veranschaulicht. Er hat das Ausgangsfoto so lange überarbeitet, bis auf dem Bild Objektform und Schattenform identisch sind. Beide Figuren sind »Erscheinungen«, Abglanz eines Dritten, der Schatten ebenso wie das Objekt. Das komplizierte Abbildverfahren, das Duchamp einsetzte, um diesen Effekt zu erzielen, macht deutlich, wie sehr ihm daran gelegen war, den Flaschentrockner als plastische Figuration eines Projektionsproblems verstanden zu wissen, in dem Sinne, daß jedes gewöhnliche dreidimensionale Objekt die »Apparition«, die geisterhafte Erscheinung unsichtbarer vierdimensionaler Körper ist. Um im Betrachter diese ungewöhnliche Sicht auch im Anblick des realen Flaschentrockners hervorzurufen, hat Duchamp vorgeschlagen, ihn bei Ausstellungen aufgehängt, im Raum schwebend, zu präsentieren. Auf diese Weise würde sich das banale Haushaltsgerät in ein transparentes geometrisches Raum-Modell

6 Étienne-Jules Marey
Sukzessive Zeigerstellungen auf dem chronometrischen Ziffernblatt, welche die Zeitintervalle zwischen den sukzessiven Belichtungen angeben
Successive positions of the hands on a chronometric dial showing the time intervals between successive exposures
Le mouvement, 1894

verwandeln. Die wenigsten Aussteller haben diesen Ratschlag bisher ernst genommen. Der *Flaschentrockner* würde auf diese Weise den Hängenden Raum-Konstruktionen Alexander Rodtschenkos von 1920 ähneln, allerdings mit einem charakteristischen Unterschied. Wie den futuristischen Skulpturen Boccionis im Vergleich mit Duchamps *Fahrrad-Rad*, so fehlt auch Rodtschenkos abstrakten plastischen Raumkonstruktionen der für Duchamps »sculptures toutes faites« typische Humor. Die ersten skulpturalen Werke Duchamps sind ebenso wie die *Hängenden Raum-Konstruktionen* Rodtschenkos von Ideen in der neuesten Geometrie inspiriert, doch anders als der russische Konstruktivist nimmt Duchamp das wissenschaftliche Erklärungsmodell der Welt nicht ernst, von einer Anbetung oder künstlerischen Verherrlichung dieses Weltbildes ganz zu schweigen. Die »Vierte Dimension« als Inbegriff des »unerforschten Unbekannten« ist das »Thema« sowohl des *Fahrrad-Rades* als auch des *Flaschentrockners*. Doch ist diese Welt in einer höheren Dimension für Duchamp nur eine Denkmöglichkeit, Figur eines künstlerisch inspirierten Gedankenspiels, ohne jeden Anspruch auf wissenschaftliche oder metaphysische Wahrheit. In Duchamps Kunst ist die Relativierung immer absolut, die Kategorien der Kunst mit eingeschlossen. In seiner Gedankenwelt wie in seiner Kunst gibt es nichts, an das man sich halten kann, es sei denn die unmittelbare Anschauung.

* Der Aufsatz ist Teil einer größeren Studie des Autors über Marcel Duchamp als Bildhauer, die sich in Vorbereitung befindet.

1 Dictionnaire Abrégé du Surréalisme, Paris 1938, S. 23.

2 Zwei weitere Repliken fertigte Duchamp 1961 für das Moderna Museet in Stockholm und 1963 für seinen großen Verehrer, den englischen Popmaler Richard Hamilton in London, an. 1964 brachte die Mailander Galerie Arturo Schwarz eine Auflage von 8 von Duchamp signierten Exemplaren auf den Markt, von denen einige in die Sammlungen der bedeutendsten internationalen Museen für moderne Kunst eingegangen sind, darunter das Musée National d'art moderne im Centre Georges Pompidou in Paris und das Museum Ludwig in Köln.

3 Marcel Duchamp. Die Schriften, Bd. 1, übersetzt und herausgegeben von Serge Stauffer, Zürich 1981.

4 Marcel Duchamp. Notes, übersetzt und herausgegeben von Paul Matisse, Paris, Centre Georges Pompidou 1980.

5 Marcel Duchamp. Die Schriften, a.a.O., S. 97.

6 Die Rede ist von einem »Régime de la pesanteur«.

7 Marcel Duchamp. Die Schriften, a.a.O., S. 92. An anderer Stelle konzipiert er eine »Tropfenskulptur« (»sculpture de gouttes«), die die Vermittlung zwischen den Domänen der Junggesellen und der Braut darstellen soll. Siehe ebenda, S. 89. Dieser Entwurf datiert allerdings erst aus der Zeit nach 1915.

8 Siehe dazu den Essay von Jean Suquet, Le guéridon et la virgule, Paris 1976 und ders., In vitro, in vitro. Le Grand Verre à Venise, Paris 1994, S. 85ff.

9 Marcel Duchamp. Die Schriften, a.a.O., S. 128, Nr. 120 und 123.

10 Marcel Duchamp. Die Schriften, a.a.O., S. 129, Anm. 123.

11 Robert Lebel, Marcel Duchamp. Von der Erscheinung zur Konzeption, erweiterte Auflage, Köln 1972, S. 63.

12 A.a.O., S. 64.

13 Zit. nach Francis M. Naumann, Affectueusement, Marcel: Ten Letters from Marcel Duchamp. In: Archives of American Art Journal, New York, Bd. 22, Nr. 4, 1982, S. 5.

14 Zit. nach Umbro Apollonio, Der Futurismus, Köln 1972, S. 73.

15 A.a.O., S. 67.

16 Ebenda.

17 Marcel Duchamp. Die Schriften, a.a.O., S. 125.

18 »As you know, in 1914, even 1913, I had in my studio a bicycle wheel turning for no reason at all. Whithout even knowing whether I should put it with the rest of my works or call it work.« Interview mit Francis Roberts, Pasadena 1963. Zit. nach André Gervais, Roue de bicyclette. Épitexte, texte et intertextes. In: Les Cahiers du Musée National d'art moderne, Paris, Nr. 30, Winter 1989, S. 59 ff.

19 A.a.O., S. 69.

20 A.a.O., S. 71.

21 Sie waren eine mechanische, absichtlich unterkühlt gewählte Ausdrucksform für eine Empfindungs-welt, in der sich fast alles im Kreise dreht. Die Schokoladenreibe (und alle nachfolgenden Rotations-maschinen in seinem Werk) interpretierte Duchamp selbst als Ausdruck einer unbewußten überstei-gerten Selbstbezogenheit. »It is a kind of narcisism, this selfsufficiency, a kind of onanism.« Zit. nach Robert Francis, I Propose to Strain the Laws of Physics. Interview mit Marcel Duchamp. In: Art News, New York, Dezember 1968, S. 63.

22 Heute in den Archiven des Musée National d'art moderne, Centre Georges Pompidou, Paris, Fonds Brancusi. In Duchamps spärlichem Nachlaß hat sich dieses Manifest bislang nicht nachweisen las-sen. Allerdings hat Duchamp mit großem Bedacht ausgewählt, was er für die Nachwelt erhalten wis-sen wollte.

23 Zit. nach Marcel Duchamp. Duchamp du Signe, Écrits, hrsg. von Michel Sanouillet, Paris 1975, S. 242. Léger berichtet über dieses Ereignis: »Duchamp war von diesen präzisen Gegenständen (den Propellern) sehr angezogen. Ich selbst hatte eher eine Vorliebe für die Motoren und die Dinge aus Metall als für die Luftschrauben (die aus Holz bestanden, Anm. d. Verf.)«. Zit. in Ausstellungskatalog Fernand Léger, Haus der Kunst, München 1954, S. 31.

24 A.a.O., S. 72/73.

25 In einem Brief an Guy Weelen, den damaligen Generalsekretär des Internationalen Kunstkritiker-verbandes. Zit. nach AICARC Bulletin, Nr.1, 1974. Duchamps Äußerungen zum Fahrrad-Rad sind von André Gervais in seinem Aufsatz »Roue de Bicyclette«, a.a.O., S. 61–62 übersichtlich ver-sammelt.

26 Duchamp stand in ständigem Gedankenaustausch mit seinen beiden älteren Brüdern, dem Maler Jacques Villon und dem Bildhauer Raymond Duchamp-Villon, die wie er in Paris lebten. Über seine künstlerischen Kontakte in der Zeit um 1912 sagte Duchamp: »I was not a café frequenter. I was wor-king quite by myself at the time – or rather with my brothers.« In: Michel Sanouillet, Marchand du Sel, Paris 1958, S. 110. Vgl. auch Les 3 Duchamp. Jacques Villon, Raymond Duchamp-Villon, Marcel Duchamp, Text von Pierre Cabanne, Neuchâtel 1975.

27 A.a.O., S. 70.

28 Siehe Elizabeth Cowling, Picasso. Sculptor, Painter, London Tate Gallery 1994.

29 Siehe Apollinaire, Chroniques d'art 1902–1918, Paris 1960.

30 Marchand du Sel, Paris 1958, S. 111/112.

31 A.A.O., S. 69.

32 D. h. die 4. Dimension.

33 Marcel Duchamp. Die Schriften, a.a.O., S. 94.

34 Die möglichen Verbindungen des Fahrrad-Rades mit der Ästhetik der Chronofotografie haben Jean Clair in: Duchamp et la photographie, Paris 1977, und Ulf Linde: »La roue de bicyclette«, in: Kat. Marcel Duchamp. Abécédaire, Paris 1977, ausführlich diskutiert.

35 Valentine de Saint-Point publizierte im März 1912 das »Manifest der futuristischen Frau« und im März 1913 das »Futuristische Manifest der Wollust«.

36 Gladys Fabre, Le cercle littéraire de l'Abbaye. L'occultisme et l'art d'avantgarde français (1906–1915). In: Kat. Okkultismus und Avantgarde. Von Munch bis Mondrian. 1900–1915, Ostfil-dern 1995. Ich bedanke mich bei Gladys Fabre, die mir vor der Drucklegung Einsicht in ihr Manus-kript gewährt hat.

37 Zu ihm gehörten neben Alexandre Mercereau, dem zentralen Kritiker des Zirkels, die Künstler Gleizes, Metzinger und Delaunay.

38 Vgl. Linda Henderson, The Artist, The Fourth Dimension and non-Euclidean Geometry 1900–1930, Yale University, 1985 und Jean Clair, Marcel Duchamp ou le grand fictif, Paris 1975.

39 »La construction de l'ouvrage en est sa première originalité. Il est construit comme une roue, avec un moyeu, des rayons et une jante et non pas déductivement à la manière ordinaire. Le moyeu c'est l'idée d'unité de temps et de lieu, c'est le concept central de la quatrième dimension, les rayons c'est sont les voies diverses, toutes logiquement sur le même plan et qui aboutissent à l'Inconnu inexploré, la jante de cette roue idéale.« In: Montjoie, Paris, Nr. 5, 14. April 1913. Zitiert nach Gladys Fabre, a.a.O.

40 Zitiert nach der deutschen Ausgabe: Helden und Lehren des Dr. Faustroll (Pataphysiker), Berlin 1968, S. 27. Die Definition lautet im Original: »La pataphysique est la science des solutions imaginaires qui accorde symboliquement aux linéaments les propriétés des objets décrits par leur virtualité.«

41 Arturo Schwarz, The Complete Works of Marcel Duchamp, 2. erw. Aufl., New York 1970, S. 442.

42 Siehe Andre Gervais, La Roue de Bicyclette, a.a.O., S. 61/62.

43 Erst 1916 kam Duchamp auf die Idee, dem Flaschentrockner einen ähnlich rätselhaften Titel zu geben wie der Schneeschaufel. Er schrieb an seine Schwester in Paris: »Ich habe eine Idee hinsichtlich des besagten Flaschentrockners. Hör zu . . . Nimm den Flaschentrockner für dich. Ich werde ihn aus der Entfernung zu einem »Readymade« machen. Du hast auf den Sockel, auf die Innenseite des untersten Rings, in kleinen mit einem Malpinsel aufgetragenen Buchstaben, in silberweißer Farbe, die Inschrift zu schreiben, die ich dir weiter unten angeben werde, und du signierst ihn folgendermaßen: d'après Marcel Duchamp«, zit. nach Francis M. Naumann, Affectuesement, Marcel, a.a.O., S.5. Leider bricht der Brief hier ab, so daß die Inschrift nicht überliefert ist. Später konnte oder wollte Duchamp sich an den Wortlaut dieser Inschrift nicht mehr erinnern. Der Flaschentrockner hatte sich vollkommen von ihm und seinen ursprünglichen Intentionen entfernt und begonnen, ein Eigenleben in der Kunstgeschichte zu führen, eine Entwicklung, in die der Künstler nicht mehr einzugreifen beabsichtigte.

44 Zit. nach Alice Goldfarb Marquis, Marcel Duchamp. Eros. C'est la vie, A Biography, New York 1981, S. 65.

45 Siehe Marcel Duchamp. Die Schriften, a.a.O., S. 161.

46 Zit. nach Henri Poincaré, Der Wert der Wissenschaft, Leipzig und Berlin 1910, S. 54.

47 Ebenda, S. 55.

48 Zitiert nach Henri Poincaré, Wissenschaft und Hypothese, Leipzig 1914, S. 71.

49 Marcel Duchamp. Die Schriften, a.a.O., S. 150.

50 Ebenda, S. 161.

51 Ebenda, S. 148.

52 In diesem Sinne läßt sich die Äußerung Duchamps gegenüber Richard Hamilton verstehen, er habe den Flaschentrockner gekauft, »to answer some questions of my own – as a means of solving an artistic problem without the usual means of processes.« Zit. nach Kat. The Almost Complete Works of Marcel Duchamp, Tate Gallery, London 1966, S. 52.

53 Pierre Cabanne, Gespräche mit Marcel Duchamp, Köln, o. J., S. 53. Duchamp war auf diesen Analogieschluß in Ésprit Pascal Jouffrets Traité élémentaire de Géométrie à quatre dimensions et introduction à la Géometrie à n dimensions von 1903 gestoßen.

54 Marcel Duchamp. Die Schriften, a.a.O., S. 163.

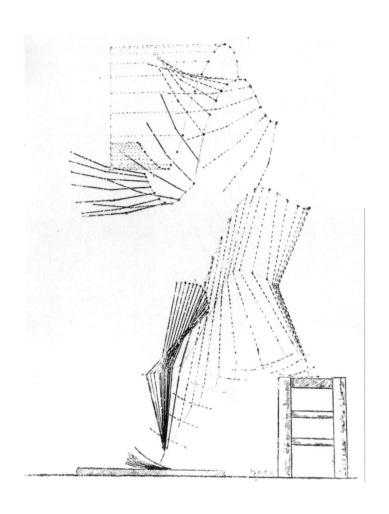

7 Étienne-Jules Marey
Geometrisches Fotogramm, Sprung nach unten
Geometric photogram, downward leap
Le mouvement, 1894

145

Herbert Molderings

The Bicycle Wheel and the Bottle Rack Marcel Duchamp as a Sculptor*

Marcel Duchamp has influenced the art of the twentieth century to a degree equaled only by Pablo Picasso. It would be completely justified to claim that without his work, the course of art history would have been another. Duchamp and Picasso – those are the two faces of the Janus-like art of our century. On one side we have an entirely painterly temperament, a virtuoso of the hand who had mastered every form of pictorial expression, and who knew how to adapt them to the visual experiences of the modern age. For Picasso, the artistic traditions of the whole history of humanity served as a model; there is hardly a single style, whether it be European or African or Oceanic, that he did not take up and renew. On the other side, we have an intellectual artist, an ascetic, who did not want to be seduced by the beauty of forms and the colors of the painter's craft, and for whom the execution of a painting or a sculpture was not first and foremost a task of the hand, but rather of the mind. If Picasso was filled by the passion of a painter, who enchanted people with lines and colors, then Duchamp was motivated by the lust of the destroyer, who achieved fulfillment in shock, the breaking of conventions, and the malicious disappointment of every expectation of art. Both men tried to fascinate the viewer, the first through a bubbling over of fantasy, the second through the baffling of the aesthetic: Picasso, the sensualist, constantly opened new possibilities for the physical act of painting and sculpting, while Duchamp played the role of the negator, the sceptic, who paved new ways for the intellectual attitude towards art. The idea in Duchamp's work that had the greatest consequences for the history of art was doubtless the Ready-made. According to André Breton's definition in the "Dictionary of Surrealism" of 1938, it is "a utilitarian object, which, through the simple choice of the artist, has been elevated to the level of an art work."[1] In its complete simplicity, Breton's explanation has succeeded in asserting itself historically, and it guides the understanding of the Ready-made up until today. According to Breton, the Ready-mades are not intellectual metaphors, but rather vehicles of an artistic strategy that is bent on subverting and dismantling what had been considered the unchangeable, absolute criteria for art. There are concrete historical reasons for Breton's narrow view of the Ready-mades. I am not going to elaborate on these. Instead, I would like to use the example of the two first Ready-mades, the *Bicycle Wheel* and the *Bottle Rack* from 1913 and 1914 to try to demonstrate that these objects are not the gags of

146

a sensationalist artist and a notorious farceur (although, of course, they do have something of this), but that they are modern sculptures.

Two things stand against the widespread notion that the Ready-mades are transformed utilitarian objects that became art through a mere transfer of location. Firstly, the term and concept of the Ready-made were not yet formulated by Duchamp in 1913. This term appears for the first time in New York in the autumn of 1915. As the term obviously suggests, "Ready-made" means finished when you buy it. The word describes industrially produced objects, mass products, that the buyer does not commission to suit his or her individual demands. According to our present knowledge, Duchamp used this expression for the first time when he presented a snow shovel to his astounded artist friends in New York and lifted the shovel from the ocean of mass wares into the realm of the Ready-mades by inscribing it with the words "In Advance of the Broken Arm". Secondly, we must realize that another simple fact concerning the context of their presentation contradicts this view. Using the example of the *Bicycle Wheel*, we see that it was first publicly exhibited in 1951, some 38 years after it had come into being.

This was done in January/February 1951 in the exhibition "Climax in XXth Century Art: 1913–1951" in the New York gallery of Sidney Janis. The work exhibited was neither the original *Bicycle Wheel* of 1913, nor the first replica of 1916. Because of his move to New York from Paris, and then back to Paris from New York, Duchamp had thrown or had somebody else throw the first two bicycle wheels mounted on stools into the garbage. Thus, in 1951, he had to make a third replica, which is today the oldest existing version of the work and may be found in the cathedral of modern art, the MOMA in New York (ill. 1).[2]

Since the date that Duchamp's writings have been accessible – he published them as collections of loose pieces of paper packed in boxes, the first *Green Box* in 1934, the *White Box*[3] in 1966 and the posthumous *Notes* published by his step-son Paul Matisse in 1980[4] – we can reconstruct the intellectual and aesthetic development which lead him from painting to the invention of the Ready-made sculpture.

The first two Ready-made sculptures, the *Bicycle Wheel* mounted on a kitchen stool of 1913 and the *Bottle Rack* of 1914, are both results of Duchamp's excursions into the realm of sculpture. After Duchamp had rejected oil painting in 1913 as an outdated, even medieval means of expression, classifications for art disappeared for him. On the search for new, fresh forms of expression within the sign language of modernist civilization, his curiosity lead him from the objective, emotionless "graphics" of a technical draftsman to the sculptural aesthetics of industrial artefacts. Just as the "technical drawing" on the two

glass panes called *The Bride Stripped Bare by Her Bachelors, Even* (approximately 2.7 by 1.75 meters) negated the traditional form of oil painting, so, too, did the Ready-mades assume a radical stance towards the tradition of sculpture. Of course, the Ready-mades were of far greater import to the future of sculpture than was the *Large Glass* to modern painting.

In the notes and sketches Duchamp left behind from the years 1913 to 1915, and which all relate in one way or another to the *Large Glass*, there are numerous ideas for sculptures expressed both in literary and drawn fashions. He conceived a "musical sculpture" ("Sounds leaving from different places and forming a sounding sculpture which lasts"[5]) and noted in connection with his considerations of gravity[6], "Painting or sculpture: Flat container in glass – (holding) all sorts of liquids. Colored, pieces of wood, of iron, chemical reactions. Shake the container and look through it."[7] The greatest idea in this direction was without a doubt the sculpture of a *Handler of gravity* (ill 2). According to the sketch, it was a kind of free-swinging, spiral-formed metal spring that ended in a globular thickness and was placed upon a stool-like pedestal. Duchamp did not realize the sculpture at the time of its conception. Only more than thirty years later did he produce it in a changed form with the help of Roberto Matta for the Paris exhibition "Le Surréalisme en 1947" (ill. 3).[8]

However, a sculpture related to the *Handler of Gravity*, also called *Tender of Gravity* a sculpture that similarly raises itself from a stool-pedestal came into being in 1913. It is the first three-dimensional Ready-made, a bicycle fork with its "head" down and, from all appearances, with a freely moveable vertical axis that is mounted on a kitchen stool. It is quite clear that here the idea of movement, whose depiction Duchamp had explored in painting for almost two years, has been set forth into the medium of sculpture. Inspired by the ideas of the Italian Futurists and the forms of scientific chronophotography, Duchamp had painted almost a dozen pictures from 1911 to 1913 where we sense the conflict between the static means of depiction and the desire to set the subject of the painting into motion. Duchamp pushed this effort to the greatest of contradictions. The most famous works from this period are the small painting *Coffee Mill* of 1911 (ill. 4) and the large format painting *Nude Descending a Staircase* of 1912. Just as chronophotography dissects a motion into an uninterrupted series of static moments (ill. 5, 6), or, in the case of diagrams taken from photos (ill. 7) into fans of lines, so, too, can the fans of spokes we see on the bicycle wheel when it is still, be understood as a momentary recording of a continuing movement. The lines of the spokes can, however, be set into actual motion, which means, spoken in terms of chronophotography, that the series of static moments can be transformed into a filmic experience. There are actually several comments in Duchamp's writings dating from 1913–1916, pub-

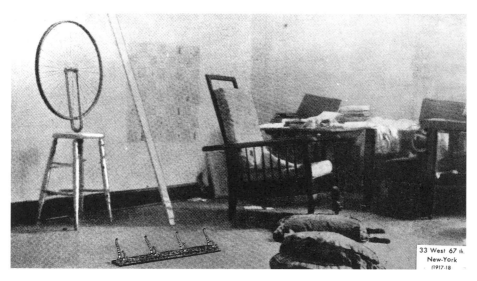

8 Vorder- und Rückseite eines Notizblattes aus der »Grünen Schachtel«, 1934
Front and back of a note for the »Green Box«

9 Duchamps Atelier in New York, 1917/18 / *Duchamp's studio in New York*
33 West 67th Street
Retuschierte Fotografie aus der »Boîte-en-valise«, 1941

149

lished during and after his lifetime, that deal with a new way of using cinematographic effects, namely for sculpture: "make a painting or a sculpture as one winds up a reel of moving picture film"[9] or in another case, "try to argue on the plastic duration" (chercher à discuter sur la durée plastique), a cryptic remark that Duchamp once explained to Cleve Gray, the publisher of the *White Box*, with the following words: "By that I mean time in space."[10] Nothing other than the translation of our feeling of time into the visual experience of space is meant.

The bicycle wheel with its fork pointing down and mounted on a stool is fundamentally a chronophotographic sculpture voiced in the language of the Futurists: a sculpture of movement. And in the theory and practice of Futurist sculpture we can prove concrete aesthetic prerequisites of this work. Robert Lebel decidedly rejected the idea of the *Bicycle Wheel* as a Futurist sculpture in his pioneering monography about Marcel Duchamp from 1959, and most other authors have followed him in this judgement. "He did not select a bicycle wheel as a beautiful modern object, as a Futurist might; he chose it just because it was commonplace.... For the moment, resting upside down on a kitchen stool as a pedestal, it enjoyed an unexpected and derisive prestige which depended entirely upon the act of choosing by which it was selected. It was a kind of sacralization."[11] But when the Futurist aesthetic is cleared out of the way, then there is far and wide no artistic tradition in sight, upon which Duchamp could have built up the construction of his sculpture with the bicycle wheel in 1913. The work must appear as an enigmatic act of choice, as an absolute, subjectively directed event outside of historic time and concrete contemporary experience. Whoever sees the bicycle wheel with this perspective also understands the artist as someone gifted with magic powers. Thus Lebel continues in his description much like a hierophant of antiquity, "He has only to bestow his seal on the objects he has chosen for them to become his work, thanks to this unique laying on of hands... He has never come so close to magic as in these veritable fetishes, which he has invested with a power that is evidently real, for since their consecration they have never ceased to inspire a devoted cult."[12] Here Lebel follows the tradition of the fetish view of the Readymades, which the surrealist artists, the theorist André Breton at their head, had launched in the Twenties and Thirties.

When Duchamp "created" the *Bicycle Wheel* in 1913 and in the following year the *Bottle Rack,* there was neither the term Ready-made, nor "object art"; there was no "assemblage", nor any other special name devised by critics for this kind of artistic operation. So what were the terms in which it was conceived and invented? A letter Duchamp wrote to his sister Suzanne in Paris on January 15th, 1916 proves that he did, in fact, continue to think in established

categories of art when he made these objects. On the 15th of July in that year, the lease on Duchamp's studio in Neuilly, on the fringe of Paris, was due to run out. He suggests that she take it over, and in this connection he writes, "If you went to my place you saw in my studio a bicycle wheel and a bottle rack. I had purchased this as a sculpture already made." ("sculpture toute faite")[13] And he suggests that she inscribe the bottle rack belatedly in his name along the inner side of one of the rings, much as he had inscribed the snow shovel with the phrase he had invented, "In Advance of the Broken Arm". This letter shows beyond a doubt that Duchamp understood the first two Ready-mades as sculpture. The *Bicycle Wheel* and the *Bottle Rack* could not have been conceived in any other artistic category than that of sculpture. Even during the first exhibition of Ready-mades, the presentation of the snow shovel *In Advance of the Broken Arm* and the typewriter cover "Underwood" in the "Exhibition of Modern Art" in the Bourgeois gallery, 1916, New York, they are listed in the catalogue as "2 Ready-mades" in the department "Sculpture".

These hints alone ought to be enough to make us search for the artistic prerequisites for such new kinds of works in the avantgarde sculpture of 1913–1914.

As far as new materials in sculpture are concerned, the first to demand them rather loudly was Umberto Boccioni, and that is, already in 1912. In the *Technical Manifesto of Futurist Sculpture* from the 11th of April, 1912, he had proclaimed, "Destroy the wholly literary and traditional nobility of marble and of bronze. Deny the exclusiveness of one material for the entire construction of sculptural ensemble. Affirm that even twenty different materials can compete in a single work to effect plastic emotion. Let us enumerate some: glass, wood, cardboard, iron, cement, horsehair, leather, cloth, mirrors, electric lights, etc., etc. "[14] In another spot he also writes, "The new plastic art will, then, be a translation into plaster, bronze, glass, wood, any other material, of those atmospheric planes that link and intersect things."[15] The use of "non-artistic", industrial materials – one could speak in a social sense of proletarian materials – would, of course, have immediate consequences for the subject, the contents of the sculpture. Boccioni saw this very clearly. That is why he goes on the offensive and explains unmistakably that "in the lines of a match, in the frame of a window, there is more truth than in all the twisting of muscles, all the breasts and buttocks of the heroes and Venuses that inspire the modern idiocy in sculpture." For this reason "abolish in sculpture as in every other art *The Traditional Sublimity of the Subject*."[16] There is no artist that fulfilled the central demands of the manifesto of Futurist sculpture more radically than the painter Marcel Duchamp. As far as the heady, aesthetic emotion of the sublime is concerned – and academic sculptors of 1913 were still calling for it in the tradition

151

of the Renaissance and the Baroque – there wasn't a drop of it left in the *Bicycle Wheel* inverted on a kitchen stool. No other artist had succeeded in making the aristocratic-bourgeois expectations for bronze and marble sculpture look so ridiculous as had Duchamp, with his metal *Bicycle Wheel* as a sculpture and its worn stool as a pedestal. This position was so far to the front of the Paris art scene, that Duchamp could neither exhibit this "sculpture toute faite", nor could he show it to friends or acquaintances from the art world in his studio.

There is not a single oral or written mention that tells us of someone having seen this strange sculpture in Paris between 1913 and 1915. Duchamp himself was apparently so surprised by the result of his search for new plastic elements that he didn't know if he should consider the odd thing a work of art or not. Among the papers he left behind was a note dated 1913 that posed the perplex question, "Can one make works which are not works of art?" (Peut-on faire des œuvres qui ne soient pas *d'art*?")[17] It was a question that he related directly to the bicycle wheel fifty years later in an interview. "As you know, in 1914, even 1913, I had in my studio a bicycle wheel turning for no reason at all. Without even knowing whether I should put it with the rest of my works or even call it work."[18]

Naturally Boccioni was concerned first and foremost with the depiction of movement in the manifesto of Futurist sculpture. "In sculpture, as in painting one cannot renovate without searching for *The Style of the Movement...*"[19] He finds this in the beauty of certain everyday, non-artistic experiences. "We cannot forget that the tick-tock and the moving hands of a clock, the in-and-out of a piston in a cylinder, the opening and closing of two cogwheels with the continual appearance and disappearance of their square steel cogs, the fury of a flywheel or the turbine of a propeller, are all plastic and pictorial elements of which a Futurist work in sculpture must take account. The opening and closing of a valve creates a rhythm just as beautiful but infinitely newer than the blinking of an animal eyelid."[20] Duchamp felt entirely at home in this conceptual world. Many notes for the years 1912 until 1915 deal with the staccato jerking of a train station clock's hands and the moving mechanisms of combustion motors and apparatus with gear teeth – machines that Duchamp integrated in an abstracted and transformed way into his sketches for the large glass picture, *La Mariée mise à nu par ses Célibataires, même* (The Bride Stripped Bare by Her Bachelors, Even). Also, the de-functionalized, inverted and rotating bicycle wheel belonged, when seen within the chronology of his work, to the small, primitive rotational machines that he placed in the lower half of the picture, the domain of the bachelors.[21]

Boccioni's reference to the incomparable beauty of the turning propeller of an airplane brings us to a famous anecdote that has Duchamp as its focus. In

October/November 1912, Duchamp and his friends Fernand Léger and Constantin Brancusi attended the fourth aviation salon held in the Grand Palais. While strolling past the newest airplanes, Duchamp stopped in front of one of the wooden propellers and said to the sculptor Brancusi (who, of course, possessed a copy of Boccioni's *Technical Manifesto of Futurist Sculpture*[22]), "Painting's washed up. Who'll do anything better than that propeller? Tell me, can you do that?"[23] Duchamp mentions only the end of painting, however sculpture was doubtlessly meant as well. This, too, had come to a standstill, and in as far as Duchamp posed the question about the end of classical artistic mediums of expression while looking at a sculpture-like object, it seems he was concerned with sculpture as well as painting at the time. The rhetorical question posed by Duchamp to Brancusi in the Grand Palais aviation exhibition already contains the seed of the "sculpture toute faite", the *Bicycle Wheel*, produced one year later.

By refering to everyday experiences in a modern industrial and technical civilization, Boccioni had also called for real movement in traditionally static sculpture. Point three of his final summing up in the Futurist sculpture manifesto treated this aspect. "Thus, in perceiving bodies and their parts as *Plastic Zones,* a Futurist composition in sculpture will use metal or wood planes for an object, static *or moved mechanically,* furry spherical forms for hair, semicircles of glass for a vase, wire and screen for an atmospheric plane, etc." (Italics of the author).[24] In this text from the 11th of April, 1912, a real moveable sculpture is conceived of for the first time in the art of the twentieth century. However, it was Duchamp, not Boccioni, who realized this concept. With the bicycle wheel/stool construction, Duchamp created the first real moveable futuristic sculpture. He wasn't afraid of drawing literal practical conclusions from the most radical aesthetic theory of his time. Almost to a letter, the bicycle wheel mounted on the kitchen stool corresponded to Boccioni's manifesto concept of a sculpture of "wood and metal", whose parts may be "mechanically moveable".

In 1912 and 1913, Boccioni himself continued to work with plaster and bronze and stayed a step behind his own ideas. A first large exhibition of his sculpture was shown in June/July of 1913 in the Paris gallery La Boétie. There Duchamp could have seen sculptures like *Development of a Bottle in Space* (1912) and *Unique Forms of Continuity in Space* (1913) – both sculptures using the aged materials of plaster and bronze that Boccioni had theoretically rejected. While the *Development of a Bottle in Space* is a translation of a Cubist still life into the third dimension, the *Unique Forms of Continuity in Space* picks up on the theme of Rodin's *Striding Man* (1877), whose surfaces are more or less roughed up like the surface of a stormy ocean. Just like Rodin's sculptures, the works of Boccioni

demand that the viewer move around them to view them from all sides. This becomes particularly clear when viewing the spiraling surfaces of *Development of a Bottle in Space*. In this context, one of Duchamp's comments about the *Bicycle Wheel* takes on a new light. It was a comment he uttered in 1955 when asked about the basic idea of the work as a possible "explanation" of his then thirty-year old sculptural construction. "In those days I probably joyfully accepted the turning of the wheel as a kind of antidote to the usual movement of an individual around the viewed object."[25]

The new ideas, the revolutionary questions of form and material brought forth by the Futurist manifesto were, in 1913, a subject with which he was confronted on an almost daily basis through his brother.[26] Duchamp's eleven year older brother, the sculptor Raymond Duchamp-Villon, had met Boccioni in Paris in 1912 and had signed his soul away to the ideas of his Italian colleague. In 1914 he created his sculptural masterpiece, the so-called *Large Horse*, a bronze sculpture taken from a plaster model. Because this sculpture embodies the dynamic of a horse, not in an Impressionist fashion as a series of movements, but rather as a potential, stilled, yet tense and ready possibility of movement, because its mechanical forms and the anatomical forms of the horse's body both penetrate each other and grow from the horse's center, Duchamp-Villon's work is an exact translation of Boccioni's demands for a "style of movement". As the Italian sculptor writes, "A futuristic sculpture will integrate modern technical objects in the depiction of man…, thus from the shoulder of a mechanic may protrude the wheel of a machine."[27] In the sculpture of the *Large Horse,* mechanical wheels and the connecting rod of a locomotive stick out of groups of muscles. "We break open the figure and enclose it in environment," as Boccioni proclaimed. This was exactly what Raymond Duchamp-Villon realized with his sculpture, and in so doing he created the most famous futuristic sculpture in modern French art history. As far as the material was concerned, he remained behind with Boccioni, his mentor, and continued to use the noble materials of plaster and bronze, which had been denounced in the Futurist manifesto as "idiotic".

We do not know whether or not Marcel Duchamp had a chance to see Boccioni's *Dynamic of a Racehorse and a House* of 1914–1915 before he left for New York, or if he perhaps saw preparatory models for the sculpture. This was the first work where Boccioni used the new materials he called for in the manifesto: wood, copper and iron sheeting painted with oils and gouache. In any case, the aesthetic conditions concerning the materials for modern sculpture, and for the bicycle wheel/stool, were already set by April 1912 with the manifesto. We can assume that they were the basis of many discussions between the young Marcel Duchamp and the sculptors Brancusi and Duchamp-Villon, such

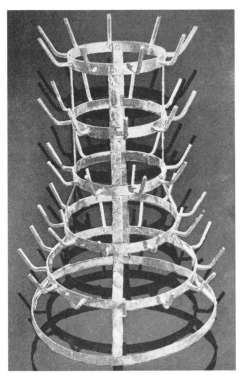 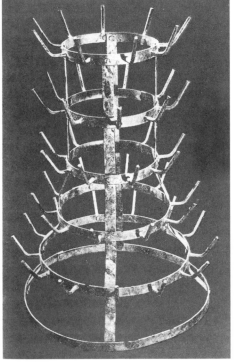

10 Porte-bouteilles, 1914 / *Flaschentrockner*
Reproduktion aus der »Boîte-en-valise«

11 Porte-bouteilles, 1914 / *Flaschentrockner*
Andruck ohne die um 12 mm nach unten versetzte,
mit einem gelbgrünlichen Lack gedruckte Schatten-
form

as the anecdote from the aviation exhibition in 1912 suggests. However, in 1913 there were already sculptures that were not just conceived, but actually made using cardboard, wood, metal sheeting and wire. Their author was Pablo Picasso, who had constructed such works since 1912.[28] It is true that these were not shown publicly, however Duchamp must have known something about them from Apollinaire, with whom Duchamp had enjoyed a more intimate acquaintance since the autumn of 1912, and who was not only a friend of Picasso, but also a constant visitor in his studio. Apollinaire commented upon almost every new artistic step of Picasso in his published criticisms of 1912–1913.[29]

Now it would be unusual if Marcel Duchamp, who wanted "to put art once again at the service of the mind"[30], only intended to use the *Bicycle Wheel* for the retinal experience of the wheel movement and the beauty of primitive materials. Also, since Duchamp was developing the conviction that art should be more than an abstract construction of forms and colors, space and volumes, masses and surfaces, that it should express ideas, one must admit that the theoretic-scientific leanings of the Futurists were closer to him than the pragmatic Cubism of Picasso or Braque. In this context, I would like to make one more reference to a central postulate of the *Technical Manifesto of Futuristic Sculpture*, "A Futurist composition in sculpture", wrote Boccioni, "will embody the marvelous mathematical and geometrical elements that make up the objects of our time…"[31] The *Bicycle Wheel* was just such an object, and in Duchamp's notes of 1913/1914 there are numerous mathematic and geometric speculations that stand in connection with their sculptural application. They usually deal with the production of geometric forms through rotation, a long-known principle of geometric thinking. The appearance of the wheel on the kitchen stool comes closest to a two-page long note from the *Green Box*. The complicated language says that, like in the rotation of lines around an axis where the differentiation between right and left loses its meaning, so do the categories of inside and outside lose their meaning in a fourth dimension continuum and become interchangeable (ill. 8). A small sketch accompanying the notepage shows a situation comparable to the *Bicycle Wheel*: the making of circle by the rotation of a straight line. The complete note is as follows: "The right and the left are obtained by letting trail behind you a tinge of persistence in the situation. This symmetrical fashioning of the situation distributed on each side of the vertical axis is of practical value (as right different from left) only as a residue of experiences on fixed exterior points. And on the other hand: the vertical axis considered separately turning on itself, a generating line at a right angle e.g., (here follows the small sketch with the definition of the axis and the directional arrows A and B, note of the author) will always determine a circle in the 2 cases 1st

turning in the direction A, 2nd direction B. – Thus if it were still possible, in the case of the vertical axis at rest., to consider 2 contrary directions for the generating line G., the figure engendered (whatever it may be), can no longer be called left or right of the axis. – As there is gradually less differentiation from axis to axis., e.e. as all the axes gradually disappear in a fading (gray) verticality the front and the back, the reverse and the obverse acquire a circular significance: the right and the left which are the 4 arms of the front and back. melt. along the verticals. the interior and exterior (in a fourth dimension)[32] can receive a similar identification. but the axis is no longer vertical and has no longer a one-dimensional appearance."[33] The poetic phrasing of "fading gray verticality" (I have added the word "gray" to G. H. Hamilton's incomplete English translation), into which, according to Duchamp, the clearly visible axes or lines of the resting figure disappear when it is set into motion describe very clearly the image of a quickly turning bicycle wheel, whose spokes generate a half transparent, half opaque gray surface. Thus, it becomes difficult for the viewer to differentiate clearly between front and back. Still, I do not want to use this note as a building instructions or an "explanation" of this first Readymade. It is only one of many elements figuring in the description of this imaginative field of energy which made possible a "sculpture toute faite" like the *Bicycle Wheel* on a stand – an object that cannot be explained with terminology or with metaphors. Everyone knows from his or her own experience that the rotation of lines (spokes) creates the image of a circular surface. If one were to allow the circular surface (the bicycle wheel) to rotate quickly around the free vertical axis, one would see a three-dimensional volume, a sphere. Up until this point, we are on the safe terrain of geometry that can be proved by experiment. Yet Duchamp reaches for these concepts within a fully speculative context, namely, in connection with the question of how an invisible, but mathematically thinkable reality of the fourth dimension could allow itself to be made visible. The question of the visualization of the fourth dimension's hyper-space was the central concern of the majority of his notes from 1913 to 1915. Finding visual answers to this puzzle, in both the material and graphic sense, became the middlepoint of his sketches for the glass picture *The Bride Stripped Bare by Her Bachelors, Even*. Indeed, this work was the depiction of an invisible, but thoroughly possible reality, a slice of a world in the fourth dimension.

The rotation of a line results in a surface, the rotation of a two-dimensional surface results in a three-dimensional body. And in analogy, reasons Duchamp, the rotating of a three-dimensional body must result in a continuum of the fourth dimension, "l'étendue 4". The line becomes a virtual surface as soon as one mentally begins the rotation, the virtual surface becomes a virtual body, and the virtual body becomes an expansion into the fourth dimen-

sion. But how should one imagine its spatial realization, and specifically, how should it be shown in a work of art? If one wanted to apply Duchamp's pseudo-scientific, but strict analogical thinking to the *Bicycle Wheel*, one might posit the following theory: just as chronophotography or the diagram abstracting it translate the movement of three-dimensional objects in a series of lines on a surface, so, too, can the turning *Bicycle Wheel* be considered a kind of three-dimensional chronophotography of a movement in the invisible fourth dimension.[34]

In her study about the literary circle of the Abbaye de Creteil, Gladys Fabre has proved that not only Duchamp, but also the famous Paris Futurist, Valentine de Saint-Point[35], speculated in 1913 about the structure of a bicycle wheel in connection with the space of the fourth dimension.[36] Duchamp had numerous contacts with this literary circle.[37] In 1912, Gaston de Pawlowski published the novel, *Le voyage au pays de la quatrième dimension* (The Voyage into the Land of the Fourth Dimension), a mixture of popular science dimension theory and science fiction. Excerpts from this novel had already been published in the magazine "Comœdia" beginning in 1908. Marcel Duchamp was not only one of the novel's enthusiastic readers, he also let himself be inspired by it with many ideas for his *Large Glass: The Bride Stripped Bare by Her Bachelors, Even*.[38] A review of the novel in the magazine "Montjoie" from the 14th of April, 1913, Valentine de Saint-Point praises the "melding of modern scientism with timeless idealism" as being particularly relevant and describes the structure of the *Journey to the Land of the Fourth Dimension* with the following words: "The construction of the work is, in and of itself, already quite original. It is built like a wheel, with a hub, with spokes and a rim, and not deductive, as is usually the case. The hub is the idea of the unity of time and space, this is the central idea of the fourth dimension, the spokes are the many paths which all move logically on the same plane and run on until they reach the unexplored unknown, the rim of this ideal wheel."[39] We don't know in which month of 1913 Duchamp mounted the *Bicycle Wheel* of the "sculpture toute faite" (in reality it wasn't "toute faite", since the wheel had to be combined, wheel up, with the stool, a classical pedestal), but it is conceivable that Valentine de Saint-Point's descriptive analogy between the structure of a bicycle wheel and that of Pawlowski's novel was involved in the creative process.

But now it is time to limit the definition of the *Bicycle Wheel* as a futuristic sculpture. Unlike Duchamp, the Futurist is famous for neither humor nor irony. Even though Duchamp agrees with Boccioni in getting rid of the traditionally sublime subject matter of sculpture, he differed from his Italian colleague in that he did not seek to replace the Sublime with serious and emphatic admiration for modern technology. Instead of the glorification of movement,

158

12 Blick in die »Exposition Surréaliste d'Objets«, Galerie Charles Ratton, Paris 1936
In dieser Ausstellung wurde der »Flaschentrockner«, 22 Jahre nach seiner »Entstehung«, zum ersten Mal öffentlich gezeigt.
A View of the »Exposition Surréaliste d'Objets«, Galerie Charles Ratton, Paris 1936
22 years after its "completion" the "porte-bouteilles" was shown to the public for the first time at this exhibition.

machine rhythym and the natural sciences that we bump up against in Boccioni's sculptures, the *Bicycle Wheel* sculpture offers an ironic and humorous, in short, a "pataphysical" exchange with the geometric and mathematical ideas underlying technical objects. Influences from Alfred Jarry's pataphysics, with its story *Gestes et opinions du Docteur Faustroll, Pataphysic* (1911), may be found in Duchamp's work since 1913. According to Jarry's definition, pataphysics is the science of imaginary solutions, which brings into correspondence with baselines the properties of objects described by their virtuality.[40] Not unlike Duchamp in his notes about the *Large Glass* and the first Readymades from 1913–1915, the main figure of the story, Dr. Faustroll, a caricature of the modern scientist, uses geometric suppositions about virtual volumes and line diagrams as the point of departure in his recognition of what he calls the unknown dimension of the universe. Jarry's definition of the new type of physics is not without a few rational aspects, despite all the nonsense. This mixture is characteristic for Jarry and for Duchamp in their treatment of the natural sciences and their view of the world. It is never a question of their complete rejection and the transition to utter irrationalism, but rather an attempt at making them poetic with humor and irony. Obeying the laws of pataphysics, the objects are never only themselves, but also a possibility of viewing something else that is not immediately visible. The aim of pataphysics exists in the attempt to order properties of objects symbolically to the "linéaments", a pattern of lines. If one considers the bicycle wheel on the kitchen stool against the background of this definition, and compares it to the notes Duchamp left behind which correspond to it, then this work could be addressed as a "pataphysical sculpture". The aesthetic of the work would consist of its beauty of movement and its "subject" would be the "unexplored unknown" evoked by Valentine de Saint-Point.

Thus, while we can reconstruct Duchamp's speculative, "four-dimensional" field of associations where this first Ready-made evolved from the notes he left in the *Green Box* and the *White Box*, it was the written recording of a talk between Duchamp and Arturo Schwarz that gave us a hint of his specific aesthetic interest in the *Bicycle Wheel*. "The *Bicycle Wheel* still had little to do with the idea of the Ready-made. Rather it had more to do with the idea of chance. In a way, it was simply letting things go by themselves and have a sort of created atmosphere in a studio, an apartment where you live. Probably, to help your ideas to come out of your head. To see that wheel turning was very soothing, very comforting, a sort of opening of avenues on other things than material life of every day. I liked the idea of having a bicycle wheel in my studio. I enjoyed looking at it, just as I enjoy looking at the flames dancing in a fireplace."[41] (ill. 9) The "avenues on other things than material life of every day" immediately

evoke the sentence of Valentine de Saint-Point's elogy on Pawlowski's *Journey into the Land of the Fourth Dimension,* where spokes are compared to paths leading to and ending in the "until now unexplored unknown" ("les voies..., qui aboutissent à l'Inconnu inexploré"). The comparison of the turning wheel with the movement of flames in an open fireplace was repeated by Duchamp in almost all of his comments on the *Bicycle Wheel* between 1955 and 1967[42], and by so doing, he emphasized the meditative and contemplative function that this sculpture had for him, despite its radicality of new materials and its new form. In this way it is no different than certain traditional paintings or sculptures, since these were also always objects of contemplation and meditation. Duchamp's aesthetic experience of the work – the calming circling of the wheel, which unbound his thoughts from all function – was just the opposite of the shocking and provocative effect that Robert Lebel claimed as Duchamp's intention for the object. The pointless movement of the wheel was an ideal window through which his thoughts could drift, an experience that was, of course, dependent on being able to use it alone in the closed and private atmosphere of studio or living quarters. In the loud public domain of the Museum Ludwig or the Centre Georges Pompidou this effect can no longer be felt. It seems that it was this individual aesthetic experience that Duchamp prized the most in his sculptural construction, because even though he always threw it away when he re-located, he did re-construct it in every new studio into which he moved. There is no apartment, no studio of Duchamp's known in which he neglected to install this artistic equivalent to a fireplace.

The second "ready made sculpture" that Duchamp mentions in the letter cited above to his sister Suzanne of January 1916 is a galvanized iron bottle rack, a household item such as was owned by nearly every French family at the time. Duchamp bought it in 1914 in the big department store "Bazar de l'Hôtel de Ville", where even today similar racks may still be purchased in the household department.

While the inverted *Bicycle Wheel* on a stool of 1913 was still a "sculptural construction", a bringing together of two separate sculptural elements, the *Bottle Rack* was a completely unchanged industrial artefact, the first three-dimensional Ready-made in Duchamp's work, or, as the artist called it at the time of its conception, the first "sculpture toute faite" in a literal sense.

Like the futuristically inspired sculpture of the inverted *Bicycle Wheel*, the *Bottle Rack* did not originally have a written title. The inscription was not a characteristic element of the Ready-made until two years later in New York.[43] Thus it was not a literary idea that assisted him in the choice of this object, but rather aesthetic considerations of form. The *Bottle Rack* seemed to him to be a perfectly complete sculpture to which nothing more should be added. And it

must be admitted that this prickly object is not devoid of a kind of bizarre beauty, so that we cannot really contradict the statement of the American painter Robert Motherwell, who called the *Bottle Rack* "a more beautiful form than almost anything made, in 1914, as sculpture."[44]

If one desires to approach understanding the aesthetic considerations that nourished Duchamp's fascination for this object in 1914, one will necessarily have to turn to the only authentic historic document that has survived relating to it, namely the reproduction that Duchamp himself prepared for his œuvre catalogue *La Boîte-en-Valise* and had printed at the end of 1936 (ill. 10). The sculpture appears on this image without a standing surface, without a means of being hung and without any detailing that would define space. Even with the help of the definite shadow, the general position of the body in space cannot be determined. After more careful examination, we can see that the shadow is a false one. It has been printed with the assistance of a stencil as a direct repetition of the *Bottle Rack's* figuration, which has simply been lowered several centimeters (ill. 11). The resulting confusion of spatial perception immediately raises a question of identity – what is shadow and what is image? Is the dark *Bottle Rack* the shadow thrown by the light *Bottle Rack*, or is the light one the projection of the dark one?

Once again, as in the case of the sculptural construction with the *Bicycle Wheel*, it is the idea of an invisible hyper-space that is the source of this "sculpture toute faite". In his speculations about the possibilities of the visual depiction of a hypothetical world in the fourth dimension, Duchamp expressly refers to the theory of dimensions formulated by the most popular French mathematician of the time, Henri Poincaré.[45] In his classic work, *The Value of Science* from 1905, Poincaré built the determination of the number of dimensions of a continuum upon the concept of an intersection or cut. "...to divide space, cuts that are called surfaces are necessary; to divide surfaces, cuts that are called lines are necessary; to divide lines, cuts that are called points are necessary; we can go no further, the point cannot be divided, so the point is not a continuum."[46] Poincaré recognized the advantage of this new definition's flexibility. "Moreover, we see that this definition applies not alone to space; that in all which falls under our senses we find the characteristics of the physical continuum, which would allow of the same classification; that it would be easy to find there examples of continua of four, of five, dimensions, in the sense of the preceding definition; such examples occur of themselves to the mind."[47] Duchamp took up Poincaré's definition of dimensions as intersections and developed it in all possible directions in order to get an answer to the following question: If the three dimensional space is a cut through a four dimensional continuum, how would this four dimensional world be depicted visually? That

13 Blick in die erste Duchamp-Ausstellung in Deutschland, Kestner-Gesellschaft, Hannover 1965
A view in the first Duchamp exhibition in Germany, Kestner-Gesellschaft, Hannover 1965
Foto: Umbo

its depiction was not only possible, but also quite easy had been expressed by Poincaré already in 1902 in *Science and Hypothesis*. "Well, in the same way that we draw the perspective of a three-dimensional figure on a plane, so we can draw that of a four-dimensional figure on a canvas of three (or two) dimensions. To a geometer this is but child's play."[48] Although it is child's play, Poincaré never did it himself. He did not give any tips in any of his books just how this four-dimensional perspective might look on a three-dimensional canvas. In his speculations about how he could visualize the imaginary world of the fourth dimension, Duchamp reached the conclusion that the three-dimensional canvas can only be a mirror or a pane of glass. Just as a three-dimensional seeing human being does not perceive a line separating two planes as an unsurmountable wall (as would a two-dimensional being only living on the surface), so, too, supposed Duchamp, would the four-dimensional eye not perceive an extended three-dimensional body as a closed, inpenetrable obstacle, but rather simultaneously from all sides and as a transparent object. He writes that in the fourth-dimensional perspective "the object 3 is seen circumhyperhypoembraced" (vu à l'embrasse circhyperhypovu, footnote of the author).[49] An artistic means of showing this perspective could be a three-part mirror. "The 4-dim'l native," as it says in a long text in the *White Box*, "when perceiving this symmetrical 4-dim'l body will go from one region to the other by crossing instantaneously the median space 3. One can imagine this instantaneous crossing of a space 3 by recalling certain effects with 3-sided mirrors in which the images disappear (behind) new images."[50] In the context of such speculation we not only discover Duchamp's reason for using glass as the carrier of this new, transparent image, *The Bride Stripped Bare By Her Bachelors, Even* ("Use transparent glass and mirror for perspective 4," he noted at the time[51]), but also his fascination for the aesthetic appearance of the bottle rack. According to Duchamp, characteristic of vision in the fourth-dimensional continuum is that the three-dimensional object is always seen in its entirety. It was thoughts like this that continually occupied him in 1914 as he was working on the *Large Glass*, and as his glance lighted on the strange geometric form of the *Bottle Rack* while brousing in the department store. It must have appeared to him as the ideal configuration for his speculations about the structure of vision in the fourth dimension.[52] Nothing needed to be added to this work, nothing needed to be changed. It was a real "sculpture toute faite". The *Bottle Rack* is a three-dimensional body of almost mirror image symmetry that can be seen with one glance and is at the same time transparent – all qualities that Duchamp had worked out as typical of a fourth-dimensional perspective.

As far as the strange depiction of the *Bottle Rack* in Duchamp's reproduction for the *Boîte-en-Valise* is concerned, we can find one explanation in a con-

14 Umbo
Marcel Duchamp in Hannover, September 1965

versation that Duchamp had with Pierre Cabanne in 1966. "Since I found that one should make a cast shadow from a three-dimensional thing, any object whatsoever – just as the projecting on the sun of the earth makes two dimensions – I thought that by simple intellectual analogy, the fourth dimension could project an object of three dimensions, or, to put it another way, any three-dimensional object, which we see dispassionately, is a projection of something fourth-dimensional, something we're not familiar with."[53] And, as he artfully adds, "It was a bit of a sophism, but still it was possible." In other words, everything that exists in the three-dimensional world is, according to Duchamp, only the "projection", the "depiction", the "reflex" of invisible things existing in another world of a higher dimension. Since our organs of vision are limited to three dimensions, the continuum of higher dimension is only open to access through the imagination. This makes it a world particularly appropriate to the artistic realm. The concept of the fourth dimension, the focus of Duchamp's pataphysical speculations in the years from 1913 to 1915, serves to describe this hypothetic other world. All objects are images of other invisible objects, which themselves are also images. Because even the world "in the fourth dimension" is not the real, true world. If the analogy holds true for the second into the third, and the third into the fourth dimension, then it is also true for the fourth into the fifth dimension and so on ad infinitum. In Duchamp's mind, the world is an endless tunnel of mirrors, projections and illusions. Because our understanding only deals with appearances, and is not confronted with the real objects themselves, that which some philosophers call objective reality is, in principle, irrecognizable. This agnostic outlook found its sculptural manifestation in the 1914 choice of the bottle rack.

"Each ordinary 3-dim'l body, inkpot, house, captive balloon is the perspective projected by numerous 4-dim'l bodies upon the 3-dim'l medium."[54] This idea was captured on the reproduction of the *Bottle Rack* for the *Box-in-the-Suitcase*. He worked over the original photograph for as long as it took until the object shape and the shadow shape were entirely identical. Both figures – the shadow as well as the object – are "appearances", reflections of a third something. The complicated means of reproduction that Duchamp used to achieve this effect makes it clear how much it meant to him to have the *Bottle Rack* understood as the sculptural figuration of a projection problem. It was a projection in the sense that every common three-dimensional object is the "apparition", the ghostly reminder of fourth-dimensional body. To remind the viewer of this unusual idea while he or she was looking at the *Bottle Rack*, Duchamp suggested showing the rack by hanging it floating freely within the exhibition space itself. In this way the banal household object would be tranformed into a transparant, geometric space model. Only seldom has this suggestion been

taken seriously. When hung, the *Bottle Rack* then ressembles the *Hanging Space Constructions* of Alexander Rodtschenko from 1920, with, however, one characteristic difference. As with the comparison of Boccioni's futuristic sculptures to Duchamp's *Bicyle Wheel*, Rodtschenko's spatial construction is lacking one important element – the humor typical to the "sculptures toutes faites." Duchamp's first sculptural works are, like the *Hanging Space Constructions* of Rodtschenko, inspired by contemporary ideas of geometry. Yet unlike the Russian constructivist, Duchamp does not take the scientific explanation of the world seriously, nor does he come close to heroizing or praising this world view. The "Fourth Dimension" as the realm of the "unexplored Unknown" is the theme of both the *Bicycle Wheel* and the *Bottle Rack*. But this world of higher dimension is only an intellectual possibility for Duchamp, the configuration of an artistically inspired game of thought with no aspirations to scientific or metaphysical truth. In Duchamp's art, relativity is always absolute, including the categories of art. In the world of his thoughts as well as in the world of his art, there is no firm point of orientation for viewers, except perhaps that which can be directly seen.

* This essay is the first chapter of a broad study about Marcel Duchamp as a sculptor, which the author is preparing.

1 Dictionnaire Abrégé du Surréalisme, Paris 1938, p. 23.
2 Duchamp later made two other replicas: one in 1961 for the Moderna Museet in Stockholm and the other for his great admirer, the English pop artist Richard Hamilton in London. Finally, in 1964, the Milan gallery of Arturo Schwarz produced an edition of eight "roue de bicyclettes" which were signed by Duchamp and put on the market. Some of these have entered prestigious international collections of modern art, among them the Musée National d'art moderne in the Centre Georges Pompidou in Paris and the Museum Ludwig in Cologne.
3 Salt Seller. The Writings of Marcel Duchamp. (Marchand du Sel), edited by Michel Sanouillet and Elmer Petersen, New York, 1973.
4 Marcel Duchamp, Notes, edited and translated by Paul Matisse, Paris, Centre Georges Pompidou, 1980.
5 The Bride Stripped Bare By Her Bachelors, Even. Translated by George Heard Hamilton, Stuttgart – London – Reykjavik, 1960, non-paginated.
6 There is mention of a "Régime de la pésanteur."
7 The Bride Stripped Bare By Her Bachelors, Even. Translated by George Heard Hamilton, as above. In another spot he conceives of a "sculpture de gouttes" (a "drop sculpture"), which is supposed to mediate between the domains of the bachelors and the bride. This idea is, however, dated, from after 1915.
8 See also the essay by Jean Suquet, "Le guéridon et la virgule", Paris 1976.
9 Salt Seller, op.cit., p. 75.
10 Ibid, p. 77.
11 Robert Lebel, Marcel Duchamp. With chapters by M. Duchamp, A. Breton and H.P. Roché. Translated G.H. Hamilton, New York, 1959 and London, 1960, p. 35.
12 Ibid, p. 36.
13 Quoted from Francis M. Naumann, Affectueusement, Marcel; Ten Letters from Marcel Duchamp, in: "Archives of American Art Journal", New York, Vol. 22, Nr. 4, 1982, p. 5.

14 Umberto Boccioni, "Technical Manifesto of Futurist Sculpture", 1912 in: Theories of Modern Art, A Source Book by Artists and Critics, Herschel B. Chipp, Berkeley and Los Angeles, 1968, p. 304.
15 Ibid, p. 300.
16 Ibid, p. 303–304.
17 Marcel Duchamp, The Essential Writings of Marcel Duchamp. Salt Seller, ed. Michel Sanouillet & Elmer Petersen, London, New York, 1975, p. 74.
18 Interview with Francis Roberts, Pasadena, 1963. Quoted from André Gervais, Roue de bicyclette, Épitexte, texte et intertextes. In: Les Cahiers du Musée National d'art moderne, Paris, No. 30, Hiver 1989, p. 59 and following.
19 Boccioni, Technical Manifesto, op.cit., p. 301.
20 Ibid, p. 303.
21 They were a mechanical form of expression, chosen with deliberate understatement for a world of feelings in which nearly everything is in rotation. Duchamp himself interpreted the chocolate grinder (and all of the other rotating machines in subsequent works) as the articulation of an unconsciously exaggerated self-centredness. "It is a kind of narcism, this self-sufficiency, a kind of onanism". Cited from Robert Francic, "I Propose to Strain the Laws of Physics", interview with Marcel Duchamp in Art News, New York, December 1968, p. 63.
22 Today in the archives of the Musée National d'art moderne, Centre Georges Pompidou, Paris, Fonds Brancusi. So far there is no proof that this manifesto was owned by Duchamp, since it was not among the items of his meagre estate. Duchamp did choose the things carefully that were to be found and interpreted after his death.
23 Quoted from Salt Seller, op. cit., p. 160. Léger reports this experience as follows: "Duchamp was very attracted by these things (the propellers). I myself rather prefered the motors and the things made of metal than the propellers (which were made of wood, note of the author)." Quoted from the exhibition catalogue Fernand Léger, Haus der Kunst, Munich, 1954, p. 31.
24 Boccioni, Technical Manifesto of Futurist Sculpture, op.cit., p. 304.
25 In a letter to Guy Weelen, at the time general secretary of the International Art Critics Union. Quoted from AICARC Bulletin, Nr. 1, 1974. Duchamp's comments on the bicycle wheel were collected by André Gervais in his essay "Roue de Bicyclette", op. cit., p. 61–62.
26 Duchamp stood in constant contact to his two older brothers, the painter Jacques Villon and the sculptor Raymond Duchamp-Villon, with whom he both lived in Paris. About their intellectual exhange around 1912 Duchamp once said, "I was not a café frequenter. I was working quite by myself at the time – or rather with my brothers." In: Michel Sanouillet, Marchand du Sel, Paris 1958, p. 110. Compare also Les 3 Duchamp. Jacques Villon. Raymond Duchamp-Villon. Marcel Duchamp. Text by Pierre Cabanne, Neuchâtel, 1975.
27 Boccioni, Technical Manifesto, op.cit., p. 301.
28 See Elizabeth Cowling, Picasso. Sculptor, Painter, London: Tate Gallery 1994.
29 See Apollinaire, Chroniques d'art 1902-1918, Paris, 1960.
30 Marchand du Signe. Duchamp du Signe, Écrits, edited by Michel Sanouillet, Paris, 1975, p. 111–112.
31 Bocccioni, Technical Manifesto of Futurist Sculpture, op.cit., p. 301.
32 In French roughly expressed as "the expansion 4". G. H. Hamilton's English translation is not entirely accurate in some details.
33 Salt Seller. The Writings of Marcel Duchamp. (Marchand du Sel), edited by Michel Sanouillet and Elmer Peterson, New York, 1973, p. 29.
34 The connections of the bicycle wheel with the aesthetic of chronophotography was discussed in detail by Jean Clair in Duchamp et la photographie, Paris, 1977 and Ulf Linde, "La roue de bicyclette", in the exhibition catalogue Marcel Duchamp. Abécédaire, Paris, 1977.
35 In March 1912, Valentine de Saint-Point published the "Manifesto of the Futuristic Woman" and in March 1913, the "Futuristic Manifesto of Lust".
36 Gladys Fabre, Le cercle littéraire de l'Abbaye, l'occultisme et l'art d'avantgarde français (1906–1915), in the exhibition catalogue Okkultismus und Avantgarde. Von Munch bis Mondrian. 1900–1915, Edition Tertium, Ostfildern, 1995. I would like to thank Gladys Fabre for sending me her manuscript before it was published.
37 Besides Alexandre Mercereau, the central critic of the circle, the artists Gleizes, Metzinger and Delaunay were also members.
38 Compare Linda Henderson, The Artist, The Fourth Dimension and non-Euclidean Geometry 1900–1930, Yale University, 1985 and Jean Clair, Marcel Duchamp ou le grand fictif, Paris, 1975.

39 "Montjoie", Paris, Nr. 5, 14. April 1913. "La construction de l'ouvrage en est sa première originalité. Il est construit comme une roue, avec un moyeu, des rayons et une jante et non pas déductivement à la manière ordinaire. Le moyeu c'est l'idée d'unité de temps et de lieu, c'est le concept central de la quatrième dimension, les rayons ce sont les voies diverses, toutes logiquement sur le même plan et qui aboutissent à l'Inconnu inexploré, la jante de cette roue idéale." Quoted from Gladys Fabre, op.cit.

40 "La pataphysique est la science des solutions imaginaires qui accorde symboliquement aux linéaments les propriétés des objets décrits par leur virtualité."

41 Arturo Schwarz, The Complete Works of Marcel Duchamp, 2nd expanded edition, New York, 1970, p. 442.

42 See Andre Gervais, op.cit., p. 61–62.

43 Only in 1916 did Duchamp get the idea of giving the bottle rack a puzzling title similar to the snow shovel. He wrote to his sister in Paris "And I have an idea concerning this said bottle rack: Listen... You take for yourself this bottle rack. I will make it a 'Readymade' from a distance. You will have to write at the base and on the inside of the bottom ring in small letters painted with an oil-painting brush, in silver white colour, the inscription that I will give you after this, and you will sign it in the same hand as follows: (after) Marcel Duchamp." Cited from F.M. Naumann, Affectueusement, Marcel, as above, p. 5. Unfortunately, the letter breaks off here, so that the inscription is no longer known. Later Duchamp couldn't or didn't want to remember the inscription. The bottle rack had distanced itself from him and his original intentions and begun to lead its own life within art history. It was a development the artist didn't intend to interfere with, and accepted.

44 Cited from Alice Goldfarb Marquis, Marcel Duchamp. Eros, C'est la vie, A Biography, New York, 1981, p. 155.

45 See Marcel Duchamp's writings in the White Box.

46 Quoted from Henri Poincaré, The Value of Science, authorized translation (anon), introduction by George Bruce Halsted, New York, 1958, p. 44.

47 As above.

48 Quoted from Henri Poincaré, Science and Hypothesis (translated by W.J.G. 1905), with a preface by J. Larmor, New York, 1952, p. 69.

49 Marcel Duchamp, The Essential Writings of Marcel Duchamp, as above, p. 84.

50 As above, p. 94.

51 As above, p. 88.

52 In this sense we can understand Duchamp's statement to Richard Hamilton that he bought the bottle rack "to answer some questions of my own – as a means of solving an artistic problem without the usual means of processes." Quoted from the exhibition catalogue "The Almost Complete Works of Marcel Duchamp", Tate Gallery, London, 1966, p. 52.

53 Pierre Cabanne, Dialogues with Marcel Duchamp, translated from the French by Ron Padgett, New York, no date, p. 40. Here Duchamp paraphrases an idea outlined by Esprit Pascal Jouffret in "Introduction à la Géometrie à n dimensions", Paris, 1903.

54 Duchamp du Signe, p. 135.

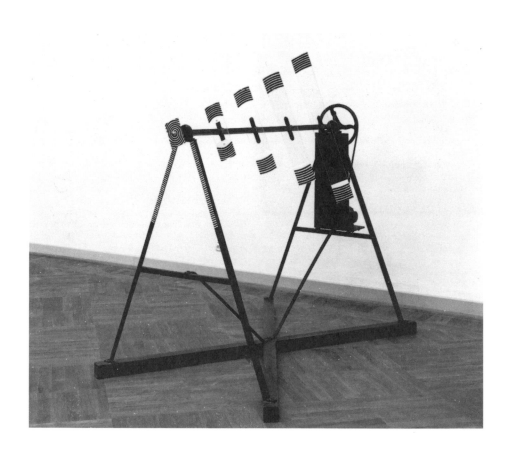

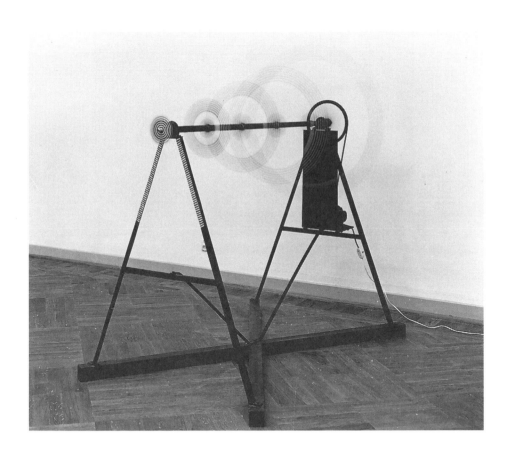

Rotative-plaque-verre, 1920/1961 / *Rotierende Glasplatten*

Cover for Minotaure, No. 6, 1935 / *Umschlag für Minotaurus, Nr. 6* Rotoreliefs, 1935

LANTERNE CHINOISE

ESCARGOT

SPIRALE BLANCHE

COROLLES

CERCEAUX

Two versions of Self-Portrait in Profile, 1959 / *Zwei Versionen von Selbstporträt im Profil*

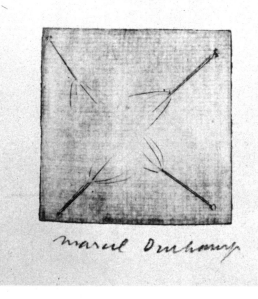

Tiré à 4 épingles, 1959 / *Von 4 Nadeln gezogen*

176

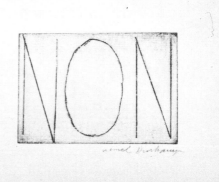

P. A. BENOIT
P R
MARCEL DUCHAMP
L U M
I È R E

Première Lumière, 1959 / *Erstes Licht*

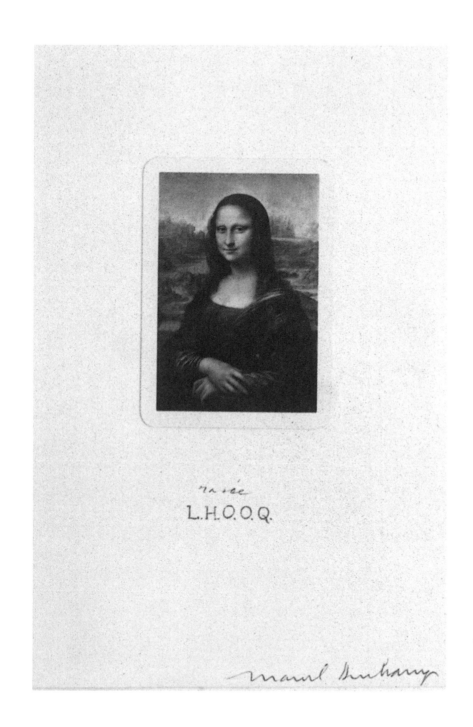

L.H.O.O.Q. rasée, 1965 / *L.H.O.O.Q. rasiert*

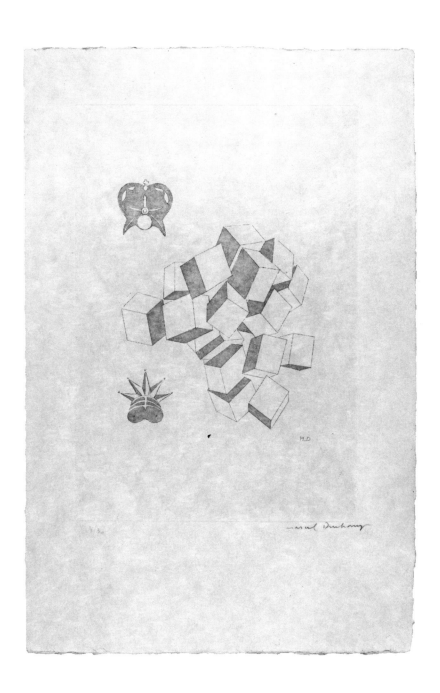

King and Queen, 1968 / *König und Königin*

180

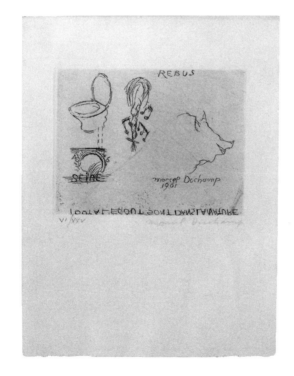

Certificat de Lecture, 1964 / *Zertifikat für die Lektüre* Rebus, 1961

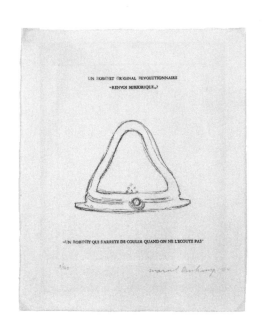

Mirrorical Return, 1964 / Gespiegelte Wiederkehr The Clock in Profile, 1964 / *Die Uhr im Profil*

Bouche-Évier (different versions), 1964/1967 / *Ausgußstopfen (unterschiedliche Versionen)*

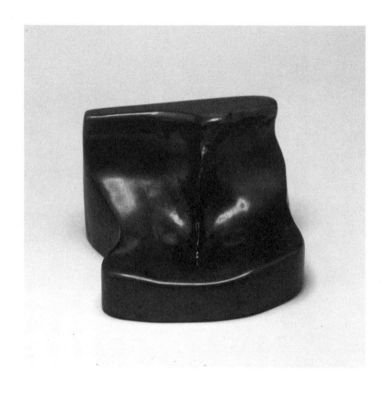

Female Fig Leaf, 1950/1961 / *Weibliches Feigenblatt*

184

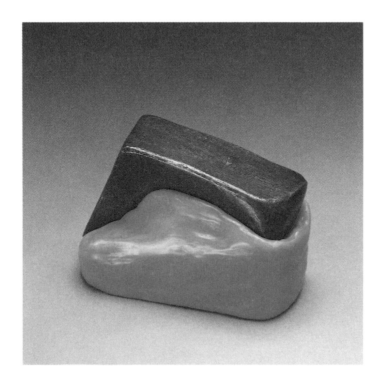

Wedge of Chastity, 1954/1963 / *Keil der Keuschheit*

185

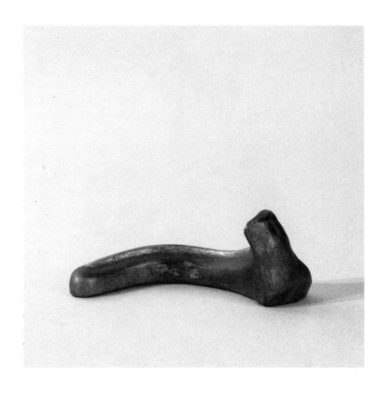

Objet Dard, 1951 / *Kunst-Objekt (Wortspiel)*

186

Couple of Laundress's Aprons, 1959 / *Paar Schürzen der Wäscherin*

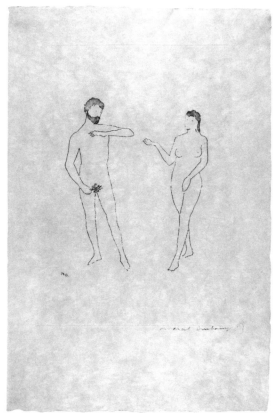
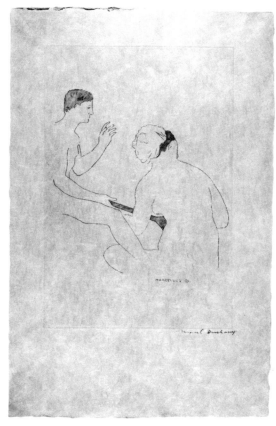

Morceaux choisis d'après Cranach et Relâche, 1967 / *Ausschnitt nach Cranach und Relâche*

Morceaux choisis d'après Ingres I, 1968 / *Ausschnitt nach Ingres I*

188

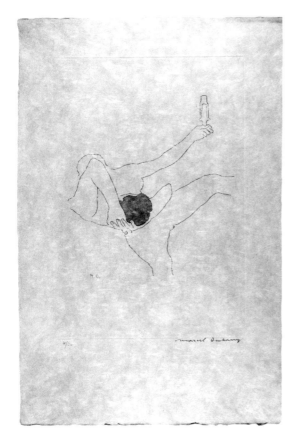

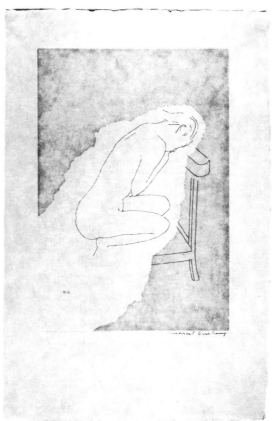

The Bec Auer, pun for instance with The Bachelor, 1968 / *Wortspiel*

La Mariée mise à nu …, 1968 / *Die Jungfrau, nackt entblößt*

189

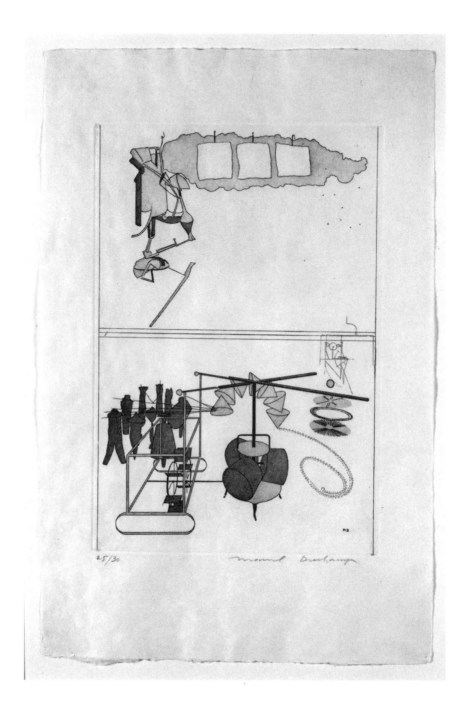

The Large Glass Completed, 1965 / *Das Große Glas komplettiert*

190

Where do we go from here?

Um die Zukunft zu erfinden, muß man vielleicht ausgehen von einer mehr oder weniger fernen Vergangenheit, die für uns heute mit dem Realismus von Courbet und Manet zu beginnen scheint. Es scheint tatsächlich so, als hätte der Realismus am Anfang der Befreiung des Künstlers als Individualisten gestanden, dessen Werk durch sich selbst existiert und dem sich der Betrachter oder der Sammler anpaßt, manchmal nur mit Anstrengung.

Diese Periode der Befreiung erzeugte ziemlich rasch die »Ismen«, die in den letzten 100 Jahren – etwa mit der Geschwindigkeit eines »Ismus« alle 15 Jahre – aufeinander gefolgt sind.

Um zu erraten versuchen, was sich morgen ereignen wird, muß man diese »Ismen«, anstatt sie auseinanderzuhalten, eher in einer gemeinsamen Direktive zusammenfassen.

Innerhalb eines Jahrhunderts moderner Kunst betrachtet, zeigen die allerneuesten Erzeugnisse des »Abstrakten Expressionismus« deutlich den Höhepunkt der retinalen Annäherung, die mit dem Impressionismus einsetzte. Mit »retinal« meine ich, daß der ästhetische Genuß fast ausschließlich vom Eindruck auf die Netzhaut abhängig ist, ohne eine andere Hilfsinterpretation zu beanspruchen.

Vor kaum 20 Jahren verlangte das Publikum von einem Kunstwerk noch irgendwelche gegenständlichen Einzelheiten, um sein Interesse oder seine Bewunderung verantworten zu können.

Heute ist beinahe das Gegenteil wahr ... das große Publikum kennt die Existenz der Abstraktion, versteht sie und fordert sie sogar von den Künstlern.

Ich spreche nicht von den Sammlern, die bereits seit 50 Jahren dieses Fortschreiten in Richtung einer vollständigen Aufgabe der Gegenständlichkeit in den visuellen Künsten unterstützt haben; sie sind, genauso wie die Künstler, vom Lauf der Dinge mitgerissen worden. Die Tatsache, daß sich das Problem der letzten hundert Jahre fast ausschließlich auf das Dilemma des »Gegenständlichen und des Ungegenständlichen« reduzierte, scheint mir die Wichtigkeit zu bekräftigen, die ich weiter oben dem vollständig retinalen Aspekt der gesamten Produktion der verschiedenen »Ismen« beimaß.

Darum bin ich nach dieser Überprüfung der Vergangenheit zu glauben geneigt, daß der junge Künstler von morgen sich weigern wird, sein Werk auf eine so einseitige Philosophie wie die des Dilemmas von »gegenständlich oder ungegenständlich« abzustützen.

Wie »Alice im Wunderland« wird er, davon bin ich überzeugt, bewogen

sein, durch den Spiegel der Netzhaut hindurchzugehen, um zu einem tieferen Ausdruck vorzudringen.

Ich weiß zu gut, daß der Surrealismus unter all den »Ismen«, die ich oben erwähnte, die Erforschung des Unbewußten eingeführt und die Rolle der Netzhaut auf die eines Fensters reduziert hat, das für die Phänomene der »grauen Materie« offen steht.

Der junge Künstler von morgen wird, glaube ich, genau in dieser Richtung noch weiter gehen müssen, um neue Schock-Werte an den Tag zu fördern, die die Grundlage der künstlerischen Revolutionen sind und immer sein werden.

Wenn wir nun eher die technische Seite einer möglichen Zukunft ins Auge fassen, so ist es sehr wahrscheinlich, daß der Künstler – des Ölkults in der Malerei müde – dazu bewogen sein wird, dieses 5 Jahrhunderte alte Verfahren vollständig aufzugeben, dessen akademisches Joch seine Ausdrucksfreiheit nur behindert.

In jüngster Zeit sind bereits andere Techniken aufgetaucht, und man kann voraussehen, daß – so wie die Erfindung neuer Instrumente in der Musik die Sensibilität einer ganzen Zeitepoche verändert – die Lichtphänomene, die man den gegenwärtigen Fortschritten der Technik verdankt, unter anderen Mitteln zum neuen Werkzeug des neuen Künstlers werden können.

Im gegenwärtigen Zustand der Beziehungen zwischen Künstlern und Publikum sind wir Zeugen einer Riesenproduktion, die vom Publikum übrigens unterstützt und ermuntert wird. Durch ihre enge Verknüpfung mit dem Gesetz von Angebot und Nachfrage sind die visuellen Künste eine »commodity« geworden: das Kunstwerk ist jetzt ein gangbares Produkt wie die Seife und die »securities«.

Man kann sich also sehr wohl die Schaffung eines Syndikats vorstellen, welches sämtliche den Künstler betreffenden ökonomischen Fragen regeln würde ... man kann sich vorstellen, wie dieses Syndikat den Verkaufspreis der Kunstwerke bestimmt, so wie das Syndikat der Bleileger die Löhne jedes Arbeiters reglementiert ... man kann sich weiter vorstellen, wie dieses Syndikat den Künstler zwingt, seine Persönlichkeit in einem Maße aufzugeben, daß er nicht einmal mehr das Recht hat, seine Werke zu signieren. Würde die Gesamtheit der künstlerischen Produktion, von einem derartigen Syndikat dirigiert, wohl eine Art epochemachendes Monument darstellen, das mit den anonymen Kathedralen vergleichbar wäre?

Diese verschiedenen Aspekte der heutigen Kunst führen uns dazu, sie global in der Form einer hypertrophierten Exoterik zu betrachten. Ich meine damit die Tatsache, daß das große Publikum viel Kunst, viel zu viel Kunst akzeptiert und verlangt; daß das große Publikum heute ästhetische Befriedigungen

sucht, die in einem Spiel von materiellen und spekulativen Werten verpackt sind, und daß es die künstlerische Produktion zu einer massiven Verwässerung treibt.

Diese massive Verwässerung, die das an Qualität verliert, was sie an Quantität gewinnt, wird von einer Nivellierung von unten her des gegenwärtigen Geschmacks begleitet und wird in naher Zukunft einen Nebel von Mittelmäßigkeit zur Folge haben.

Zum Schluß hoffe ich, daß diese Mittelmäßigkeit, die durch zuviele, der Kunst per se fremde Faktoren bedingt ist, eine Revolution, diesmal eine von asketischer Art, herbeiführen wird, über die sich das große Publikum nicht einmal bewußt werden wird und die bloß einige Eingeweihte entwickeln werden, – am Rande einer Welt, die durch das ökonomische Feuerwerk geblendet ist.

The great artist of tomorrow will go underground.

Zit. nach: Marcel Duchamp, Die Schriften, Bd. 1, Hrsg. Serge Stauffer, Zürich 1981, S. 241–242; Erstdruck in: Studio International, London, Bd. 189, Nr. 973, Januar – Februar 1975, S. 304

Where do we go from here? / *Wohin gehen wir von hier aus?*
Vortrag vom 20. März 1961
Philadelphia Museum College of Art

Philadelphia, 1960

colloquif art

WHERE DO WE GO FROM HERE?

Pour inventer l'avenir il faut peutêtre partir d'un passé
plus ou moins récent qui pour nous aujourdhui semble commencer avec
le réalisme de Courbet et de Manet. Il semble bien en effet que le
réalisme ait été à la base de la libération de l'artiste en tant
qu'individu dont l'oeuvre existe par elle-même et à laquelle le spectateur ou le collectioneur s'adapte, quelquefois avec effort.

Cette période de libération donne bien vite naissance à tous
les ismes qui se sont succédés pendant les 100 dernières années,
à la vitesse d'un nouvel isme toutes les 15 ans environ.

Il faut je crois, au lieu de différencier ces ismes, les
grouper dans une directive commune pour essayer de deviner ce qui
se passe, demain.

Considérées dans le cadre d'un siècle d'art moderne, les
productions très récentes d'abstract-expressionism montrent bien
l'apogée de l'approche rétinienne commencée par l'impressionisme.
Par "rétinien" j'entends que la délectation esthétique dépend presque
exclusivement de l'impression sur la rétine sans faire appel à aucune
interprétation auxiliaire.

Il y a 20 ans à peine le public demandait encore à l'oeuvre
d'art quelque détail représentatif pour justifier son interêt ou
admiration.

Aujourd'hui le contraire est presque vrai...le grand public
connait l'existence de l'abstraction, la comprend et l'exige même
des artistes.

2

Je ne parle pas des collectionneurs qui ont soutenu depuis
50 ans cette progression vers un complet abandon de la réprésentation
dans les arts visuels, ils ont été, comme les artistes, entrainés par
le courant. Le fait que le problème des cent dernières années se
réduise presque au seul dilemme du "représentatif et du non représentatif" me semble corroborer l'importance que je donnais il y a
un instant à l'aspect complètement rétinien de toute la production
des différents ismes.

Therefore après cet examen du passé je suis enclin à croire que
le jeune artiste de demain refusera de baser son oeuvre sur une philosophie aussi simpliste que celle du dilemme "représentatif ou non
représentatif."

Il sera amené, j'en suis convaincu, à traverser le miroir de la
rétine comme Alice in Wonderland pour atteindre à une expression
plus profonde.

Je sais trop bien que parmi les ismes dont je viens de parler,
le surréalisme a introduit l'exploration du subconscient et réduit
le rôle de la rétine à celui de fenêtre ouverte sur des phénomènes
"matière grise."

Le jeune artiste de demain devra je crois aller plus loin
encore dans cette même direction pour mettre à jour de nouvelles
valeurs de choc qui sont et seront toujours la base des révolutions
artistiques.

Si maintenant nous envisageons le côté plus technique d'un
avenir possible il est très probable que, las du culte de l'huile dans
la peinture, l'artiste se trouvera amené à abandonner complètement ce
procédé vieux de 5 siècles et dont le joug académique, génera sa
liberté d'expression.

3

D'autres techniques se sont déjà fait jour récemment et on
peut prévoir que de même que l'invention de nouveaux instruments
en musique change toute la sensibilité d'une époque, les phénomènes
lumineux dus aux progrès scientifiques actuels peuvent entre autres
moyens, devenir l'outil nouveau pour l'artiste nouveau.

Dans l'état actuel des rapports entre artistes et public nous
sommes témoins d'une production gigantesque que le public d'ailleurs
soutient et encourage. Les arts visuels par leur étroite connexion
avec la loi de l'offre et de la demande sont devenus une "commodity".
L'oeuvre d'art est maintenant un produit courant comme le savon et
les "securities."

On peut donc parfaitement imaginer la création d'un syndicat
qui règlerait toutes les questions économiques concernant l'artiste...
on peut imaginer ce syndicat décidant du prix de vente des oeuvres d'art
comme le syndicat des plombiers règlemente les salaires de chaque
ouvrier...on peut encore imaginer ce syndicat forçant l'artiste
à abdiquer sa personnalité au point de ne pas même avoir le droit
de signer ses oeuvres. L'ensemble de la production artistique
dirigée par un syndicat de ce genre formerait-il une sorte de
monument de l'époque comparable aux cathédrales anonymes??

Ces divers aspects de l'art d'aujourd'hui nous amènent à
l'envisager globalement sous la forme d'un exotérisme hypertrophié.
J'entends par là que le grand public accepte et demande beaucoup
d'art, beaucoup trop d'art; que le grand public recherche aujourd'hui
des satisfactions esthétiques enveloppées dans un jeu de valeurs
materielles et spéculatives, et entraine la production artistique
vers une dilution massive.

4

Cette dilution massive perdant en qualité ce qu'elle gagne
en quantité s'accompagne d'un nivellement par le bas du goût présent
et aura pour conséquence immédiate un brouillard de médiocrité sur
un avenir prochain.

Pour conclure j'espère que cette médiocrité conditionnée par
trop de facteurs étrangers à l'art per se amènera une révolution
d'ordre ascétique cette fois dont le grand public ne sera même
pas conscient et que seuls quelques initiés développeront en marge
d'un monde aveuglé par le feu d'artifice. économique.

The great artist of tomorrow will go underground.

Marcel Duchamp

Where do we go from here?

To imagine the future, we should perhaps start from the more or less recent past, which seems to us today to begin with the realism of Courbet and Manet. It does seem in fact that realism is at the heart of the liberation of the artist as an individual, whose work, to which the viewer or collector adapts himself, sometimes with difficulty, has an independent existence.

This period of liberation rapidly gave birth to all the "isms" which have followed one another during the last century, at the rate of one new "ism" about every fifteen years.

I believe that to try and guess what will happen tomorrow, we must group the "isms" together through their common factor, instead of differentiating them.

Considered in the framework of a century of modern art, the very recent examples of Abstract Expressionism clearly show the ultimate in the retinal approach begun by Impressionism. By "retinal" I mean that the aesthetic pleasure depends almost entirely on the impression on the retina, without appealing to any auxiliary interpretation.

Scarcely twenty years ago the public still demanded of the work of art some representative detail to justify its interest and admiration.

Today, the opposite is almost true ... the general public is aware of the existence of abstraction, understands it and even demands it of the artists.

I am not talking about the collectors who for fifty years have supported this progression towards a total abandon of representation in the visual arts, like the artists, they have been swept along by the current. The fact that the problem of the last hundred years boils down almost entirely to the single dilemma of the "representative and the non-representative" seems to me to reinforce the importance I gave a moment ago to the entirely retinal aspect of the total output of the different "isms".

Therefore I am inclined, after this examination of the past, to believe that the young artist of tomorrow will refuse to base his work on a philosophy as oversimplified as that of the "representative or non-representative" dilemma.

I am convinced that, like Alice in Wonderland, he will be led to pass through the looking-glass of the retina, to reach a more profound expression.

I am only too well aware that among the "isms" which I have mentioned, Surrealism introduced the exploration of the subconscious and reduced the role of the retina to that of an open window on the phenomena of the brain.

The young artist of tomorrow will, I believe, have to go still further in this

same direction, to bring to light starting new values which are and will always be the basis of artistic revolutions.

If we now envisage the more technical side of a possible future, it is very likely that the artist, tired of the cult for oils in painting, will find himself completely abandoning this five-hundred-year-old process, which restricts his freedom of expression by its academic ties.

Other techniques have already appeared recently and we can foresee that just as the invention of new musical instruments changes the whole sensibility of an era, the phenomenon of light can, due to current scientific progress, among other things, become the new tool for the new artist.

In the present state of relations between artists and the public, we can see an enormous output which the public moreover supports and encourages. Through their close connection with the law of supply and demand the visual arts have become a "commodity"; the work of art is now a commonplace product like soap and securities.

So we can perfectly well imagine the creation of a union which would deal with all the economic questions concerning the artist ... we can imagine this union deciding on the selling price of works of art, just as the plumbers' union determines the salary of each worker ... we can even imagine this union forcing the artist to abandon his identity, even to the point of no longer having the right to sign his works. Would the total artistic output controlled by a union of this kind form a sort of monument to a given era comparable to the anonymous cathedrals?

These various aspects of art today bring us to look at it as a whole, in terms of an over-developed exoteric. By that I mean that the general public accepts and demands a lot from art, far too much from art; that the general public today seeks aesthetic satisfaction wrapped up in a set of material and speculative values and is drawing artistic output towards an enormous dilution.

This enormous dilution, losing in quality what it gains in quantity, is accompanied by a levelling down of present taste and its immediate result will be to shroud the near future in mediocrity.

In conclusion, I hope that this mediocrity conditioned by too many factors foreign to art per se, will this time bring a revolution on the ascetic level, of which the general public will not even be aware and which only a few initiates will develop on the fringe of a world blinded by economic fireworks.

The great artist of tomorrow will go underground.

Where do we go from here?, in: Studio International, London, Vol. 189, Nr. 973, January – February 1975, p. 304

Two drawings of Cheminée anaglyphe, 1968 / *Zwei stereometrische Zeichnungen für einen Kamin*

Marcel Duchamp ou le château de la purité by Octavio Paz
Marcel Duchamp oder das Schloß der Reinheit von Octavio Paz

198

BIOGRAPHIE

1887 Am 27. Juli wird Henri Robert Marcel Duchamp in Blainville geboren. Sein Vater, Eugène Duchamp, ist Notar. Die Mutter, Marie Lucie Caroline Nicolle, stammt aus einer Künstlerfamilie, ihr Vater, Emile Nicolle, war Maler und Graveur. In der Familie begeistert man sich für die Künste. Marcel und seine beiden Brüder Jacques Villon (Maler) und Raymond Duchamp-Villon (Bildhauer) wählen den Künstlerberuf. Außerdem hat Marcel noch drei jüngere Schwestern, Suzanne, die auch Malerin wird, Yvonne und Madeleine.

1902 Es entstehen erste Gemälde in der Umgebung von Blainville.

1904 Beendet die Schule und siedelt nach Paris über, wo er bei seinem Bruder Jacques wohnt. Hin und wieder besucht er die Académie Julian.

1905 Volontariat in einer Druckerei in Rouen. Anschließend absolviert er einen ein-jährigen Militärdienst.

Kneeling Peasant, back view, 1904–05 / *Kniender Bauer, Rückenansicht*

199

1906 Duchamp ist wieder in Paris, wo er Karikaturen für Zeitungen zeichnet.

1908 Sein Wohnsitz wird Neuilly, erstmals stellt er im Salon d'Automne aus.

1910 Beteiligt er sich an Ausstellungen im Salon des Indépendants. Begegnet bei
 Zusammenkünften in Villons Atelier in Puteaux u.a. Albert Gleizes, Fernand
 Léger, Roger de la Fresnaye, Guillaume Apollinaire und Jean Metzinger. Sein
 Malstil zeigt Einflüsse von Cézanne, des Symbolismus, Kubismus und Futuris-
 mus. Beschäftigung mit der Chronofotografie. Duchamp lernt Francis Picabia
 kennen. Erstes Maschinenbild *Kaffeemühle*.

1912 Es entsteht der *Akt, die Treppe herabsteigend*, das Bild wird vom Salon des
 Indépendants abgelehnt, jedoch in Barcelona gezeigt. Besuch des Theaterstücks
 Impressions d'Afrique von Raymond Roussel, das ihn stark beeindruckt. Reise
 nach München. Dort Studien zu *Braut* und *Junggeselle*. Über Wien, Prag, Dres-
 den und Berlin reist er nach Paris zurück, wo er im Salon de la Section d'Or,
 von der Gruppe Puteaux organisiert, mitwirkt. Gemeinsam mit Picabia und
 Apollinaire reist er nach Etival, im Schweizer Jura. Duchamp beschließt, mit der
 Malerei aufzuhören und neue Ausdrucksformen für sich zu suchen. Er arbeitet
 in der Bibliothek von Sainte-Geneviève und beschäftigt sich mit Fragen zur Per-
 spektive.

1913 Teilnahme an der internationalen Ausstellung moderner Kunst (Armory Show)
 in New York. Ein Skandal um sein Werk *Akt, die Treppe herabsteigend* macht ihn
 in den USA berühmt. Erste Studien zum *Großen Glas* entstehen. Montiert das
 Roue de bicyclette.

1914 Kauft in einem Pariser Kaufhaus einen Flaschentrockner, den er in sein Atelier
 stellt. Die erste Schachtel mit reproduzierten Notizen entsteht.

1915 Reise nach New York. Wohnt bei Louise und Walter Arensberg, die seine wichtig-
 sten Mäzene werden sollten. Beginnt mit den Arbeiten des *Großen Glases* und
 spricht erstmals von »Ready-made«. Lernt Man Ray kennen.

1916 Duchamp macht die Bekanntschaft von Beatrice Wood und Henri-Pierre Roché.

1917 Gründungsmitglied der Society of Independent Artists, übernimmt die Funktion
 eines der Direktoren. Zu einer Ausstellung reicht er *Fontäne*, ein Pissoirbecken,
 ein, das er mit »R. Mutt« signiert hat. Nachdem es abgelehnt wurde, tritt
 Duchamp zurück.
 Veröffentlicht gemeinsam mit Beatrice Wood und Roché zwei Zeitschriften im
 dadaistischen Stil, »The Blind Man« (zwei Nummern) und »Rongwrong« (eine
 Nummer).

1918 Stellt für Katherine Dreier sein letztes Gemälde *Tu m'* fertig.

1919 Reise nach Buenos Aires. Beginnt sich mit dem Schachspiel zu beschäftigen.
 Kurzer Aufenthalt in Paris.

Place Cards for Fania Marinoff and Carlo van Vechten, 1917
Platzkarten für Fania Marinoff und Carlo van Vechten

1920 Gründet in New York mit Katherine Dreier und Man Ray die Société Anonyme, das erste Museum für moderne Kunst in den USA. Er konstruiert sein erstes optisches Gerät, *Rotierende Glasplatten*. Er wählt das Pseudonym »Rrose Sélavy«.

1921 Die einzige Nummer von »New York Dada« entsteht.

1923 Stellt die Arbeiten am *Großen Glas* ein. Kehrt nach Europa zurück und lebt mit wenigen Unterbrechungen in Paris. Nimmt erstmals an Schachturnieren teil. Da er sich bis 1934 weitgehend dem professionellen Schachspiel widmet, entsteht der Eindruck, daß er sich von der Kunst zurückzieht.

1926 Beteiligung an der Internationalen Ausstellung für Moderne Kunst in New York u. a. mit *Das Große Glas*, das hier erstmals gezeigt wird. Während eines späteren Transportes zerbricht es.

1934 Herausgabe der *Grünen Schachtel*, in der sich eine Sammlung von Notizen, Zeichnungen und Fotos zum *Großen Glas* befindet.

1936 Hält sich in den USA auf, wo er das *Große Glas* repariert und in der Bibliothek von Katherine Dreier aufstellt.

1937 Erste Einzelausstellung in Chicago. Entwurf der Glastür *Gradiva* für die Galerie von André Breton in Paris.

1938 Aufbau der »Internationalen Ausstellung des Surrealismus« in Paris.

1940 Beendet die *Schachtel im Koffer*.

1942 Rückkehr nach New York, nimmt Quartier bei Peggy Guggenheim und Max Ernst. Organisiert gemeinsam mit André Breton die Ausstellung »First Papers of Surrealism«.

1943 Entwirft das Titelblatt für die Zeitschrift »VVV« Nr. 2–3. Das *Große Glas* wird bis 1946 im Museum of Modern Art in New York aufgestellt.

1945 Ausstellung »Duchamp, Duchamp-Villon, Villon« in New Haven. Entwurf für das Titelblatt einer Nummer der Zeitschrift »View«, die ihm selbst gewidmet ist. Erster musealer Ankauf eines Werkes von Duchamp durch das Museum of Modern Art in New York.

1946 Die Arbeiten zu seinem Werk *Etant donnés* beginnen. Es wird in 20 Jahren ausgearbeitet und erst nach Duchamps Tod in der Öffentlichkeit bekannt.

1947 Beteiligung an einem Film von Hans Richter *Dreams that Money can buy*, die Musik stammt von John Cage.

1949 In San Francisco nimmt er an einer Diskussion zur modernen Kunst teil. In Chicago besucht er Louise und Walter Arensberg, die in einer Ausstellung ihre Sammlung vorstellen, in der sich auch dreißig Werke Duchamps befinden.

1950 Gedruckt wird der Katalog der Société Anonyme im Verlag der Yale Universität, er enthält 33 Texte Duchamps, verfaßt von 1943 bis 1949.

1953 Beteiligung an den Vorbereitungen der Ausstellung »Dada 1916–1923« in New York, 12 Werke von Duchamp werden gezeigt. In New York ist die Ausstellung »Marcel Duchamp – Francis Picabia« zu sehen.

1954 Ehe mit Alexina (Teeny) Sattler. Sein Hochzeitsgeschenk ist *Coin de Chasteté*.

1955 Nimmt die amerikanische Staatsbürgerschaft an. Seine Trauzeugen sind Alfred Barr (Direktor des Museum of Modern Art, New York), James Johnson Sweeny (Guggenheim Museum, New York) und James Thrall Soby (Museum der Yale University).

1959 Robert Lebels Buch *Sur Marcel Duchamp*, die erste wichtige Studie zu Duchamp, erscheint in Paris. Beteiligt sich an der »Internationalen Ausstellung des Surrealismus«, Organisation durch André Breton.

1960 Besucht Happenings in New York, wird zu einer Größe in der jüngeren Künstler-
generation, Rauschenberg, Morris, Arman, Johns interessieren sich für sein
Werk. Das National Institute of Arts and Letters in New York wählt ihn zum
Mitglied.

1961 Repliken seiner Werke entstehen, Ulf Linde baut das *Große Glas* nach. Ehrendok-
torwürde der Wayne State University, Detroit.

1963 Retrospektive seines Werkes im Pasadena Art Museum, Titel der Ausstellung:
»By or of Marcel Duchamp or Rrose Sélavy«.

1964 Repliken von 13 Ready-mades in einer Auflage von jeweils acht Stück durch
Arturo Schwarz, Mailand.

1965 Für die Ausstellung der Werke Mary Sislers fertigt er die *Mona Lisa, rasée,* an.
Titel der Ausstellung: »Not seen and / or Less seen of / by Marcel Duchamp /
Rrose Sélavy 1904–1964«.

1966 Duchamp stellt in der Tate Gallery London aus. Die zweite von Richard Hamilton
gefertigte Replik des *Großen Glases* wird ausgestellt, insgesamt sind
240 Werke und Dokumente zu sehen. Er beendet *Etant donnés.*

1967 Nimmt am internationalen Schachturnier in Monte Carlo teil. Erste große
Ausstellung in Paris, Musée National d'Art Moderne. In New York ediert er die
Weiße Schachtel.

1968 Nimmt teil an der Musikperformance *Reunion,* die von John Cage in Toronto
veranstaltet wird. Besucht die Premiere von *Walkaround,* einem Ballett von
Merce Cunningham in der Dekoration des *Großen Glases,* die ihrerseits von
Jasper Johns konzipiert worden ist. Die Aufführung wird in Buffalo realisert.
Arbeitet an dem Projekt *Cheminée anaglyphe,* das er in seinem Haus in Cadaquès
errichten will. Kehrt im Herbst nach Paris zurück. Er stirbt am 2. Oktober in
Neuilly, seine Beisetzung findet in Rouen statt.
Auf dem Grabstein ist vermerkt: »D'ailleurs c'est toujours les autres qui meu-
rent« (Am Ende sind es immer die anderen, die sterben).

1887 Henri Robert Marcel Duchamp is born in Blainville on July 27th. His father,
Eugène Duchamp, is an attorney. His mother, Marie Lucie Caroline Nicolle,
comes from a family of artists. Her father, Emile Nicolle, is a painter and engra-
ver. Enthusiasm for the arts is a major part of family life. Marcel and his brothers
Jacques Villon (painter) and Raymond Duchamp-Villon (sculptor) choose
professions in art. Of Marcel's three younger sisters, Yvonne, Madeleine and
Suzanne, the latter also becomes a painter.

1902 First paintings are completed in the surroundings of Blainville.

1904 Duchamp finishes school and moves to Paris, where he lives with his brother
Jacques. He attends the Académie Julian irregularly.

1905 Practical training in a Paris printing shop, followed by a year of military service.

1906. Duchamp returns to Paris, where he draws caricatures for newspapers.

1908 Moves to Neuilly and exhibits his work in the Salon d'Automne for the first time.

1910 Takes part in exhibitions in the Salon des Indépendents. At gatherings in Villon's
atelier in Puteaux Duchamp meets Albert Gleizes, Fernand Léger, Roger de la
Fresnaye, Guillaume Apollinaire, Jean Metzinger and others. His painting style
shows the influence of Cézanne, of Symbolism, Cubism and Futurism. He expe-
riments with chronophotography, meets Francis Picabia and completes his first
machine painting, *Coffee-Mill.*

1912 The work entitled *Nude Descending a Staircase* is completed and rejected by the
Salon des Indépendents, but shown in Barcelona. Duchamp is greatly impressed
by a performance of Raymond Roussel's play, *Impressions d'Afrique.* Journey to
Munich, where he does studies for *Bride* and *Bachelor;* further travel to Vienna,
Prague, Dresden and Berlin before returning to Paris, where he becomes invol-
ved with the Salon de la Section d'Or, organized by the Puteaux group. Journey
with Picabia and Apollinaire to Etival, Canton of Jura in Switzerland. Duchamp
decides to abandon painting and seek new forms of expression. Working in the
library of Sainte-Geneviève, he concerns himself with questions of perspective.

1913 Duchamp participates at the international Armory Show in New York. Scandal
surrounding his work, *Nude Descending a Staircase,* brings him fame in the U.S.
First studies for *The Large Glass* completed. He is making the *Bicycle Wheel.*

1914 Purchases a "bottle rack" in a Paris department store and places it in his atelier.
The first box containing reproduced notes is completed.

1915 Journey to New York, where he lives with Louise and Walter Arensberg, who
later become his most important patrons. Duchamp begins work on *The Large
Glass,* and begins to speak of "Ready-mades" for the first time. Meets Man Ray.

La Mère – Est-ce que je monte avec toi . . . aujourd'hui, L'Accident, 1909 / *Der Unfall*
1909 / *Die Mutter, soll ich heute mit Dir mitkommen?*

1916 Duchamp meets Beatrice Wood and Henri-Pierre Roché.

1917 Duchamp becomes a founding member of the Society of Independent Artists
 and one of its directors. He submits *Fountain,* a urinal signed "R. Mutt", for an
 exhibition. The work is rejected and Duchamp retracts his application. In co-
 operation with Beatrice Wood and Roché, Duchamp publishes two periodicals
 in Dadaist style, "The Blind Man" (two issues) and "Rongwrong" (one issue).

1918 Completes his last painting, *Tu m',* for Katherine Dreier.

1919 Travel to Buenos Aires. Duchamp develops an interest in chess, takes a brief
 journey to Paris.

1920 Together with Katherine Dreier and Man Ray, Duchamp founds the Société
 Anonyme, the first museum for modern art in the U.S., in New York. He designs
 his first optical piece, *Rotative Glass Plaques,* and chooses the name "Rrose
 Sélavy" as his pseudonym.

1921 Publication of the first and only issue of "New York Dada".

1923 Duchamp interrupts work on *The Large Glass* and returns to Europe to live,
 with infrequent interruptions, in Paris. Participates for the first time in chess
 tournaments. The fact that he devotes himself almost exclusively to chess until
 1934 suggests that he has turned away from art.

1926 Participation in the "International Exhibition for Modern Art" in New York, presenting, among other works, *The Large Glass,* for the first time. The work is severely damaged during subsequent transport.

1934 Issue of the *Green Box,* containing a collection of notes, drawings and photos related to *The Large Glass.*

1936 Duchamp journeys to the U.S., where he has *The Large Glass* repaired and placed in Katherine Dreier's library.

1937 First solo exhibition in Chicago. Duchamp completes a draft for his glass door, *Gradiva,* for the Galerie André Breton in Paris.

1938 Work on the "International Surrealism Exhibition" in Paris.

1940 Duchamp completes his *Box in a Suitcase.*

1942 Return to New York, where he lives with Peggy Guggenheim and Max Ernst. Together with André Breton, he organises the exhibition entitled "First Papers of Surrealism".

1943 Duchamp drafts the title page for issues 2 and 3 of the periodical *VVV. The Large Glass* is placed on exhibit at the Museum of Modern Art in New York until 1946.

1945 Exhibition entitled "Duchamp, Duchamp-Villon, Villon" in New Haven, Connecticut. Duchamp drafts the title page for an issue of "View" dedicated to himself. The first museum purchase of a Duchamp work is made by the Museum of Modern Art in New York.

1946 Duchamp begins work on his *Etant donnés,* which is to continue over the following 20 years. The work is not revealed to the public until after Duchamp's death.

1947 Duchamp cooperates on Hans Richter's film entitled *Dreams that Money can buy,* with music by John Cage.

1949 Participation in a discussion on modern art in San Francisco. Duchamp visits Louise and Walter Arensberg in Chicago, where they present their collections containing thirty of Duchamp's works at an exhibition.

1950 The catalogue of the Société Anonyme, containing 33 texts written by Duchamp between 1943 and 1949, is published by Yale University Press.

1953 Duchamp participates in preparations for the exhibition entitled "Dada 1916–1923" in New York. Twelve works by Duchamp are exhibited. The exhibition "Marcel Duchamp – Francis Picabia" is on view in New York in the same year.

1954 Marriage to Alexina (Teeny) Sattler. Duchamp's wedding gift is his *Coin de Chasteté.*

1955 Duchamp becomes an American citizen. Witnesses include Alfred Barr (Director of the Museum of Modern Art, New York), James Johnson Sweeny (Guggenheim Museum, New York) and James Thrall Soby (Yale University Museum).

1959 Robert Lebel's book *Sur Marcel Duchamp,* the first important Duchamp study, appears in Paris. Duchamp participates in the "International Exhibition of Surrealism" organised by André Breton.

1960 Duchamp attends happenings in New York. By this time, he has become a figure of importance for the younger generation of artists. Rauschenberg, Morris, Arman and Johns show great interest in his work. The National Institute of Arts and Letters in New York elects him to membership.

1961 Replicas of his works appear. Ulf Linde recreates *The Large Glass.* Honorary doctorate awarded by Wayne State University, Detroit.

1963 The Pasadena Art Museum presents a retrospective on his work under the title "By or of Marcel Duchamp or Rrose Sélavy".

1964 Replicas of thirteen Ready-mades in editions of eight copies each by Arturo Schwarz of Milan.

1965 Duchamp creates *Mona Lisa, rasée* for an exhibition of the work of Mary Sisler under the title "Not seen and / or Less seen of / by Marcel Duchamp / Rrose Sélavy 1904–1964".

1966 Duchamp exhibits in the Tate Gallery of London. The second of Richard Hamilton's replicas of *The Large Glass* is exhibited along with 240 other works and documents. Completion of *Etant donnés.*

1967 Duchamp takes part in the international chess tournament in Monte Carlo. The first major European exhibition of his works is presented at the Musée National d'Art Moderne in Paris. Duchamp edits his *White Box* in New York.

1968 Participates in the musical performance entitled *Reunion,* organised by John Cage in Toronto; attends the premier of *Walkaround,* a ballet by Merce Cunningham with decorations from *The Large Glass,* as conceived by Jasper Johns. The performance takes place in Buffalo. Duchamp works on his project *Cheminée anaglyphe,* which he plans to construct in his house in Cadaquès. Returns to Paris in the fall. Duchamp dies on October 2nd in Neuilly and is buried in Rouen. The inscription on his gravestone reads "D'ailleurs c'est toujours les autres qui meurent" (At the end, it is always the others who die).

Man Ray
Duchamp at chess, 1921 / *Duchamp beim Schachspiel*

VERZEICHNIS DER WERKE / LIST OF WORKS

* Heute / Today: Staatliches Museum Schwerin

* **Kneeling Pesant, back view**, 1904 – 05
Kniender Bauer, Rückenansicht
Aquarell; 17,3 x 10,7 cm
Bez.: Marcel Duchamp
Collection Ronny Van de Velde, Antwerpen
Abb. S. 199

* **Singer in Evening Dress**, 1908
Sänger im Abendanzug
Bleistift, Wasserfarbe; 15,5 x 11,8 cm
Bez.: M. Duchamp / 08
Collection Ronny Van de Velde, Antwerpen

* **La Mère – Est-ce que je monte avec toi . . .
aujourd'hui**, 1909
Die Mutter, soll ich heute mit Dir mitkommen?
Bleistift, Wasserfarbe, Gouache; 58 x 44,8 cm
Bez.: Duchamp 09
Collection Ronny Van de Velde, Antwerpen
Abb. S. 205

* **L'Accident**, 1909
Der Unfall
Bleistift, Tinte, Wasserfarbe; 61,5 x 49,5 cm
Bez.: Duchamp 09
Collection Ronny Van de Velde, Antwerpen
Abb. S. 205

Étude pour les joueurs d'échecs, 1911/1965
Studie für Schachspieler
Radierung; 52,5 x 67 cm, 44 x 58 cm
Bez.: Marcel Duchamp / 1965
Epreuve d'artiste pour Dieter Keller
Graphische Sammlung/Staatsgalerie Stuttgart
Inv.-Nr. GL 3439
Abb. S. 77

Roue de bicyclette, 1913/1964
Fahrrad-Rad
Ready-made: Fahrradgabel, Rad, Hocker
Höhe 126 cm
Hessisches Landesmuseum, Darmstadt
Inv.-Nr. GK 1307a
Abb. S. 118

Porte bouteilles, 1914/1964
Flaschentrockner
Ready-made: Galvanisiertes Eisen
Höhe 63 cm, Ø 37 cm
Staatsgalerie Stuttgart
Inv.-Nr. P 993
Abb. S. 25

Tamis (grandeur définitive), 1914
Haarsiebe (definitive Größe)
Bleistift, roter und blauer Farbstift; 76,9 x 55 cm
Bez.: Marcel Duchamp / 1914 (längerer Text
innerhalb der Darstellung)
Graphische Sammlung/Staatsgalerie Stuttgart
Inv.-Nr. C 76/2588
Abb. S. 41

* **Pharmacie**, 1914/1945
Apotheke
Handkolorierter Druck; 22 x 15,6 cm
Bez.: Pharmacie. Marcel Duchamp/1914
Collection Ronny Van de Velde, Antwerpen
Abb. S. 29

* **Draft Piston**, 1914 /1965
Durchzugskolben
Druck auf Zelluloid; 29,9 x 23,7 cm
Bez.: Marcel Duchamp
Collection Ronny Van de Velde, Antwerpen
Abb. S. 31

* **Comb**,1916/1964
Kamm
Ready-made: Stahlkamm; 16,6 x 3 cm
Bez.: M.D./FEB. 17 1916 11 AM / Marcel Duchamp
1964
Collection Ronny Van de Velde, Antwerpen
Abb. S. 24

* **Traveller's Folding Item**, 1916/1964
Faltbarer Reiseartikel
Ready-made: Schreibmaschinenhülle der Marke
»Underwood«
Höhe 23 cm
Bez.: Marcel Duchamp 1964
Collection Ronny Van de Velde, Antwerpen
Abb. S. 27

The Blind Man (P.B.T.), 1917
Der blinde Mann (P.B.T.)
Buchumschlag; 28,1 x 20,5 cm
Unbez.
Collection Ronny Van de Velde, Antwerpen

* **Place Card for Carlo van Vechten**, 1917
Platzkarte für Carlo van Vechten
Tinte auf Papier; 22,7 x 14,6 cm
Bez.: Marcel Duchamp / 30 ans.
Collection Ronny Van de Velde, Antwerpen
Abb. S. 201

* Place Card for Fania Marinoff, 1917
Platzkarte für Fania Marinoff
Tinte auf Papier; 22,7 x 14,6 cm
Bez.: Marcel Duchamp / 30 ans
Collection Ronny Van de Velde, Antwerpen
Abb. S. 201

* Place Card for Picabia, 1917
Platzkarte für Picabia
Tinte auf Papier; 14,7 x 11,3 cm
Collection Ronny Van de Velde, Antwerpen

* Trébuchet, 1917/1964
Stolperfalle
Assisted Ready-made: Kleiderhaken
11,7 x 100 cm
Bez.: Marcel Duchamp 1964 4/8
Collection Ronny Van de Velde, Antwerpen
Abb. S. 26

* L.H.O.O.Q., 1919/1964
Rectified Ready-made: Bleistift, weiße Gouache
auf farbigem Druck der Mona Lisa
30,1 x 23 cm
Bez.: Marcel Duchamp
Collection Ronny Van de Velde, Antwerpen
Abb. S. 10

* Paris Air, 1919/1964
Pariser Luft
Ready-made: Glasflasche; 13,3 cm hoch
Collection Ronny Van de Velde, Antwerpen

Rotative-plaque-verre, 1920/1961
Rotierende Glasplatten
Eisen, Plexiglas, Elektromotor
140 x 185 cm
Moderna Museet, Stockholm
Inv.-Nr. NMSk 1790
Abb. S. 170/71

Témoins oculistes, 1920/1967
Augenzeugen
Silber auf Glas; 63 x 51,5 x 1 cm,
65 x 51 x 20,5
Bez.: d'après Marcel Duchamp. Richard Hamilton
33/50
Graphische Sammlung/Staatsgalerie Stuttgart
Inv.-Nr. GL 3437
Abb. S. 45

* Fresh Widow, 1920/1964
Frische Witwe
Semi-Ready-made: Bemaltes Holzfenster mit
polierten Fächern aus Leder; 77,5 x 45 cm
Basis 10 x 53,3 x 1,5 cm
Bez.: Marcel Duchamp 1964 no 4/8
Collection Ronny Van de Velde, Antwerpen
Abb. S. 59

* New York Dada, 1921
Buchumschlag; 36,8 x 25,5 cm
Unbez.
Collection Ronny Van de Velde, Antwerpen
Abb. S. 60

* Obligation pour la Roulette de Monte-Carlo,
1924
Obligation für das Roulette von Monte Carlo
Rectified Ready-made: Farbdruck; Porträtfoto von
Man Ray; 31 x 19,5 cm
Bez.: Rrose Sélavy / Marcel Duchamp
Collection Ronny Van de Velde, Antwerpen
Abb. S. 61

* Project for Rotative Demisphere, 1924/1957
Projekt für eine rotierende Halbkugel
Fotografie des Originals von Man Ray für das
Cover von Georges Hugnet,
L'Aventure Dada (1916–1922), Galerie de
L'Institut, Paris 1957; 24,5 x 19 cm, 6/30
Collection Ronny Van de Velde, Antwerpen

* Poster for the Third Chess Championship, 1925
Plakat für die dritte Schachmeisterschaft
Druck; 77 x 58,4 cm
Collection Ronny Van de Velde, Antwerpen
Abb. S. 65

Esquivons les ecchymoses ..., 1926/1968
Scheibe mit Wortspiel
Karton, Schallplatte; Ø 16,5 cm
Graphische Sammlung/Staatsgalerie Stuttgart
Inv.-Nr. GL 3435
Abb. S. 233

Anémic Cinéma, 1925–26
in Verbindung mit Man Ray und Marc Allégret
s/w 35 mm Film, ohne Ton, 7 min
Bilder von 9 Scheiben mit Wortspielen, wechseln
ab mit 10 optischen Scheiben
20,5 x 25,1 x 11,5 cm
Bez.: COPYRIGHTED BY/Rrose Sélavy/1926
und ein Fingerabdruck
Collection Ronny Van de Velde, Antwerpen

210

* La Mariée mise à nu par ses Célibataires, même,
1934
The Green Box, Die grüne Schachtel
Die Braut von ihren Junggesellen nackt
entblößt, sogar
Grüne Pappschachtel, gefüttert mit grünem
Velourspapier. Die Schachtel enthält eine Farbtafel
und 93 faksimilierte handschriftliche Notizen und
Zeichnungen zu der Entwicklung des »Großen
Glases«.
Luxusexemplar, 4/XX
Editions Rose Sélavy (Marcel Duchamp),
18, rue de la Paix, Paris
September 1934; 33,2 x 28 x 2,5 cm
Collection Ronny Van de Velde, Antwerpen
Abb. S. 113

* **The Bride,** 1934
Die Braut
Aquatinta; 49,5 x 31 cm, 64 x 50 cm, Nr. 48/200
Bez.: Jacques Villon / Marcel Duchamp / Mariée
Collection Ronny Van de Velde, Antwerpen
Abb. S. 37

* **Rotoreliefs,** 1935
Set von 6 Scheiben,
farbige Offsetlithographie, beidseitig
12 Motive, Auflage 500; Ø 20 cm
Unbez.
Collection Ronny Van de Velde, Antwerpen
Abb. S. 173

* **Cover for Minotaure, No. 6,** 1935
Umschlag für Minotaurus, Nr. 6
Hrsg. A. Skira und E. Tériade
31,7 x 24,5 cm
Unbez.
Collection Ronny Van de Velde, Antwerpen
Abb. S. 172

Fluttering Hearts, 1936
Flatternde Herzen
Collage reproduziert als Titel für: Cahiers d'Art, XI,
Nr. 1–2, Paris 1936; 31,5 x 24,5 cm
Unbez.
Collection Ronny Van de Velde, Antwerpen
Abb. S. 99

* **Nude Descending a Staircase,** 1937
Akt, eine Treppe herabsteigend
Collotypie mit Pochoir (farbig); 35 x 20 cm
Bez.: Stempel
Collection Ronny Van de Velde, Antwerpen
Abb. S. 17

* **9 Moules Mâlic,**1938/1964
9 Männische Gußformen
Collotypie mit Pochoir (farbig) auf Plexiglas
23,5 x 33,5 cm,16,8 x 27,3 cm
Miniaturreproduktion von 9 moules mâlic, Nr. 7/9
Hrsg. Cordier & Ekstrom Gallery, New York
Bez.: Marcel Duchamp 1937 (geritzt)
Collection Ronny Van de Velde, Antwerpen
Abb. S. 48

* La Mariée mise à nu par ses Célibataires, même
(Le Grand Verre), 1938/39
Die Braut von ihren Junggesellen nackt
entblößt, sogar (Das Große Glas)
Collotypie mit Pochoir (farbig) auf Zelluloid
26,2 x 22,9 cm
Miniaturreproduktion, freistehend in einem
Metallrahmen
Unbez.
Collection Ronny Van de Velde, Antwerpen
Abb. S. 53

* **La Boîte-en-Valise,** 1941
de ou par Marcel Duchamp ou Rrose Sélavy
Die Schachtel im Koffer
entweder von Marcel Duchamp oder
Rrose Sélavy
Pappschachtel mit Miniaturrepliken und Farb-
reproduktionen der Werke Duchamps
39 x 35 x 8 cm
69 Teile; Serie A; enthält Replik von Glissière
Collection Ronny Van de Velde, Antwerpen

* **La Boîte-en-Valise,** 1941
de ou par Marcel Duchamp ou Rrose Sèlavy
Die Schachtel im Koffer
entweder von Marcel Duchamp oder
Rrose Sélavy
Pappschachtel mit Miniaturrepliken und Farb-
reproduktionen der Werke Duchamps
39 x 35 x 8 cm
68 Teile, Serie B
Collection Ronny Van de Velde, Antwerpen
Abb. S. 114/15

Cover for the catalogue First Papers of
Surrealism, 1942
Einband des Kataloges First Papers of
Surrealism
Papiereinband; 28 x 21,5 cm
Hrsg. Coordinating Council of French Relief
Society Inc., New York
Organisation: André Breton und Marcel Duchamp
Unbez.
Collection Ronny Van de Velde, Antwerpen
Abb. S. 100

* Cover for VVV, Almanac for 1943, No. 2–3,
1943
Einband für VVV, Almanach 1943, Nr. 2–3
Papiereinband; 28 x 21,5 cm.
Hrsg. David Hare, editorische Beratung:
André Breton, Marcel Duchamp, Max Ernst
Unbez.
Collection Ronny Van de Velde, Antwerpen
Abb. S. 100

**Cover for the catalogue of the Man Ray
Exhibition Objects of My Affection**, 1945
**Einband des Kataloges der Man Ray
Ausstellung Objects of My Affection**
Kartoniert; 29,4 x 23 cm
Unbez.
Collection Ronny Van de Velde, Antwerpen
Abb. S. 101

* **Cover for View, Marcel Duchamp Number, V,
No. 1**, 1945
**Umschlag für View, Ausgabe für Marcel
Duchamp, V, Nr. 1**
Papiereinband; 30,5 x 23 cm
Hrsg. Charles Henri Ford
Bez.: M. Duchamp 45
Collection Ronny Van de Velde, Antwerpen
Abb. S. 102

* **Cover and Jacket for Young Cherry Trees
Secured Against Hares by André Breton**, 1946
**Titel und Umschlag für Young Cherry Trees
Secured Against Hares von André Breton**
Papiereinband; 23,7 x 16 cm
Unbez.
Collection Ronny Van de Velde, Antwerpen
Abb. S. 103

* **Cover for the catalogue
Le Surréalisme en 1947**, 1947
**Umschlag des Kataloges
Le Surréalisme en 1947**
Papiereinband; 23,5 x 20,5 cm
Hrsg. Pierre à Feu, Edition Maeght, Internationale
Surrealismus-Ausstellung, zusammengestellt von
André Breton und Marcel Duchamp
Collection Ronny Van de Velde, Antwerpen
Abb. S. 104/5

* **Female Fig Leaf**, 1950/1961
Weibliches Feigenblatt
Galvanisierter Gips; 9 x 14 x 12,5 cm
Bez.: Feuille de vigne femelle / Marcel Duchamp
1951 (sic!)
Collection Ronny Van de Velde, Antwerpen
Abb. S. 184

Objet Dard, 1951
Kunst-Objekt (Wortspiel)
Galvanisierter Gips; 7,5 x 20,1 x 6 cm
Staatsgalerie Stuttgart
Inv.-Nr. GL 3436
Abb. S. 186

* **Layout for the catalogue Dada 1916–1923**,
1953
Gestaltung für den Dada-Katalog 1916–1923
Druck; 96,5 x 63,5 cm
Unbez.
Collection Ronny Van de Velde, Antwerpen
Abb. S. 107

* **Roto-Reliefs**, 1953
Set mit 6 Scheiben; 11,5 x 24,8 cm
Serie II
Unbez.
Collection Ronny Van de Velde, Antwerpen

* **Wedge of Chastity**, 1954/1963
Keil der Keuschheit
Bronze und Dentalkunststoff; 5,6 x 8,5 x 4,2 cm
Auflage 8 Exemplare
Bez.: Marcel Duchamp / COIN DE CHASTETÉ
Collection Ronny Van de Velde, Antwerpen
Abb. S. 185

Cover for le surréalisme, même I, 1956
Umschlag für le surréalisme, même I
Papiereinband; 19,5 x 19,5 cm
Unbez.
Collection Ronny Van de Velde, Antwerpen

La Boîte-en-Valise, 1958
**de ou par Marcel Duchamp ou Rrose Sélavy
Die Schachtel im Koffer
entweder von Marcel Duchamp oder
Rrose Sélavy**
Stoffbezogene Schachtel (Bezug naturbelassen),
Miniaturrepliken und Farbproduktionen
der Werke Duchamps; 40 x 38 x 9 cm
68 Teile, Serie C
Collection Ronny Van de Velde, Antwerpen

* Eau & Gaz à Tous les Étages, 1958
Wasser & Gas auf allen Etagen
Nachgemachtes Ready-made: Weiße Buchstaben
auf blauer Emailplatte
Bei dieser Boîte/Schachtel handelt es sich um
die erste Ausgabe von Robert Lebel, Sur Marcel
Duchamp
Auflage 137 Exemplare, davon 10 Exemplare I–X
numeriert, 17 von A–Q markiert, das Selbstporträt
im Profil ist mit N bezeichnet; 15 x 20 cm
Collection Ronny Van de Velde, Antwerpen
Abb. S. 117

Cover for the catalogue Le Dessin dans l'Art
Magique, 1958
Umschlag des Kataloges Le Dessin dans l'Art
Magique
Reproduktion eines handgeschriebenen
Anagramms; 32 x 24,7 cm
Bez.: Marcel Duchamp
Collection Ronny Van de Velde, Antwerpen

* Self-Portrait in Profile, 1958
Selbstporträt im Profil
Collage, farbiges Papier, blauer Grund, Librairie
La Hune, Paris; 65 x 50 cm
Bez.: Marcel dechiravit
Collection Ronny Van de Velde, Antwerpen
Abb. S. 175

Self-Portrait in Profile, 1958
Selbstporträt im Profil
Collage, farbiges Papier, roter Grund, Librairie
La Hune, Paris; 65 x 50 cm
Bez.: Marcel Duchamp / Marcel dechiravit
Collection Ronny Van de Velde, Antwerpen
Abb. S. 175

* Self-Portrait in Profile, 1958
Selbstporträt im Profil
Collage, farbiges Papier, blauer Grund, Librairie
La Hune, Paris; 65 x 50 cm
Bez.: Marcel Duchamp La Hune 1959 / Marcel
dechiravit 13/40
Collection Ronny Van de Velde, Antwerpen

* Première Lumière, 1959
Erstes Licht
Radierung; 12,2 x 15 cm
Bez.: Marcel Duchamp
Collection Ronny Van de Velde, Antwerpen
Abb. S. 177

* Couple of Laundress's Aprons, 1959
Paar Schürzen der Wäscherin
Imitiertes Ready-made
männliche Figur 20,3 x 17,7 cm;
weibliche Figur 20,5 x 19,8 cm
Bez.: Marcel Duchamp 59.
Collection Ronny Van de Velde, Antwerpen
Abb. S. 187

Tiré à 4 épingles, 1959
Von 4 Nadeln gezogen
Radierung, in Blau; 23 x 11,5 cm
Probedruck
Bez.: Marcel Duchamp
Collection Ronny Van de Velde, Antwerpen
Abb. S. 176

Cover for the catalogue Surrealist Intrusion
in the Enchanters' Domain, 1960/61
Umschlag des Kataloges Surrealist Intrusion in
the Enchanters' Domain
Umschlag; 17,8 x 17,8 cm
Unbez.
Collection Ronny Van de Velde, Antwerpen

* Rebus, 1961
Radierung; 26,5 x 19,5 cm
Bez.: Marcel Duchamp
Collection Ronny Van de Velde, Antwerpen
Abb. S. 181

* Poster for the exhibition 50th Anniversary of
the Famous International Armory Show 1913,
1963
Plakat der Ausstellung des 50. Jahrestages der
Internationalen Armory Show
Druck auf hellem Papier; 111,8 x 67,8 cm
Auflage 200 Exemplare
Bez.: Marcel Duchamp, 1963
Collection Ronny Van de Velde, Antwerpen

* Wanted, $ 2000 Reward, 1923/1963
Gesucht, 2000 $ Belohnung
Druck; 87,5 x 69 cm
Bez.: Marcel Duchamp
Collection Ronny Van de Velde, Antwerpen
Abb. S. 87

* Télécollage for E.L.T. Mesens, 1963
Télécollage für E.L.T. Mesens
Collage für E.L.T. Mesens Retrospektive
obere Seite: 2,4 x 7 cm, Mitte: 5 x 18,3 cm
Bez.: Marcel.
Collection Ronny Van de Velde, Antwerpen

* **The Clock in Profile,** 1964
 Die Uhr im Profil
 Karton gefaltet; 22 x 28 cm
 Bez.: Marcel Duchamp 1964
 Collection Ronny Van de Velde, Antwerpen
 Abb. S. 182

* **Certificat de Lecture,** 1964
 Zertifikat für die Lektüre
 Lithographie; 32 x 46,5 cm
 Bez.: Marcel Duchamp
 Collection Ronny Van de Velde, Antwerpen
 Abb. S. 181

 Four Ready-mades, 1964
 Vier Ready-mades
 Lithographie; 32 x 23,2 cm
 Bez.: Marcel Duchamp
 Collection Ronny Van de Velde, Antwerpen

 Mirrorical Return, 1964
 Gespiegelte Wiederkehr
 Radierung; 25,5 x 20 cm, 17,5 x 13,5 cm
 Bez.: 1/100 / Marcel Duchamp 1964
 Graphische Sammlung/Staatsgalerie Stuttgart
 Inv.-Nr. GL 3438
 Abb. S. 182

* **Bouche-Évier,** 1964/1967
 Ausgußstopfen
 Bronzeguß; Ø 7 cm x 5 cm, Abguß des Originals
 Version I, Nr. 65/100
 Bez.: Marcel Duchamp 64
 Collection Ronny Van de Velde, Antwerpen
 Abb. S. 183

* **Bouche-Évier,** 1964 /1967
 Ausgußstopfen
 Silberguß; Ø 7 cm x 5 cm, Abguß des Originals
 Version II, Nr. 81/100
 Bez.: Marcel Duchamp 64
 Collection Ronny Van de Velde, Antwerpen
 Abb. S. 183

* **Bouche-Évier,** 1964/1966
 Ausgußstopfen
 Polierter Edelstahl; Ø 7 cm x 0,5 cm
 Abguß des Originals
 Version III, Nr. 50/100
 Bez.: Marcel Duchamp 1964
 Collection Ronny Van de Velde, Antwerpen
 Abb. S. 182

 Bouche-Évier, 1964/1966
 Ausgußstopfen
 Polierter Edelstahl; Ø 7 cm x 0,5 cm, Abguß des
 Originals mit Spiegelglas hinterlegt, Abstand-
 halter, in Rahmen aus dunkel gebeiztem Holz und
 kreisrunder Messingleiste
 Version III
 Bez.: Marcel Duchamp 5/10 1964
 Privatbesitz
 Abb. S. 183

* **Pulled at Four Pins,** 1964
 Von vier Nadeln gezogen
 Radierung in Bister auf handgeschöpftem
 Japan-Papier; 67 x 51,5 cm
 Bez.: Marcel Duchamp
 Collection Ronny Van de Velde, Antwerpen

* **Pulled at Four Pins,** 1964
 Von vier Nadeln gezogen
 Radierung, in Schwarz auf handgeschöpftem
 Japan-Papier; 67 x 51,5 cm
 Bez.: Marcel Duchamp
 Collection Ronny Van de Velde, Antwerpen

 Pulled at Four Pins, 1964
 Von vier Nadeln gezogen
 Radierung, in Rosé auf handgeschöpftem
 Japan-Papier; 67 x 51,5 cm
 Bez.: Marcel Duchamp
 Collection Ronny Van de Velde, Antwerpen

* **L.H.O.O.Q. rasée,** 1965
 L.H.O.O.Q. rasiert
 Ready-made: Reproduction der Mona Lisa
 8,8 x 6,2 cm, 21 x 13,8 cm
 Bez.: Marcel Duchamp; rasée / L.H.O.O.Q.
 Graphische Sammlung/Staatsgalerie Stuttgart
 Inv.-Nr. A 79/5840
 Abb. S. 179

 Rotoreliefs, 1965
 Set mit 6 Kartonscheiben, Holzkasten, betrieben
 mit einem Motor; Ø 24,8 cm
 Bez.: M.D.
 Collection Ronny Van de Velde, Antwerpen

 Rotoreliefs, 1965
 Set mit 6 Kartonscheiben, Holzkasten, betrieben
 mit einem Motor; Ø 24,8 cm
 Bez.: M.D.
 Collection Ronny Van de Velde, Antwerpen

* **The Bride,** 1965
Die Braut
Radierung; 27 x 12 cm, 33 x 25 cm
Edition auf Velin, Auflage 30 Exemplare
Bez.: Marcel Duchamp
Collection Ronny Van de Velde, Antwerpen

* **The Top Inscription,** 1965
Die höchste Eintragung
Radierung, erster Zustand; 15,9 x 35 cm,
33 x 50 cm
Edition auf Velin, Auflage 30 Exemplare
Bez.: Marcel Duchamp
Collection Ronny Van de Velde, Antwerpen

* **The Nine Mâlic Moulds,** 1965
Die neun männischen Gußformen
Radierung, erster Zustand; 13,4 x 18, 25 x 33 cm
Edition auf Velin, Auflage 30 Exemplare
Bez.: Marcel Duchamp
Collection Ronny Van de Velde, Antwerpen

* **The Sieves,** 1965
Die Siebe
Radierung, erster Zustand;
18 x 13,5 cm, 33 x 25 cm
Edition auf Velin, Auflage 30 Exemplare
Bez.: Marcel Duchamp
Collection Ronny Van de Velde, Antwerpen

* **The Oculist Witnesses,** 1965
Augentäuschung
Radierung; 14,4 x 9,5 cm, 33 x 25 cm
Edition auf Velin, Auflage 30 Exemplare
Bez.: Marcel Duchamp
Collection Ronny Van de Velde, Antwerpen

* **The Water Mill,** 1965
Die Wassermühle
Radierung, erster Zustand; 25 x 14,3 cm,
33 x 25 cm
Edition auf Velin, Auflage 30 Exemplare
Bez.: Marcel Duchamp
Collection Ronny Van de Velde, Antwerpen

* **The Chocolate Grinder,** 1965
Die Schokoladenmühle
Radierung, erster Zustand;
26,1 x 33,3 cm, 33 x 50 cm
Edition auf Velin, Auflage 30 Exemplare
Bez.: Marcel Duchamp
Collection Ronny Van de Velde, Antwerpen

*' **The Large Glass,** 1965
Das Große Glas
Radierung, erster Zustand; 35 x 22,5 cm,
50 x 33 cm
Edition auf Velin, Auflage 30 Exemplare
Bez.: Marcel Duchamp
Collection Ronny Van de Velde, Antwerpen

* **The Large Glass Completed,** 1965
Das Große Glas komplettiert
Farbradierung; 35 x 22,5 cm, 50 x 33 cm
Edition auf Velin, Auflage 30 Exemplare
Bez.: Marcel Duchamp
Collection Ronny Van de Velde, Antwerpen
Abb. S. 190

* **La Boîte-en-Valise,** 1966
de ou par Marcel Duchamp ou Rrose Sélavy
Die Schachtel im Koffer
entweder von Marcel Duchamp oder
Rrose Sélavy
Schachtel mit rotem Leder bezogen,
Miniaturrepliken und Farbreproduktionen
der Werke Duchamps; 41,5 x 38,5 x 9,9 cm
80 Teile, Serie F
Collection Ronny Van de Velde, Antwerpen

* **À l'infinitif,** 1966
The White Box
Im Infinitiv
Die Weiße Schachtel
79 faksimilierte Notizen in sieben schwarzen
Umschlägen, ein Heft, Schachtel mit weißem
Leinen bezogen, darüber Schachtel aus Plexiglas
Nr. 148/150; 33,3 x 28,4 x 40 cm
Bez.: Marcel Duchamp 1966
Graphische Sammlung/Staatsgalerie Stuttgart
Inv.-Nr. A 88/6327
Abb. S. 116

* **Poster for the exhibition Ready-mades et**
Editions de et sur Marcel Duchamp, 1967
Plakat der Ausstellung Ready-mades und der
Edition von und über Marcel Duchamp
Druck; 69,5 x 48 cm
Bez.: Marcel Duchamp
Collection Ronny Van de Velde, Antwerpen
Abb. S. 109

* **Morceaux choisis d'après Cranach et**
»Relâche«, 1967 (New York)
Ausschnitt nach Cranach und Relâche
Radierung, erster Zustand
35 x 24 cm, 50,5 x 32,5 cm
Edition von 30 Kopien auf Velin
Bez.: Marcel Duchamp
Collection Ronny Van de Velde, Antwerpen
Abb. S. 188

215

* Après l'amour, 1967
Nach der Liebe
Radierung, erster Zustand
35 x 23,8 cm, 50,5 x 32,5 cm
Edition von 30 Kopien auf Velin
Bez.: Marcel Duchamp
Collection Ronny Van de Velde, Antwerpen

La Boîte-en-Valise, 1968
de ou par Marcel Duchamp ou Rrose Selavy
Die Schachtel im Koffer
entweder von Marcel Duchamp oder
Rrose Sélavy
Schachtel mit grünfarbigem Leder bezogen,
Miniaturrepliken und Farbreproduktionen
der Werke Duchamps; 41,5 x 38,5 x 9,9 cm
80 Teile, Serie G
Bez.: Marcel Duchamp (gestempelt)
Collection Ronny Van de Velde, Antwerpen

* The Sieves, 1968
Die Siebe
Multiple, Siebdruck auf auf beschichtetem Glas;
46 x 63 cm
Bez.: d'après Marcel Duchamp / Richard
Hamilton, Nr. 30/50
Collection Ronny Van de Velde, Antwerpen
Abb. S. 45

* The Large Glass and Related Works (vol. I)
by Arturo Schwarz, 1967
Das Große Glas und verwandte Arbeiten
(Bd. I) von Arturo Schwarz
Halbband, gefalteter Umschlag; 42,5 x 25 cm
Bez.: Marcel Duchamp
Collection Ronny Van de Velde, Antwerpen

* Arturo Schwarz: The Large Glass and Related
Works (vol. II), 1968
Arturo Schwarz: Das Große Glas und
verwandte Arbeiten (Bd. II)
Halbband mit bedruckten Papieren, eingelegt in
eine mit rotem Stoff bezogene Schachtel;
beigefügt ein leinenähnlicher Koffer bedruckt mit:
»éros c´est la vie / Rrose Sélavy«; 42,2 x 25 cm
Bez.: Marcel Duchamp
Collection Ronny Van de Velde, Antwerpen

* Morceaux choisis d'après Rodin, 1968
Ausschnitt nach Rodin
Radierung, erster Zustand
35 x 24 cm, 50,5 x 32,5 cm
Edition auf Velin, Auflage 30 Exemplare
Bez.: Marcel Duchamp
Collection Ronny Van de Velde, Antwerpen

* The Bec Auer, pun for instance with
The Bachelor, 1968
Wortspiel
Radierung, erster Zustand
35 x 23,8 cm, 50,5 x 32,5 cm
Edition auf Velin, Auflage 30 Exemplare
Bez.: Marcel Duchamp
Collection Ronny Van de Velde, Antwerpen
Abb. S. 189

* Morceaux choisis d'après Ingres I, 1968
Ausschnitt nach Ingres I
Radierung, erster Zustand
35 x 23,8 cm, 50,5 x 32,5 cm
Edition auf Velin, Auflage 30 Exemplare
Bez.: Marcel Duchamp
Collection Ronny Van de Velde, Antwerpen
Abb. S. 188

* La Mariée mise à nu ..., 1968
Die Jungfrau, nackt entblößt
Radierung, erster Zustand
35 x 23,8 cm, 50,5 x 32,5 cm
Edition auf Velin, Auflage 30 Exemplare
Bez.: Marcel Duchamp
Collection Ronny Van de Velde, Antwerpen
Abb. S. 189

* Morceaux choisis d'après Ingres II, 1968
Ausschnitt nach Ingres II
Radierung, erster Zustand
35 x 23,8 cm, 50,5 x 32,5 cm
Edition auf Velin, Auflage 30 Exemplare
Bez.: Marcel Duchamp
Collection Ronny Van de Velde, Antwerpen

* King and Queen, 1968
König und Königin
Radierung, erster Zustand
35,1 x 23,9 cm, 50,5 x 32,5 cm
Edition auf Velin, Auflage 30 Exemplare
Bez.: Marcel Duchamp
Collection Ronny Van de Velde, Antwerpen
Abb. S. 180

* Morceaux choisis d'après Courbet, 1968
Ausschnitt nach Courbet
Radierung, erster Zustand
34,9 x 23,7 cm, 50,5 x 32,5 cm
Edition auf Velin, Auflage 30 Exemplare
Bez.: Marcel Duchamp
Collection Ronny Van de Velde, Antwerpen

216

* Cheminée anaglyphe , 1968
Stereometrische Zeichnung für einen Kamin I
Blauer und roter Farbstift, handschriftliche
Vermerke
Karton; 21 x 16,5 cm
Collection Ronny Van de Velde, Antwerpen
Abb. S. 197

AUTOGRAPHEN / AUTOGRAPHS

Two autograph letters signed by Duchamp to
Henri Parisot, editor of *Biens Nouveaux*
concerning the publication of Duchamp's
wordplays in one volume, *Rrose Sélavy*,
Paris 1939
Zwei Briefe von Duchamp an Henri Parisot,
Hrsg. von *Biens Nouveaux*, mit Bezug auf
Duchamps Wortspiel in *Rrose Sélavy*, Paris 1939
Collection Ronny Van de Velde, Antwerpen

Correspondance with Poupard-Lieussou,
consisting of ten autograph letters signed,
mostly one page, with envelops, and five auto-
graph *pneumatique* massages signed;
sent from Paris, Cadaque, New York and New
Hampshire to Poupard-Lieussou
Korrespondenz mit Poupard-Lieussou, aus
zehn Autographen mit Umschlägen beste-
hend, fünf sind unterschrieben mit *pneuma-
tique* ; abgeschickt aus Paris, Cadaquès, New
York und New Hampshire an Poupard-Lieus-
sou, Dezember 1954 bis August 1965
In seiner freundlichen Art beantwortet Duchamp
Fragen bezüglich Boîte-en-Valise.
Collection Ronny Van de Velde, Antwerpen

Three related letters from Duchamp to
Victor Brauner explaining the circumstances
of the making of the etching and inscription
Chess Players
Drei Briefe an Victor Brauner, zur Radierung
Chess Players
1960
In einem Brief vom 12. November 1960 aus New
York schreibt Duchamp, daß *he will keep in mind
his (Brauner's) kind promise for our chess friends* /er
seinen Schachfreund in Erinnerung behalten
werde.
Collection Ronny Van de Velde, Antwerpen

Typed Letter/Maschinengeschriebener Brief
1961
Bez.: Marcel Duchamp, aus New York, datiert
12. September 1961. In dem Brief autorisiert er die
Galerie Rive Droite, acht Bronze-Repliken seiner
Skulptur Feuille de vigne femelle herstellen zu las-
sen; eine Kopie sei für Man Ray zu reservieren.
Collection Ronny Van de Velde, Antwerpen

Where do we go from here?, 1961
Wohin gehen wir von hier aus?
Vortrag vom 20. 3.1961 im Philadelphia Museum
College of Art
Diese Frage stand im Zentrum des gleichnamigen
Symposiums, geleitet von Katherine Kuh.
Collection Ronny Van de Velde, Antwerpen

DADA SOULEVE TOUT, 1921
Dada überlebt alles
Dada manifesto, Paris, 12. Januar 1921, Duchamp
ist Mitunterzeichner des Manifestes
Collection Ronny Van de Velde, Antwerpen

Il faut dire: la crasse…, 1922
Man muß sagen: Der Schmutz…
in: Le cœur à barbe/Journal transparent, Nr. 1,
Paris, April 1922.
Ein Exemplar dieses Dada-Magazins enthält zwei
Texte von Duchamp
Collection Ronny Van de Velde, Antwerpen

Rrose Sélavy trouve qu'un incesticide…, 1922
Sechs Wortspiele aus Littérature (Nouvelle Série),
Nr. 5, 1. Oktober 1922, Umschlag; 23 x 17,5 cm
In derselben Ausgabe befindet sich der berühmte
Artikel von André Breton.
Collection Ronny Van de Velde, Antwerpen

80 Picabias, 1926
Vorwort von Rrose Sélavy unterschrieben, in:
Katalog Tableaux, Aquarelles et Dessins par FRAN-
CIS PICABIA, Appartenant à M, Marcel Duchamp,
Paris, Me Bellier, Commissaire-Priseur, 1926
Collection Ronny Van de Velde, Antwerpen

Francis Picabia
Katalog von Gertrude Stein, Galerie Rosenberg,
darin Duchamps Übersetzung eines Gedichtes ins
Französische, publiziert als Vorwort des Kataloges
Collection Ronny Van de Velde, Antwerpen

* **Marcel Duchamp ou le chateau de la Purité**
by Octavio Paz
Marcel Duchamp oder das Schloß der Reinheit
von Octavio Paz
Buch mit 16 Serigraphien
24 x 18 cm
Nr. 36/100
Bez.: Marcel Duchamp
Collection Ronny Van de Velde, Antwerpen
Abb. S.198

Paper wrapper and Lay out: L'Opposition et
les cases conjuguées sont réconciliées par
M. Duchamp et V. Halberstadt
Umschlag und Lay out: Opposition und
Schwesterfelder sind versöhnt von
M. Duchamp und V. Halberstadt
Brüssel, L'Echiquier/Emond Lancel, 1932
28 x 24,5 cm
Numerierte Luxusausgabe, Hardcover, gedruckt
auf handgeschöpftem Montgolfier Annonay-
Papier. Eins von 30 handnumerierten Exemplaren
Bez.: M. Duchamp and V. Halberstadt.
Collection Ronny Van de Velde, Antwerpen
Abb. S. 66

Le Monde des Echecs, Serie no. 1
Die Welt des Schachs, Serie, Nr. 1
Brüssel, L'Echiquier, 1933
16 x 24,3 cm, enthält 16 Abbildungen von
Schachmeistern und Großmeistern, darunter eine
Montage von Man Ray mit den Porträts von Hal-
berstadt und Duchamp
Collection Ronny Van de Velde, Antwerpen

Chessboard, 1937
Schachbrett
70 x 70 cm
Bez.: Marcel Duchamp
verso: Marcel Duchamp / 11 rue Larrey/Paris.
Collection Ronny Van de Velde, Antwerpen
Abb. S. 71

* **Pocket Chess Set**, 1943
Taschenschachspiel
Rectified Ready-made: Taschenschachspiel aus
Leder, Kunststoffiguren
Gefaltet 16 x 10,5 cm; offen 16 x 21 cm
Bez.: Marcel Duchamp 1944
Collection Ronny Van de Velde, Antwerpen
Abb. S. 71

ZUM UMFELD VON MARCEL DUCHAMP
AROUND MARCEL DUCHAMP

Raoul Hausmann
Hommage to Marcel Duchamp (Bottle-rack),
1968
Hommage an Marcel Duchamp
(Flaschentrockner)
Handkolorierte Lithographie; 38 x 28,3 cm
Bez.: le dadasophe Raoul Hausmann
Collection Ronny Van de Velde, Antwerpen

Charles Sheeler
Portrait of Marcel Duchamp, sculpture by
Elsa Baroness Freytag-Loringhoven, 1922
Porträt Marcel Duchamp, Plastik von
Elsa Baroness Freytag-Loringhoven
Fotografie; 25,5 x 20,2 cm
aus: The Little Review, IX, Nr. 2, Winter 1922, S. 41
Collection Ronny Van de Velde, Antwerpen
Frontispiz

Man Ray
Rrose Sélavy
Radierung; 38,5 x 29 cm
Nr. 112/125,
Bez.: Man Ray
Collection Ronny Van de Velde, Antwerpen

Francis Picabia
La ville de New York aperçue à travers le corps,
1913
Die Stadt New York läßt das Herz spüren bei
der Durchquerung
Gouache, Wasserfarbe; 54,6 x 74,3 cm
Bez.: Picabia 1912
Collection Ronny Van de Velde, Antwerpen

Francis Picabia
L'aile, 1923
Der Flügel
Bleistift, Tinte, Wasserfarbe auf Papier; 62 x 48 cm
Bez.: Francis Picabia
Collection Ronny Van de Velde, Antwerpen

FOTOGRAFIEN/PHOTOGRAPHS

* **Man Ray**
Project for Rotary Demisphère, 1924/1957
Projekt für Rotierende Halbkugel
Fotografie des Originals von Man Ray:
Hugnet, L'Aventure Dada (1916–1922)
28,5 x 27 cm
Collection Ronny Van de Velde; Antwerpen

Marcel Duchamp – Mary Reynolds – Brancusi
1929
Originalfotografie; 14,2 x 9,8 cm
Bez.: Marcel Duchamp – Mary Reynolds – Brancusi
Collection Ronny Van de Velde

Nat Finkelstein
Andy Warhol films Duchamp, 1966 (?)
Andy Warhol filmt Duchamp
Drei s/w-Fotografien; 28 x 35,4 cm
Unbez.
Collection Ronny Van de Velde, Antwerpen

* **Man Ray**
Duchamp
1919
s/w-Fotografie; 40,5 x 30,3 cm
Kürzlich erstellter Abzug vom Originalnegativ
Unbez.
Collection Ronny Van de Velde, Antwerpen

Man Ray
Tonsure, 1919
Tonsur
s/w-Fotografie; 40,5 x 30,3 cm
kürzlich erstellter Abzug vom Originalnegativ
Unbez.
Collection Ronny Van de Velde, Antwerpen

* **Man Ray**
Duchamp in his studio, 1920
Duchamp in seinem Atelier
s/w-Fotografie; 31,5 x 24,4 cm
kürzlich erstellter Abzug vom Originalnegativ
Unbez.
Collection Ronny Van de Velde, Antwerpen

Man Ray
Rrose Sélavy, 1921
s/w-Fotografie; 40,5 x 30,2 cm
kürzlich erstellter Abzug vom Originalnegativ
Unbez.
Collection Ronny Van de Velde, Antwerpen
Abb. S. 226

Man Ray
Duchamp at chess, 1921
Duchamp beim Schach
s/w-Fotografie; 24 x 32 cm
kürzlich erstellter Abzug vom Originalnegativ
Unbez.
Collection Ronny Van de Velde, Antwerpen
Abb. S. 208

* **Man Ray**
Le Grand Verre, non cassé, 1926
Das Große Glas, unzerstört
s/w-Fotografie; 30,5 x 29,9 cm
kürzlich erstellter Abzug vom Originalnegativ
Unbez.
Collection Ronny Van de Velde, Antwerpen
Abb. S. 78

Man Ray
Duchamp in his hammock
Duchamp in seiner Hängematte
Farbfotografie; 23,9 x 29,9 cm
kürzlich erstellter Abzug vom Originalnegativ
Unbez.
Collection Ronny Van de Velde, Antwerpen
Abb. S. 235

OBJEKTE VON MAN RAY/
OBJECTS OF MAN RAY

Obstruction, 1920/1961
Versperrung
Assemblage, 63 Kleiderbügel
Replik
Bez.
Collection Ronny Van de Velde, Antwerpen

Lampshade, 1919/1959
Lampenschirm
Weißblech, bemalt; 245 cm
Replik
Bez.
Collection Ronny Van de Velde, Antwerpen

Metronom, 1923–25
Originalobjekt, Fotografie mit Auge
Bez.
Collection Ronny Van de Velde, Antwerpen

Friedrich J. Kiesler
Collage Duchamp in his studio, 1945 / *Collage Duchamp in seinem Atelier*

221

AUSSTELLUNGEN / EXHIBITIONS

1907 Ier Salon des artistes humoristes, Palais des Glace, Paris, 25.5.–30.6.1907

1908 2e Salon des artistes humoristes, Palais de Glace, Paris, 10.5.–30.6.1908
Salon d'Automne, Grand Palais, Paris, 1.10.–8.11.1908

1909 Salon des Indépendants, Orangerie des Tuileries, Paris, 25.3.–2.5.1909
Salon d'Automne, Grand Palais, Paris, 1.10.–8.11.1909
Première Exposition de la Société Normande de Peinture moderne, Rouen,
20.12.1909–20.1.1910

1910 Salon des Indépendants, Cours-la-Reine, Paris, 18.3.–1.5.1910
Salon d'Automne, Grand Palais, Paris, 1.10.–8.11.1910
Exposition de la Société Normande de Peinture moderne, Galerie de l'Art Ancien
et de l'Art Contemporain, Paris

1911 Salon des Indépendants, Quai d'Orsay, Paris, 21.4.–13.6.1911
Deuxième Exposition de la Société Normande de Peinture moderne, Rouen,
7.5.– Juni 1911
Salon d'Automne, Grand Palais, Paris, 1.10.–8.1.1911
Exposition d'Art Contemporain, Société Normande de Peinture moderne,
Galerie de l'Art Ancien et de l'Art Contemporain, Paris, 20.11.–16.12.1911

1912 Salon des Indépendants, Quai d'Orsay, 20.3.–16.5.1912
Exposició d'Arte cubista, Galeries J. Dalmau, Barcelona, 20.4.–10.5.1912
Troisième Exposition de la Société Normande de Peinture moderne, Rouen,
15.6.–15.7.1912
Salon d'Automne, Grand Palais, Paris, 1.10.–1.11.1912
Salon de la Section d'Or, Galerie la Boétie, Paris, 10.–30.10.1912

1913 International Exhibition of Modern Art (Armory Show), New York,
17.2.–15.3.1913
Armory Show, Art Institute, Chicago, 24.3.–15.4.1913
Armory Show, Copley Society, Boston, 28.4.–18.5.1913
Post Impressionistic Exhibition, Portland Art Museum, Portland, Oregon,
November – Dezember 1913

1914 First Exhibition of Works by Contemporary French Artists, Carroll Galleries, New
York, Dezember 1914–2.1.1915

1915 French Modernists and Odilon Redon, Carroll Galleries, New York,
1.1.–3.2.1915
Third Exhibition of Contemporary French Art, Carroll Galleries, New York,
8.3.–3.4.1915

1916 Exhibition of Modern Art, Arranged by a Group of European and American Artists in New York, Bourgeois Galleries, New York, 3.4.–29.4.1916
Exhibition of Pictures by Jean Crotti, Marcel Duchamp, Albert Gleizes, Jean Metzinger, Montross Gallery, New York, 4.4.–22.4.1916
Advanced Modern Art, McClees Galleries, Philadelphia, 17.5.–15.6.1916

1917 Exhibition of the Society of Independent Artists, Grand Central Palace, New York, 10.4.–6.5.1917

1919 The Evolution of French Art – From Ingres and Delacroix to the latest modern Manifestations, Arden Gallery, New York, 29.4.–24.5.1919

1920 Eröffnungsausstellung der Société Anonyme, Galleries of the Société Anonyme, 19 East 47th Street, 30.4.–15.6.1920
Dritte Ausstellung der Société Anonyme, Galleries of the Société Anonyme, 19 East 47th Street, 2.8.–11.9.1920

1921 Salon Dada, Galerie Montaigne Paris, 6. 6.–30.6.1921

1922 Arthur Jerome Eddy Collection, Art Institute, Chicago

1926 The John Quinn Collection, New York Art Center, Januar 1926
International Exhibition of Modern Art, Brooklyn Museum, New York, 19.11.1926 – 9.1.1927

1927 The John Quinn Collection, American Art Association, New York, 9.–11.2.1927

1930 La Peinture au Défi, Galerie Goemans, Paris, März 1930

1933 Exposition Surréaliste, Galerie Pierre Colle, Paris, 7.6.–18.6.1933

1936 Exposition Surréaliste d'Objets, Galerie Charles Ratton, Paris, 22.5.–29.5.1936
The International Surrealist Exhibition, New Burlington Galleries, London, 11.6.–14.7.1936
Fantastic Art, Dada, Surrealism, Museum of Modern Art, New York, 7.12.1936–17.1.1937

1937 Exhibition of Paintings by Marcel Duchamp, The Arts Club of Chicago, 5.2.–27.2.1937

1938 Exposition Internationale du Surréalisme, Galerie des Beaux Arts, Paris, 17.1.– Februar 1938

1939 Exposicion Surrealista, Teneriffa

1942 First Papers of Surrealism, Whitelaw Reid Manison, New York, 14.10.–7.11.1942
Art of this Century (Galerie Peggy Guggenheim), New York, 20.10.– November 1942

1944 Art in Progress, Museum of Modern Art, New York, 24.5.– August 1944

1945 Duchamp, Duchamp-Villon, Villon, Yale University Art Gallery, New Haven, Connecticut, 25.2.–25.3.1945

1973 Marcel Duchamp, Philadelphia Museum of Art/Museum of Modern Art, Philadelphia

1975 Junggesellenmaschinen/Les Machines célibataires, Venedig
Kunsthalle Bern, anschließend in Venedig, Brüssel, Düsseldorf, Paris, Le Creusot, Malmö, Amsterdam, Wien

1977 L'Œuvre de Marcel Duchamp, Musée national d'art moderne, Centre Georges Pompidou, Paris

1984 The Société Anonyme and the Dreier Bequest at Yale University, New Haven, Connecticut/London
Duchamp, Fundación Joan Miró, Barcelona, Fundación Caja de Pensiones, Madrid
Museum Ludwig, Köln

1988 Übrigens sterben immer die anderen, Marcel Duchamp und die Avantgarde seit 1950, Museum Ludwig, Köln
Marcel Duchamp, la Sposa... e i Readymade, Accademia di Belle Arti die Brera, Sala Napoleonica – Palazzo di Brera

1991 Marcel Duchamp at Ronny Van de Velde, Antwerpen, 15. 9.–15.12.1991

1992 Transform – BildObjektSkulptur im 20. Jahrhundert, Kunstmuseum und Kunsthalle, Basel, 14.6.– 27.9.1992

1993 Marcel Duchamp, Palazzo Grassi, Venedig

1994 Das Jahrhundert des Multiple – Von Duchamp bis zur Gegenwart, Deichtorhallen Hamburg

1995 Marcel Duchamp, Staatliches Museum Schwerin, 27. 8.–19.11.1995

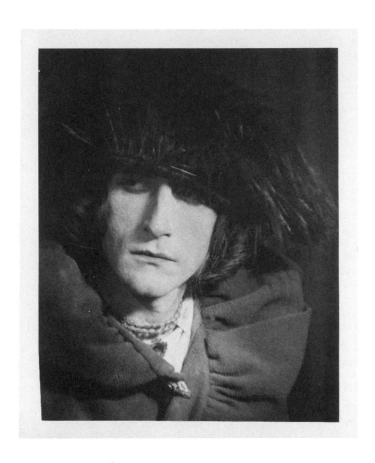

Man Ray
Rrose Sélavy, 1921

226

BIBLIOGRAPHIE / BIBLIOGRAPHY

Anonym, The Nude-descending-a-Staircase, Man surveys us, in: The New York Tribune, New York, 12.9.1915, Sec. 4, S. 2

Anonym, Marcel Duchamp visits New York, in: Vanity Fair, Bd. 5, Nr. 1, New York, September 1915, S. 57

Anonym, A complete Reversal of Art Opinions by Marcel Duchamp, Iconoclast, in: Arts and Decoration, New York, September 1915

Anonym, This Portrait made of Wire, in: New York Herald, New York, 10.4.1916, S. 12

Anonym, Fine Examples of modern Art on View, in: The New York Times, New York, 13.4.1916, S. 12

Anonym, (Apollinaire, Guillaume), Les Cas de Richard Mutt, unter der Rubrik Échos, in: Mercure de France, Nr. 480, Bd. CXXVII, Paris, 16.6.1918, Reprint: Échos et Anecdotes inédites, Hrsg. Pierre Caizergues, in: Cahiers du Musée national d'art moderne, Paris, Nr. 6, 1988, S. 15

Anonym, Société Anonyme's exciting Show, in: The Brooklyn Museum Quarterly, New York, Januar 1927, S. 20

Anonym, Lo, Marcel Duchamp himself descends the Stair, in: The New York Times, New York, 30.6.1935

Anonym, Dadadadada, in: Time, New York, 27.4.1953, S. 47

Anonym, The Dada Movement, in: Times Literary Supplement, London, 23.10.1953, S. 670

Anonym, Marcel Duchamp, Today's Artist »too serious«, in: The Atlanta Journal, Atlanta, Georgia, 13.4.1960

Anonym, Artist Marcel Duchamp visits U-classes, exhibits at Walker, in: Minnesota Daily, 22.10.1965

Anonym, Marcel Duchamp n'aura pas de Funérailles, in: L'Express, Paris, 7.10.1968

Apollinaire, Guillaume, Chroniques d'Art, 1902–1918, Hrsg. L. C. Breunig, Paris 1960

Apollinaire, Guillaume, Les Peintres Cubistes, Paris 1913, Reprint: textkritische Ausgabe, Hrsg. L. C. Breunig/J. C. Chevalier, Paris 1965

Apollinaire, Guillaume s. Anonym (Apollinaire, Guillaume, Les Cas de Richard Mutt, 1918)

Apollonio, Umbro, Der Futurismus, Köln 1972

Aragon, Louis, Les Collages, Paris 1965

Ashton, Dore, An Interview with Marcel Duchamp, in: Studio International, Bd. 171, Nr. 878, London, Juni 1966, S. 244–247

Bach, Friedrich Teja, Brancusi, Methamorphosen plastischer Form, Köln 1987

Balas, Edith, Brancusi, Duchamp and Dada, in: Gazette des Beaux-Arts, Bd. 95, Nr. 1335, Paris, April 1980, S. 165–174

Bernstein, Roberta, Jasper Johns und Marcel Duchamp, in: Kat. Köln 1988, S. 143–160

Boccioni, Umberto, Technical Manifesto of Futurist Sculpture 1912, in: Theories of Modern Art, a Source Book by Artist and Critics, Berkeley/Los Angeles 1968

Boehm, Gottfried, Das Werk als Prozeß, in: Oelmüller, Willi (Hrsg.), Colloquium Kunst und Philosophie III, Das Kunstwerk, Paderborn/München/Wien/Zürich 1983

Bohan, Ruth L., The Société Anonyme's Brooklyn Exhibition, Ann Arbor, Michigan, 1983

Bonk, Ecke, Marcel Duchamp, Die Große Schachtel, München 1989

Brecht, George, Jenseits von Ereignissen, Bern 1978

Breton, André, Marcel Duchamp, in: Littérature, Neue Folge, Nr. 5, Paris, 1.10.1922, S. 7–10; englische Übersetzung in: Motherwell, Robert (Hrsg.), The Dada Painters and Poets, New York 1951

Breton, André, Distances, in: ders., Les Pas perdus, Paris 1969 (1, Auflage 1924)

Breton, André, Nadja, Paris 1945 (1. Auflage 1928)

Breton, André, Phare de la Mariée, in: Minotaure, Nr. 6, Paris, Winter 1934/35, S. 45–49; englische Übersetzung in: View, Marcel Duchamp Nummer, Reihe V, Nr. 1, New York 1945, S. 6–9, 13; deutsche Übersetzung in: Lebel, Robert, Marcel Duchamp, Köln 1962

Breton, André, Die Manifeste des Surrealismus, Reinbek bei Hamburg 1986

Brown, Milton W., The Story of the Armory Show, New York 1963

Buffet, Gabrielle, Cœurs volants, in: Cahiers d'Art, Nr. 1–2, Paris 1936, S. 34–43

Burnham, Jack, Unveiling the Consort, in: Artforum, Bd. 9, New York, März 1971, S. 55–60

Burnham, Jack, Unveiling the Bride, in: Artform, Bd. 9, New York, April 1971, S. 42–51

Burnham, Jack, La Signification du Grand Verre, in: VH 101, Nr. 6, Paris 1972, S. 63–110

Cabanne, Pierre, Dialogues with Marcel Duchamp, New York o.J.

Cabanne, Pierre, Gespräche mit Marcel Duchamp, Köln 1972

Cabanne, Pierre, Les 3 Duchamp, Jacques Villon, Raymond Duchamp-Villon, Marcel Duchamp, Neuchâtel 1975

Cage, John, in: Sers, Philippe, Faut-il vraiment vénérer Duchamp? in: Connaissance des Arts, Nr. 299, Paris, Januar 1977

Calas, Nicolas, The Brothers Duchamp all at once, in: Art News, New York, Februar 1957, S. 26

Calas, Nicolas, The Large Glass, in: Art in America, Bd. 57, Nr. 4, New York, Juli/August 1969, S. 34 f.

Calas, Nicolas, Étant donnés, in: Opus international, Paris, Nr. 49, März 1974, S. 55–57

Camfield, William Arnett, Marcel Duchamp, Fountain, Houston, Texas, 1989

Carling, Elizabeth, Picasso, Sculptor, Painter, London 1994

Carrouges, Michel, Les Machines célibataires, Paris 1954, erweiterte Neuauflage mit vier Briefen Duchamps, Paris 1976

Casey, Phil, Marcel Duchamp dies, in: The Washington Post, Washington, D.C., 3.10.1968

Caumont, Jacques/Gough-Cooper, Jennifer, Kat. L'Œuvre de Marcel Duchamp, Bd. 1, Chronologie, Centre Georges Pompidou, Paris 1977

Caumont, Jacques/Gough-Cooper, Jennifer, Kiesler und »Die Braut von ihren Junggesellen nackt entblößt, sogar«, in: Bogner, Dieter (Hrsg.), Friedrich Kiesler, Wien, 1988, S. 287–296

Chanin, A. L., Then and Now, The New York Times Magazine, 22. 1.1956, S. 25

Clair, Jean, Marcel Duchamp ou le grand Fictif, Paris 1975

Clair, Jean, Duchamp et la Photographie, Paris 1977

Clifford, Henry, Introduction, in: The Louise and Walter Arensberg Collection, Philadelphia 1954

Copley, William, Marcel Duchamp 1887–1968, in: The New York Times, New York, 13.10.1968

Crespelle, Jean-Paul, La Vie quotidienne à Montmartre au Temps de Picasso, 1900–1910, Paris 1978

Daniels, Dieter, Marcel Duchamp – Die richtige Ausstellung zur falschen Zeit?, in: Kunstforum, Bd. 73–74, Köln, Juni – August 1984, S. 290–293

Daniels, Dieter, Duchamp und die anderen, Köln 1992

Danto, Arthur C., Die Verklärung des Gewöhnlichen: Eine Philosophie der Kunst, Frankfurt a. M. 1984

de Duve, Thierry, Kant nach Duchamp, in: Kunstforum, Bd. 100, Köln, April/Mai 1989, S. 187–206

Desnos, Robert, Rrose Sélavy, in: Littérature, Neue Folge, Nr. 7, Paris 1.12.1922, S. 14–22

Dickie, George, Aesthetics, New York 1971

Dreier, Katherine S., Western Art and the New Era, New York 1923

Dreier, Katherine S., Regarding modern Art, in: The Brooklyn Museum Quarterly, New York, Oktober 1926, S. 116–119

Dreier, Katherine S./Matta, Echaurren, Duchamp's Glass, La Mariée mise à nu par ces célibataires, même. An analytical Reflection, New York 1944

Duchamp, Marcel, The Bride stripped bare by her own Bachelors, in: This Quarter, Bd. V, Nr. 1, Paris, September 1932

Duchamp, Marcel, Briefe an Marcel Jean, München 1987

Duchamp, Marcel, Interviews und Statements, Hrsg. Ulrike Gauss, Stuttgart 1992

Duchamp, Marcel, Die Schriften, Bd. 1, Hrsg. Serge Stauffer, Zürich 1981

Duchamp, Marcel/Halberstadt, Vitaly, L'Opposition et les Cases conjuguées sont réconciliées, Paris 1932

Duchamp, Marcel, Rrose Sélavy, in der Serie Biens Nouveaux, Édition G.L.M., Paris 1939

Duchamp, Marcel, Notes, Hrsg. Paul Matisse, Paris 1980

Duchamp, Marcel, Étant donnés, Manual of Instructions, Philadelphia 1987

Dumont, Pierre, Les Indépendants, in: Les Hommes du Jour, Nr. 221, Paris, 13.4.1912

Düchting, Hajo, Apollinaire zur Kunst, Köln 1989

Ernst, Max, Écritures, Paris 1970

Fabre, Gladys, Le cercle littéraire de l'Abbaye, l'occultisme et l'art d'avantgarde français, in: Kat.Okkultismus und Avantgarde. Von Munch bis Mondrian, 1900–1915, Ostfildern 1995

Farnham, Emily, Charles Demuth: Behind a laughing Mask, Oklahoma City, Oklahoma 1971

Felix, Zdenek (Hrsg.), Das Jahrhundert des Multiple – Von Duchamp bis zur Gegenwart, Hamburg 1994

Freeman, Judy (Hrsg.), Das Wort-Bild in Dada und Surrealismus, München 1990

Fry, Edward, Der Kubismus, Köln 1966

Genauer, Emily, Puns and Games, in: International Herald Tribune, Paris, 14.1.1965

Gervais, André, Roue de bicyclette, Épitexte, texte et intertextes, in: Les Cahiers du Musée National d'art moderne Paris, Nr. 30, Winter 1989

Gleizes, Albert/Metzinger, Jean, Du Cubisme, Paris 1912

Gold, Laurence S., A Discussion of Marcel Duchamp's Views on the Nature of Reality and Their Relation to the Course of His Artistic Career, B.A. Dissertation, Princeton University, 1968

Golding, John, Duchamp: The Bride stripped bare by her Bachelors, even, London 1972

Goth, Max, unbetitelter Brief an Louis Vauxelles, in: Les Hommes du Jour, Nr. 249, Paris 20. (26.) 10.1912

Haftmann, Werner, Malerei im 20. Jahrhundert, München 1954

Hahn, Otto, Entretien Marcel Duchamp, Paris-Express, Nr. 684, 23.7.1964

Hahn, Otto, Passport No. G255300, Art and Artists, London, I/4, Juli 1966, S. 7–11

Hamilton, George Heard/Hamilton, Richard, Marcel Duchamp speaks, Interview für BBC London 1959, veröffentlicht als Tonkassette, Audio Arts Magazin, Bd. 2, Nr. 4, London 1976

Hamilton, George Heard/Hamilton, Richard, The Bride stripped bare by her Bachelors, even, London/New York 1960

Hamilton, George Heard, In Advance of whose broken Arm?, in: Art and Artists, Bd. 1, Nr. 1, London, Juli 1966, S. 29–31

Hamilton, Richard, Son of the Bride stripped bare, in: Art and Artists, Bd. I, Nr. 4, London, Juli 1966, S. 22–26

Hellman, Geoffrey, Marcel Duchamp, The New Yorker, New York, XXXIII/7, 7. 4.1957, S. 27

Henderson, Linda, The Artist, The Fourth Dimension and non-Euclidean Geometry 1900–1930, Yale University, New Haven 1985

Hofmann, Werner, Grundlagen der modernen Kunst, Stuttgart 1978

Hofmann, Werner, Marcel Duchamp und der emblematische Realismus, in: Merkur, Stuttgart, Nr. 211, 1965, S. 941–955

Holländer, Hans, Ars inveniendi et investigandi: Zur surrealistischen Methode, in: Wallraf-Richartz-Jahrbuch, Köln 1970, S. 193–234

Huelsenbeck, Richard, Reise bis ans Ende der Freiheit, Autobiographische Fragmente, Hrsg. Ulrich Karthaus/Horst Krüger, Heidelberg 1984

Hulten, Pontus (Hrsg.), Brancusi, Stuttgart 1988

Hulten, Pontus (Hrsg.), Marcel Duchamp, Venedig 1993

Huyghe, René, La Peinture française: Les Contemporains, Paris 1939

Jouffret, Esprit Pascal, Traité élémentaire de Géométrie à quatre dimensions et indroduction à la Géométrie à n dimensions, Paris 1903

Jouffroy, Alain, Entendre John Cage, entendre Duchamp, in: Opus international, Paris, Nr. 49, März 1974, S. 5867

Kiesler, Friedrich, J., Design-Correlation, in: The Architectural Record, Bd. 81, Nr. 5, New York, Mai 1937, S. 53–60

Krasne, Belle, A Marcel Duchamp Profile, The Art Digest, New York, XXVI/8, 15. 1.1952

Kuh, Katherine, Marcel Duchamp, in: dies., The Artist's Voice, New York 1962, S. 81–93, 1919

Lebel, Robert, Marcel Duchamp, Von der Erscheinung zur Konzeption, erweiterte Auflage, Köln 1972

Lebel, Robert, Marcel Duchamp, Paris 1985

Leiris, Michel, Arts et Métiers de Marcel Duchamp, in: Fontaine, Nr. 54, 1946; deutsche Übersetzung in: ders., Die Lust am Zusehen, Frankfurt a. M. 1988

Leiris, Michel, La Mariée mise à nu par ses Céliba-
taires, même, par Marcel Duchamp, in: La Nou-
velle Revue Française, Nr. 279, Paris, Dezember
1936, S. 1087–1089

Levy, Julien, Duchampiana, in: View, Reihe V, Nr. 1,
New York, März 1945, S. 33 f.

Liberman, Alexander, The Artist in His Studio, Lon-
don 1960, S. 57

Linde, Ulf, MARiée CELibateire, in: Kat. Marcel
Duchamp, Ready-mades etc. (1913–1964), Gale-
rie Schwarz, Mailand/Paris 1964, S. 41–66

Linde, Ulf, La Copie de Stockholm, in: Kat. Paris
1977, Bd. 3, S. 31 f.

Linde, Ulf, L'Ésotherique, in: Kat. Paris 1977, Bd. 3,
S. 60 ff.

Lyotard, Jean-François, Les TRANSformateurs
DUchamp, Paris 1977;.deutsche Übersetzung:
ders., Die TRANSformatoren DUchamp, Stuttgart
1986

Man Ray, Selbstportrait, München 1983, 1. Auf-
lage 1963

Marquis, Alice Goldfarb, Eros c'est la Vie: A Biogra-
phy, New York, 1981

Massot, Pierre de, La mariée mise à nu par ses céli-
bataires, même, in: Orbes, Reihe 2, Nr. 4, Paris,
Sommer 1935, S. XVII–XXII

McBride, Henry, The Walter Arensbergs, in: The
Dial, Juli 1920, Reprint in: McBride 1975

McBride, Henry, The Flow of Art, Essays and Critic-
ism of Henry McBride, Hrsg. Daniel Catton Rich,
New York 1975

McBride, Henry, Marcel Duchamp's latest Work,
in: The New York Sun, New York, 18.5.1935, S. 31

Mink, Janis, Marcel Duchamp 1887–1968, Kunst
als Gegenkunst, Köln 1994

Moffitt, John F., Marcel Duchamp, Alchemist of
the Avantgarde, in: Kat. The Spiritual in Art:
Abstract Painting 1890–1985, Los Angeles
1986/87

Molderings, Herbert, Marcel Duchamp, Parawis-
senschaft, das Ephemere und der Skeptizismus,
Frankfurt a. M./Paris 1983

Motherwell, Robert (Hrsg.), The Dada Painters
and Poets, New York 1951

Naumann, Francis M., Walter Conrad Arensberg:
Poet, Patron and Participant in the New York
Avantgarde, 1915–1920, in: Philadelphia Museum
of Art Bulletin, Bd. 76, Nr. 328, Philadelphia, Früh-
jahr 1980

Naumann, Francis M., Man Ray, Early Paintings
1913–1916, Theory and Practice in the Art of two
Dimensions, in: Artforum, Bd. XX, Nr. 9, New
York, Mai 1982

Naumann, Francis M., Affectueusement, Marcel.
Ten Letters from Marcel Duchamp to Suzanne
Duchamp and Jean Crotti, in: Archives of Ameri-
can Art Journal, Bd. 22, Nr. 4, New York, 1982,
S. 3–19

Naumann, Francis M., Marcel Duchamp's Letters
to Walter and Louise Arensberg, 1917–1921, in:
Dada/Surrealism, Nr. 16, Iowa City, Iowa 1987,
S. 203–227

Ozenfant, Amédée, Arts, Paris 1928

Paz, Octavio, *water writes always in* plural, in:
Kat. Philadelphia 1973, S. 153 ff.; deutsche Über-
setzung: Paz 1987, S. 116 ff.

Paz, Octavio, Nackte Erscheinung, Das Werk von
Marcel Duchamp, Berlin 1987

Picabia, Francis, unbetitelter Artikel, in: 391, Nr. 5,
New York, Juni 1917, S. 8

Picabia, Francis, unbetitelter Artikel, in: 391, Nr. 8,
Zürich, Februar 1919, S. 8

Picabia, Francis, Tableau Dada par Marcel
Duchamp, in: 391, Nr. 12, Paris, März 1920

Picabia, Francis (Hrsg.), Abb. Tzanck-Scheck, in:
Cannibale, Nr. 1, Paris, 25.4.1920, S. 1

Picabia, Francis (Hrsg.), Abb. von: A regarder d'un
œil, de prés pendant presque une heure, in: 391,
Nr. 13, Paris, Juli 1920, S. 2

Poincaré, Henri, Der Wert der Wissenschaft, Leip-
zig/Berlin 1910

Poincaré, Henri, The Value of Science, New York
1958

Poincaré, Henri, Science and Hypothesis,
New York 1958

Poincaré, Henri, Wissenschaft und Hypothese,
Leipzig 1914

Raynal, Maurice, L'Exposition de la Section d'Or,
in: Le Journal, Nr. 7319, Paris, 10.10.1912

Restany, Pierre, Bei vierzig Grad über Dada, in: Les
Nouveaux Réalistes, München 1963

Richter, Hans, Dada, Kunst und Antikunst, Köln
1964

Richter, Hans, Begegnungen von Dada bis heute,
Köln 1973

Roberts, Francis, I Propose to Strain the Laws of Physics – Interview with Marcel Duchamp, Art News, New York, LXVII, 8,12/1968, S. 62–64

Roché, Henri-Pierre, Marcel Duchamp, l'Homme mirade, in: Arts-Spectacles, Nr. 491, Paris, 24.–30.11.1954

Roché, Henri-Pierre, Vie de Marcel Duchamp, in: La Parisienne, Nr. 24, Paris, Januar 1955, S. 62–69

Rosenblum, Robert, Cubism and 20th Century Art, New York 1976 (1. Auflage 1959)

Roth, Moira, Marcel Duchamp in America: A Self Ready-made, in: Arts Magazine, Bd. 51, Nr. 9, New York, Mai 1977, S. 92 ff.

Samaltanos, Katia, Apollinaire, Catalyst for Primitivism, Picabia and Duchamp, Ann Arbor, Michigan, 1984

Sanouillet, Michel, Dans l'atelier de Marcel Duchamp, Les Nouvelles Litteraires, Paris, Nr. 1424, 16.1.1954, S. 5

Sanouillet, Michel, Dada à Paris, Paris 1965

Sanouillet, Michel (Hrsg.), Marcel Duchamp, Duchamp du Signe, Écrits, Paris 1975

Sanouillet, Michel/Peterson, Elmer (Hrsg.), Salt Seller, The Essential Writings of Marcel Duchamp, London/New York 1975

Sanouillet, Michel, Marchand du Sel, Paris 1958

Sartre, Jean-Paul, Situations II (Qu'est-ce que la Littérature?), Paris 1948

Schuster, Jean, Marcel Duchamp, vite, Le Surréalisme, même, Paris, Nr. 2, Frühjahr 1957, S. 144

Schwarz, Arturo, The complete Works of Marcel Duchamp, London/New York 1969

Schwarz, Arturo, New York Dada, München 1973

Schwarz, Arturo, Rrose Sélavy alias Marchand du Sel alias Belle Haleine, in: L'Arc, Nr. 49, Avignon 1974, S. 29–35

Schwarz, Arturo, Marcel Duchamp, Luzern 1974

Schwarz, Arturo, Die alchemistische Junggesellenmaschine, in: Kat. Junggesellenmaschinen, Venedig 1975, S. 156–171

Seitz, William, What's happened to Art?, in: Vogue, Bd. 3, Nr. 2, New York, Februar 1963, S. 110–113, 129–131

Siegel, Jeanne, Some late Thoughts of Marcel Duchamp, in: Arts Magazine, Nr. 43, New York, Dezember 1968/Januar 1969, S. 21f.

Soby, James Thrall, The Arensberg Collection, in: The Saturday Review, New York, Bd. XXXVII, Nr. 45, 6. November 1954, S. 60 f.

Spies, Werner, Die Heiligsprechung des Zynikers, in: Frankfurter Allgemeine Zeitung, Frankfurt a. M., 26.3.1977

Stauffer, Serge, Marcel Duchamp, Ready-made!, Zürich 1973

Sweeny, James Johnson, Eleven Europeans in America, in: The Museum of Modern Art Bulletin, Bd. XIII, Nr. 4–5, New York 1946

Taylor, Simon Watson, Ready-made, in: Art and Artists, Bed. 1, Nr. 4, London, Juli 1966, S. 46

Tomkins, Calvin, Profiles: Not Seen and/or Less Seen – Marcel Duchamp, The New Yorker, New York, 6.2.1965, S. 24–25

Tomkins, Calvin, The Bride and the Bachelors, New York 1968

Tovar, Günther, Film anläßlich der Duchamp-Ausstellung in der Kestner-Gesellschaft Hannover, gesendet in der Reihe Aus Wissenschaft und Kunst, NDR, Studio III, 15.10.1965

Vauxelles, Louis, unbetitelter Leserbrief, in: Les Hommes du Jour, Nr. 248, Paris, 19.10.1912

View, the modern Magazine, Marcel Duchamp Number, Reihe V, Nr. 1, New York, März 1945

Vischer, Theodora (Hrsg.), Transform – BildObjektSkulptur im 20. Jahrhundert, Basel 1992

Wendt, Wolf Rainer, Ready-made, Das Problem und der philosophische Begriff ästhetischen Verhaltens, dargestellt an Marcel Duchamp, Meisenheim am Glan 1970

Wood, Beatrice, Marcel, in: Dada/Surrealism, Nr. 16, Iowa City, Iowa 1987, S. 12–17

Zaunschirm, Thomas, Bereites Mädchen – Ready-made, Klagenfurt 1983

Zaunschirm, Thomas, Robert Musil und Marcel Duchamp, Klagenfurt 1982

Zaunschirm, Thomas, Marcel Duchamps unbekanntes Meisterwerk, Klagenfurt 1986

NACHWEIS DER STATEMENTS
REFERENCE OF THE STATEMENTS

1 Zit. nach: Marcel Duchamp, Interviews und Statements, Hrsg. Ulrike Gauss, Stuttgart 1992, S. 180;
 übersetzt aus: C. Tomkins, Profiles: Not Seen and/or Less Seen, Marcel Duchamp, The New Yorker,
 New York, 6. 2.1965, S. 24–25

2 Zit. nach: Marcel Duchamp, Interviews und Statements, a.a.O., S. 77, übersetzt aus: G. H. Hamilton,
 New York und R. Hamilton, London, Marcel Duchamp Speaks, ausgestrahlt vom BBC-Third Program
 (Series Art, Anti-Art), London, ca. Oktober 1959 – CW D129

3 Zit. nach: Marcel Duchamp, Interviews und Statements, a.a.O., S. 77, übersetzt aus: G. H. Hamilton,
 New York und R. Hamilton, London, Marcel Duchamp Speaks, ausgestrahlt vom BBC-Third Program
 (Series Art, Anti-Art), London, ca. Oktober 1959 – CW D129

4 Zit. nach: Marcel Duchamp, Interviews und Statements, a.a.O., S. 80, übersetzt aus: G. H. Hamilton,
 New York und R. Hamilton, London, Marcel Duchamp Speaks, ausgestrahlt vom BBC-Third Program
 (Series Art, Anti-Art), London, ca. Oktober 1959 – CW D129

5 Zit. nach: Marcel Duchamp, Interviews und Statements, a.a.O., S. 205; O. Hahn, Passport No.
 G255300, Art and Artist, London I/4, Juli 1966, S. 10 – CW D206; Franz. Marcel Duchamp, VH 101,
 Paris, Nr. 3, Herbst 1970, S. 60 (Quelle)

6 Zit. nach: Marcel Duchamp, Interviews und Statements, a.a.O., S. 183; übersetzt aus: C. Tomkins,
 Profiles: Not Seen and/or Less Seen – Marcel Duchamp, The New Yorker, New York, 6. 2.1965, S. 38

7 Zit. nach: Marcel Duchamp, Interviews und Statements, a.a.O., Stuttgart 1992, S. 45; übersetzt aus:
 B. Krasne, A Marcel Duchamp Profile, The Art Digest, New York, XXVI/8, 15.1.1952, S. 11 – CW D73

8 Zit. nach: Marcel Duchamp, Interviews und Statements, a.a.O., S. 86, übersetzt aus: A. Liberman,
 The Artist in His Studio, London, 1960, S. 57 – CW D140

9 Zit. nach: Marcel Duchamp, Interviews und Statements, a.a.O., S. 65; übersetzt aus: Unsign. (G.
 Hellman), Marcel Duchamp, The New Yorker, New York, XXXIII/7, 7. April 1957, S. 27 – CW D102
 (Autorzuschreibung Arturo Schwarz)

10 Zit. nach: Marcel Duchamp, Interviews und Statements, a.a.O., S. 62; übersetzt aus: A. L. Chanin,
 Then and Now, The New York Times Magazine, 22. 1. 1956, S. 25 – vgl. CW D130

11 Zit. nach: Marcel Duchamp, Interviews und Statements, a.a.O., S. 156/157; übersetzt aus:
 F. Roberts, I Propose to Strain the Laws of Physics, Interview with Marcel Duchamp, Art News,
 New York, LXVII/8, Dezember 1968, S. 62–64

12 Zit. nach: Marcel Duchamp, Interviews und Statements, a.a.O., S. 156/157; übersetzt aus:
 F. Roberts, I Propose to Strain the Laws of Physics, Interview with Marcel Duchamp, Art News,
 New York, LXVII/8, Dezember 1968, S. 62–64

13 Zit. nach: Marcel Duchamp, Interviews und Statements, a.a.O., S. 68; L. S. Gold, A Discussion of
 Marcel Duchamp's Views on Nature of Reality and Their Relation to the Course of His Artistic Career,
 B.A. Dissertation, Princeton University, Mai 1958, Nr. 27

14 Zit. nach: Marcel Duchamp, Interviews und Statements, a.a.O., S. 75, übersetzt aus: G. H. Hamilton,
 New York und R. Hamilton, London, Marcel Duchamp Speaks, ausgestrahlt vom BBC-Third Program
 (Series Art, Anti-Art), London, ca. Oktober 1959 – CW D129

Esquivons les ecchymoses ..., 1926/1968 / *Scheibe mit Wortspiel*

Man Ray
Duchamp in his hammock, o. J. / *Duchamp in seiner Hängematte*

IMPRESSUM

Die erste Auflage dieses Buches erschien
anläßlich der Ausstellung »Marcel Duchamp –
Respirateur«, die vom 27. 8. bis. 19.11. 95 im
Staatlichen Museum Schwerin gezeigt wurde.

Herausgeber
Kornelia von Berswordt-Wallrabe

Konzeption
Kornelia von Berswordt-Wallrabe
Gerhard Graulich
Ronny Van de Velde

Redaktion und Administration
Helga Piper
Julia-Kornelia Romanski

Restaurierung
Ursula Kanter
Vollrat Dreyer

Ausstellungstechnik
Werner Rehfeld
Werner Halle

Gestaltung des Katalogs
Eduard Keller-Mack

Fotos
Ronny Van de Velde, Antwerpen
Hessisches Landesmuseum, Darmstadt
Moderna Museet, Stockholm
Staatsgalerie Stuttgart

Übersetzungen
John Southard
Janis Mink (Text: H. Molderings)

Lektorat
Barbara Hartmann

Gesamtherstellung
Dr. Cantz'sche Druckerei
Ostfildern-Ruit

© 1999 Staatliches Museum Schwerin
Hatje Cantz Verlag und Autoren

© 1999 für die abgebildeten Werke bei
den Künstlern oder ihren Rechtsnachfolgern,
für Marcel Duchamp und Man Ray bei
VG Bild-Kunst, Bonn

Bearbeitete Neuauflage der Ausgabe von 1995

Museumsausgabe
ISBN 3-86106-053-1

Buchhandelsausgabe
ISBN 3-7757-0895-2

Erschienen im Hatje Cantz Verlag
Senefelderstraße 12 · 73760 Ostfildern
Tel. (0)7 11/44 05 0 · Fax (0)7 11/44 05 220

Printed in Germany

Distribution in the US
D.A.P., Distributed Art Publishers, Inc.
155 Avenue of the Americas, Second Floor
USA-New York, N.Y. 10013-1507
Tel. 0 01/2 12/6 27 19 99
Fax 0 01/2 12/6 27 94 84

Innere Umschlagseiten
Friedrich J. Kiesler
Collage Duchamp in his studio, 1945
aus: View, V, Nr. 1, März

Frontispiz
Charles Sheeler
Portrait of Marcel Duchamp, Sculpture by
Elsa Baroness Freytag-Loringhoven, 1922
aus: The Little Review, IX, Winter 1922, S. 41

Der Titel »Respirateur« bezieht sich auf
einen Ausspruch Marcel Duchamps,
hier wiedergegeben auf Seite 12.

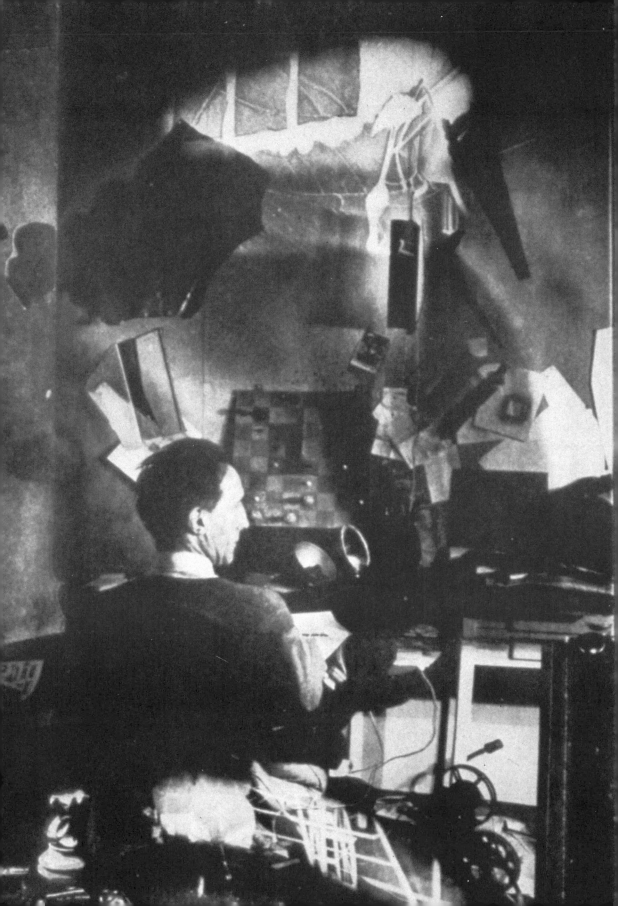